This Modern Romance

--

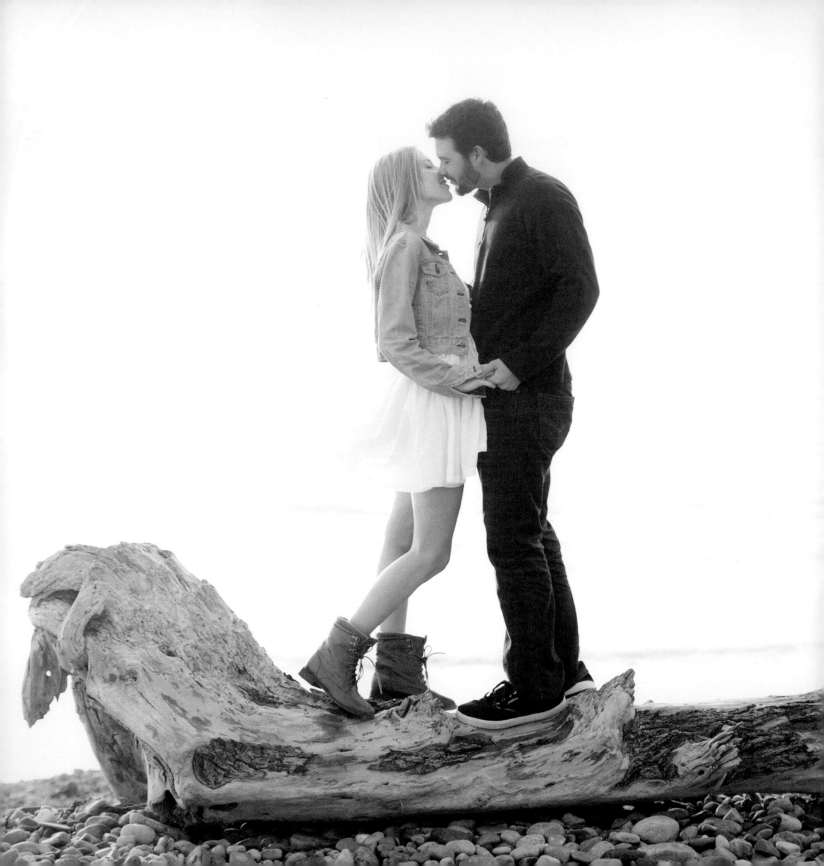

This Modern Romance

THE ARTISTRY, TECHNIQUE, AND BUSINESS OF ENGAGEMENT PHOTOGRAPHY

Stephanie Williams

with

Christen Vidanovic

Focal Press
Taylor & Francis Group

NEW YORK AND LONDON

First published 2014
by Focal Press
70 Blanchard Rd Suite 402
Burlington, MA 01803

Published in the UK
by Focal Press
2 Park Square, Milton Park, Abingdon, Oxon OX14 4RN

Focal Press is an imprint of the Taylor & Francis Group, an informa business

Notices

Knowledge and best practice in this field are constantly changing. As new research and experience broaden our understanding, changes in research methods, professional practices, or medical treatment may become necessary.

Practitioners and researchers must always rely on their own experience and knowledge in evaluating and using any information, methods, compounds, or experiments described herein. In using such information or methods they should be mindful of their own safety and the safety of others, including parties for whom they have a professional responsibility.

Product or corporate names may be trademarks or registered trademarks, and are used only for identification and explanation without intent to infringe.

Library of Congress Cataloging in Publication Data
Williams, Stephanie, 1983–
 This modern romance : the art of engagement photography / by Stephanie Williams with Christen Vidanovic.
 pages cm
 1. Wedding photography. 2. Portrait photography. 3. Couples—Portraits. 4. Betrothal.
 I. Vidanovic, Christen. II. Title.
 TR819.W55 2014
 778.9′93925—dc23 2013014751

ISBN: 978-0-415-82826-0 (pbk)
ISBN: 978-0-203-51495-5 (ebk)

Typeset in Minion Pro and Myriad
by Florence Production Ltd, Stoodleigh, Devon, UK

Printed by 1010 Printing International Limited

Bound to Create

You are a creator.

Whatever your form of expression — photography, filmmaking, animation, games, audio, media communication, web design, or theatre — you simply want to create without limitation. Bound by nothing except your own creativity and determination.

Focal Press can help.

For over 75 years Focal has published books that support your creative goals. Our founder, Andor Kraszna-Krausz, established Focal in 1938 so you could have access to leading-edge expert knowledge, techniques, and tools that allow you to create without constraint. We strive to create exceptional, engaging, and practical content that helps you master your passion.

Focal Press and you.

Bound to create.

We'd love to hear how we've helped you create. Share your experience:
www.focalpress.com/boundtocreate

f **Focal Press**
Taylor & Francis Group

"To my husband, Isaac.

*You are the reason I know
that true love
and soulmates
really do exist."*

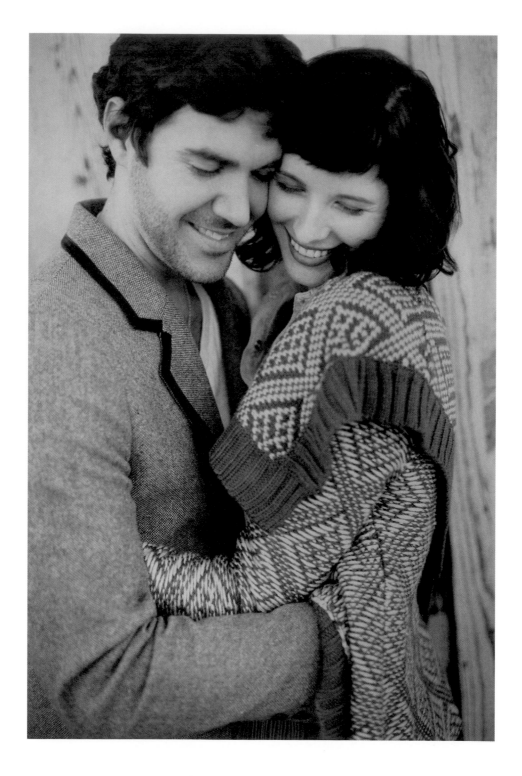

Contents

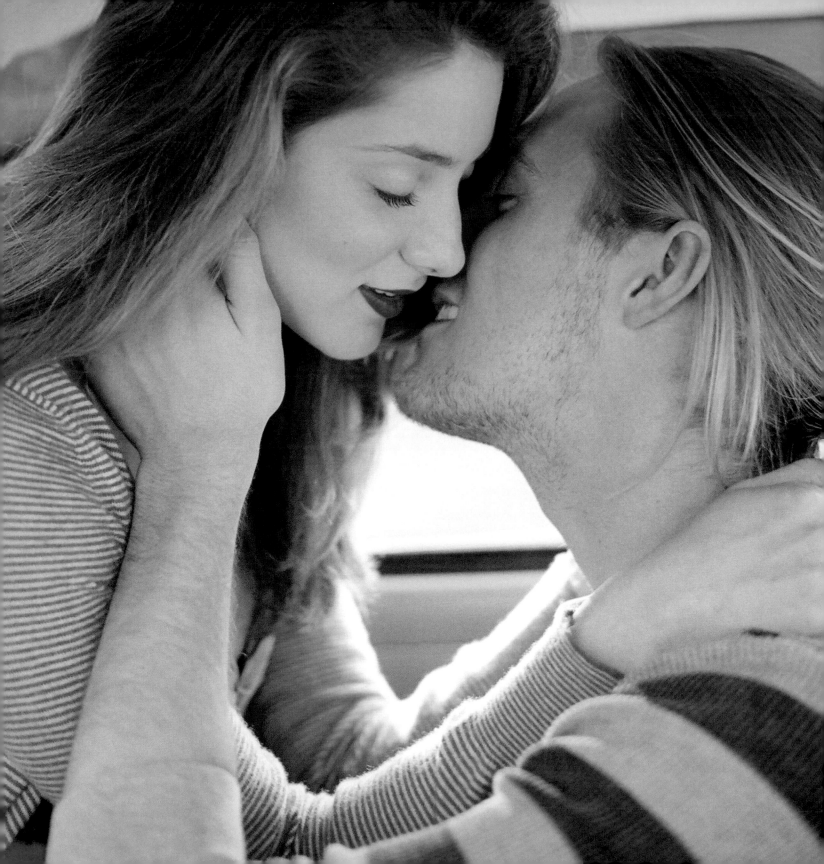

The Intention of the Engagement Session

Photographing Love

There is a stirring in the wedding industry. Static poses, bland backgrounds, and overly Photoshopped photos of couples are no longer suitable to a growing demographic of stylish, educated, and design-savvy consumers. Engagement and wedding photography has taken a bewitching turn toward spirited, compelling imagery that showcases a couple's individual personality and style. Together, photographers and couples are energizing the wedding industry by celebrating their engagements with creative, unique photo shoots. Photographers around the world have raised the bar for the wedding industry through editorial storytelling and dynamic lifestyle shoots that delight viewers with fashion-inspired scenes, natural, intimate poses and image processing that uses or emulates film.

Couples are seeking out photographers that are a part of this worldwide shift toward magazine-style shoots. This book is directed toward photographers who want to take their photography business to the next level, capturing heart-stopping engagement sessions in a relevant and highly artistic way. The wedding industry has grown rapidly and is in a state of constant flux—the tools in this book will help you be attentive to the industry's fast-paced changes so that you can keep ahead of the trends.

The concepts and workflows integrated throughout the pages of this book will enhance your ability to create stunning engagement sessions that embody the deep love that has brought your couple together. These concepts will help you approach your clients with confidence and gentle guidance, making images that they will fondly look at for the rest of their lives. The ideas in this book can be applied toward many types of portraiture, but will be most relevant when photographing couples in love. This book will help guide you toward becoming more comfortable photographing couples, whether they are engaged, celebrating an anniversary, or simply want to document their love. Love is less confined than ever, as is our desire to capture it.

The opportunity to market and increase revenue for your photography business is exploding. Use the suggestions in the following chapters to explore your creativity and develop a clear brand that reflects your unique voice. This will help you book more sessions and establish a strong, lucrative business and brand. Satisfied clients will remember your work, referring you to friends and turning to you as their trusted photographer for not only their wedding, but their maternity, family, and anniversary sessions. Providing your couples with excellent, personalized service, from the engagement session to the final prints, will help you stand out as a stellar photographer in a booming industry.

Engagement shoots, unlike weddings, have very few restraints and provide a unique opportunity for photographers and couples to be extra creative and adventurous at their sessions. From the location chosen to the time of day

"Engagement images are moving toward a lifestyle, organic, and editorial feel. Couples want to show their personalities and love in a way that is unique to them. This couple is laying on a sheet of lace, a family heirloom from her mother's wedding."

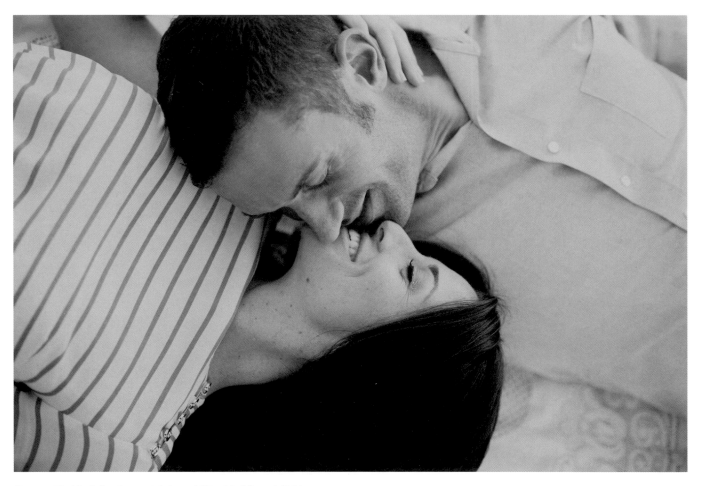

Canon 5D Mark II, 50mm 1.2 lens, ISO 400, f/2 at 1/250 sec

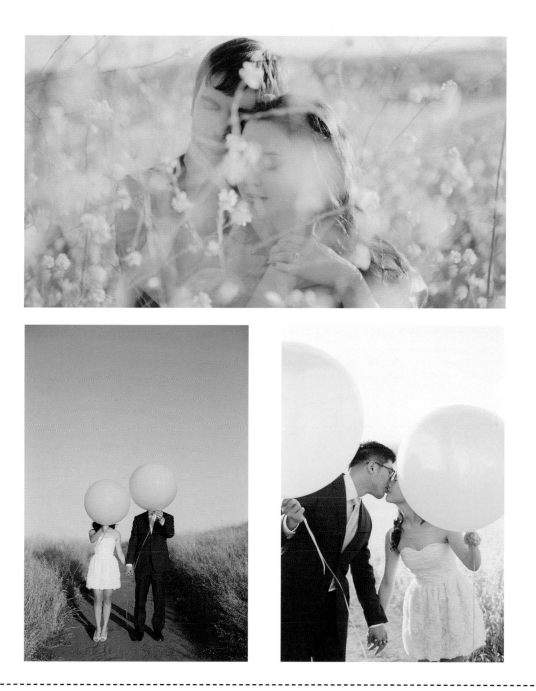

"The sunny pops of yellow evoke a sense of joy."

All three images shot with Canon 5D Mark II

and the styling, much of the control is placed in the hands of the photographer. These photo sessions are a great opportunity for your art and business to evolve with the rest of the industry's fast-paced movement. Look for tips throughout the book from prominent wedding professionals, bloggers, editors, and stylists, in addition to some personal experiences from real life couples that have hired Stephanie Williams for their engagement sessions.

Throughout this book, we will delve into both digital photography and film photography, exploring which one of them works best for you. Both have positive attributes and limitations. Essential to both is mastery of your equipment and a deep understanding of how to direct your subjects. While this book will touch on the technical and business aspects of engagement photography, the emphasis will be on improving how you direct and interact with your couples.

A technically sound foundation will allow you to focus on your creativity. Photographing more engagement sessions will improve your ability to shoot weddings and other portraits in addition to building a solid referral base for the future of your business.

The images in this book will hopefully light the flame of creative inspiration within you, enticing you to discover your own unique vision and execute thoughtful and intentional photography. Today is the day to learn something new about yourself and your photography! Whether you are looking to start building a new portfolio or want to revitalize your vision and your business, the techniques in this book will help you stay relevant in a changing industry. You will learn to direct your clients fluidly, use media tools to get your best sessions published, strengthen your brand, and build a larger client base.

--

"The beautiful skin tones from a well shot and processed film image are hard to replicate with digital capture. Here I exposed for the shadows during capture and only had to add a touch of contrast in post-processing."

Canon EOS-1V, 85mm 1.2 lens, f/2 at 1/250 sec. Fujicolor Pro 400H film

CHAPTER 1

Building Your Portfolio and Educating Clients

Getting engaged is like falling in love all over again. Butterflies in the stomach, an ear-to-ear smile every day and the fuzzy feeling that comes with knowing you've found your soulmate are intoxicating. The opportunity to capture and celebrate these rare moments gives engagement photographers a very special role. As the years pass, the images and memories created become more and more precious. This unique period in your couple's life, combined with an artistic and vibrant wedding industry, makes this an exciting time to be a photographer.

With over a decade's experience in the wedding industry **publisher and editor-in-chief of** *Southern Weddings* **magazine, Lara Casey** states that:

in my opinion, there is nothing more valuable in the tangible world (besides people) than great photographs. Engagement sessions give you the opportunity to immortalize your love for generations to come. I only wish my grandparents had candid photos of them in love! What priceless memories!

Getting Started

Engagement sessions can be a great way to expand your portfolio by integrating fun, stylized imagery that strengthens your brand. By improving your directing and shooting skills, you can create and display imagery that attracts your ideal client. Photographers, regardless of how long they have been shooting, will benefit from regularly revisiting and revitalizing their portfolios. Designing your business to reflect your photographic style will challenge you creatively and help you develop a current and marketable portfolio.

To construct a flourishing business that also satisfies you as an artist, you must invest in more than just costly equipment and a modern website—you must also spend time nurturing your photography and directing skills and streamlining your style. Your portfolio and branding are what sell "you." It is what clients are initially drawn to and a substantial reason that they chose you as their photographer. Devoting your time and energy to producing a polished portfolio that showcases your style will help you attract the kind of clients that you want. If engagement sessions are new to you or you'd like to create a new niche for yourself, try shooting a few stylized sessions with friends to get the ball rolling. On the other hand, if you have been in the industry for a while, energize your current portfolio with fresh imagery by creating new work in your unique voice and by staying up to date on current trends in the wedding industry. Like any hard earned accomplishment, mastery of your craft comes with time, hard work, and patience. Malcom Gladwell, author of *Outliers: The Secret to Success*, affirms that the secret to achievement in almost any area is having practiced it for 10,000 hours. While you may have an intrinsic talent in your creative pursuits, the only way you will ever be able to grow is through dedication and regular practice.

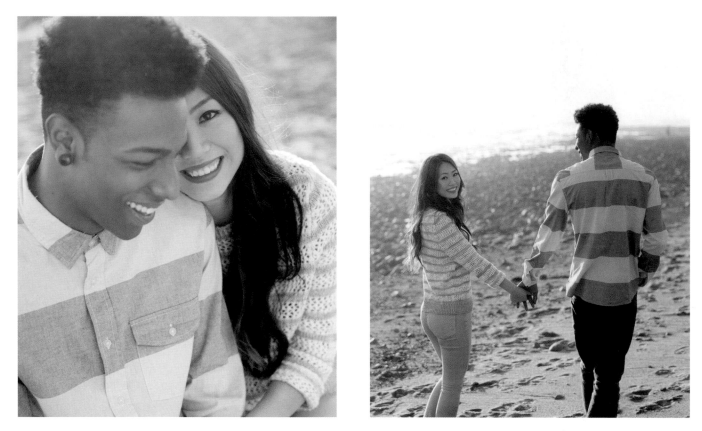

Both images shot with the Canon EOS 5D Mark III, 24-70mm 2.8L II lens, ISO 400, f/2.8 at 1/1600 sec

"This vibrant young couple were all smiles at the beach right before sunset. For the walking image, I asked the couple to walk toward the water, smile and look at each other. Part way through the walk, I asked her to glance over her shoulder at me."

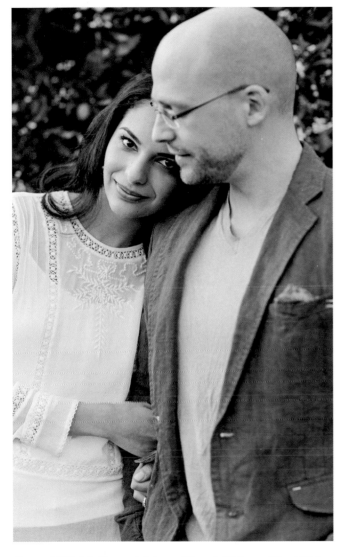

Canon EOS-1V, 50mm 1.2 lens, f/2 at 1/125 sec. Ilford FP4 Plus 125 Black and White film

"I recently began incorporating film coverage alongside digital and continually experiment with different film stocks and exposures during test shoots. I found that I love the look and grain of Ilford FP4 plus 125."

Show to Sell

Like attracts like, they say. In order to work at a certain level or attract a specific client, you must show that you are able to produce the type of work desired by that client. The images that you show on your website and portfolio, along with your branding, will draw in clients that are seeking that style. Whether you are a hopeless romantic with a penchant for soft and dreamy photos or fascinated by strong lines and hyperreal images, like those of photographer David LaChapelle, creating work that echoes your style will benefit both your business and your sanity in the long run. Many photographers make the mistake of trying to market and appeal to everyone, only to find that they are not directly targeting their ideal client, nor are they displaying a consistent voice. Find a style that excites you and fill your portfolio with only your best images.

Instead of churning out pictures of couples wearing matching white-collared shirts and jeans, tap into your artistic side and plan shoots that involve the locations, colors, and props that suit the type of client you want to attract. If you spend time shooting images that you don't love, you will be unsatisfied in the future with the direction of your business. Shooting images that you do love, on the other hand, will attract clients who harmoniously sync with your style.

"Shooting images that you do love,
on the other hand, will attract
clients who harmoniously sync
with your style."

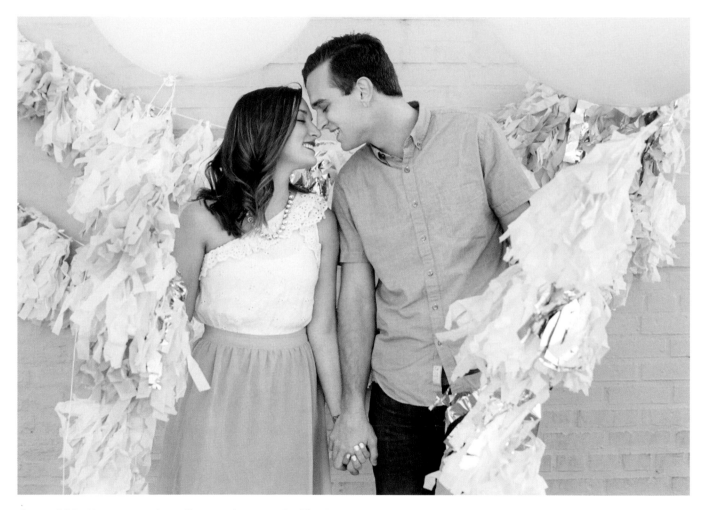

Canon EOS-1V, 50mm 1.2 lens, f/3.8 at 1/125 sec. Fujifilm Pro 400H

"For this image, I asked her to jump into his arms and kick up her heels for a kiss! It's OK to have your couple try this a few times to get just the right shot and it usually elicits a lot of genuine laughter."

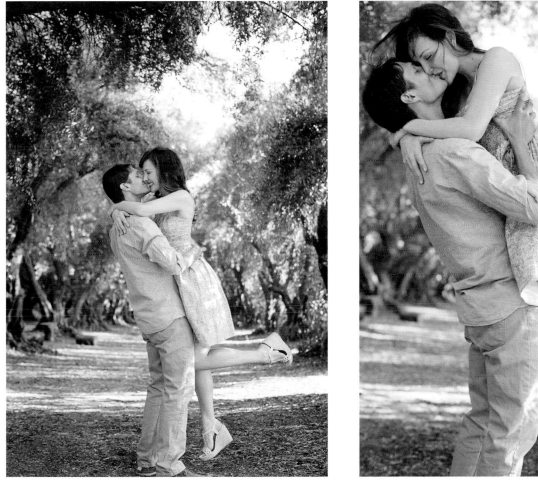
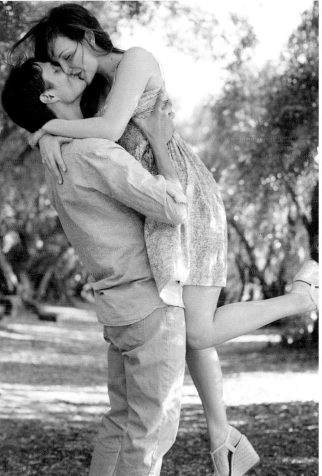

Canon EOS-1V, 50mm 1.2 lens, f/2 at 1/250 sec. Fujifilm Pro 400H

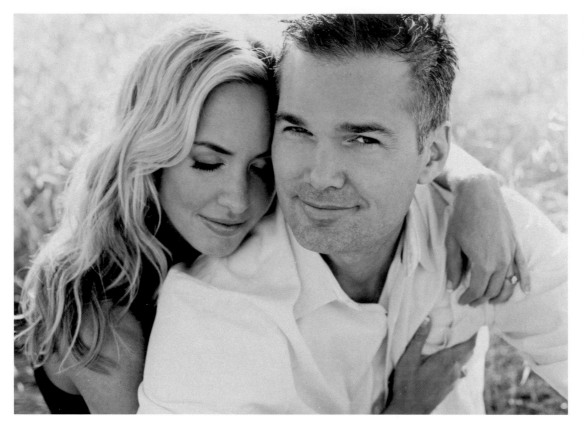

Canon EOS 5D
Mark II, 50mm 1.2
lens, ISO 100, f/3.5
at 1/320 sec

Test Shoots

Successful commercial and fashion-based photographers often expand their portfolios by setting up unpaid photo shoots so that they can experiment with a new look, play with a new concept, or test out a new piece of equipment or film stock. The fashion industry refers to these unpaid sessions as 'test shoots.' Commercial and fashion-based photographers are expected and encouraged to do test shoots in order to develop as skilled professionals and artists. Why shouldn't wedding and portrait photographers do the same? No matter how long you have been a photographer, always look for a reason to pick up your camera and do what you love. Scout locations that excite you, find people to photograph that

inspire you and plan shoots outside of your paid jobs. You will learn a lot by educating yourself through books and workshops, but nothing can replace actual experience.

Test shoots provide an opportunity to work out the kinks in your shooting strategies and mature your workflow without the pressure of a paying client. Brainstorming new ideas involving color palettes, pre-scouted locations, and props will inspire you to move away from conventional portraits and adapt yourself to current trends while maintaining your unique voice as an artist. Setting up a test shoot takes time and effort but they become easier to plan over time after you establish relationships with other industry

professionals. When looking for local resources, reach out to friends and family or aspiring models. Websites like Model Mayhem (www.modelmayhem.com) and, to a lesser extent, Craigslist (www.craigslist.com) can connect you with people who are eager to collaborate with photographers. Involving local coordinators, make-up artists, hair stylists, and aspiring fashion stylists is not only great networking, but can add a sense of excitement and style. Working with people who are enthusiastic about being photographed will initially help develop your directing style. When testing or sourcing models, ensure that you have the rights to use the images in your portfolio by having them sign a model release form. Collaborative projects are an advantageous way to organize a test shoot without directly advertising freebies on your blog, Facebook page or website, which could negatively affecting your business and brand. Regularly devoting yourself to artistic growth will help that growth to become a habit. Pushing yourself to try something new or to finally set up a shoot that you've been dreaming of will be the foundation that strengthens your work and boosts your business!

The Initial Meeting/ Booking the Session

Most engagement sessions are booked during the initial meeting for a wedding or added later in addition to wedding coverage, although sometimes a couple will inquire about engagement images even before they have set a date for their wedding. For many couples, this is the first time they are getting married and may even be the first time they have been photographed professionally. Think of yourself as a guide to help them understand the standard practices of the wedding industry.

Once potential clients have shown an interest in hiring you for their engagement session and/or wedding, set up a meeting with them to provide them with information on the benefits of an engagement session and how to best approach the shoot. Meeting in your studio, over Skype, or getting together for a cup of coffee is a good starting point for your relationship, where you can discover more about their

"Throughout my photography career, I have always worked from home. Initially, I was a bit embarrassed to meet couples at a coffee shop. In the back of my mind, I was worried that they wouldn't see me as a true professional without a flashy studio or big presentation. I found, however, that I could use the casual setting to my advantage and really connect on a personal level with my potential clients. My goal right off the bat is to find out more about them and their relationship. I want them to feel absolutely comfortable with me, like sharing a cup of tea with a friend. Now, although I could potentially work out of studio or office space, I still choose to work from home and enjoy the low overhead costs!"

personalities, show them samples of products and albums, book the session and begin to collaborate on themes, locations, and style.

An integral part of creating a beautiful engagement session and selling it to your client as a part of their wedding package is educating them about the process. Couples may

not be aware of how an engagement shoot will enhance their entire wedding experience. **Wedding coordinator extraordinaire, Michelle Buckley of Mint Julep Social Events**, recommends to all her clients to book an engagement session before their wedding since "these shoots are so important for the couple to become comfortable in front of the camera and confident in their photographer. It makes the wedding day so much more enjoyable!"

Weddings can be high-stress and fast-paced affairs where, often, the bride and groom are so caught up in the flow of the wedding that, between the tug of parents' desires and adhering to a schedule, they may not be as relaxed as they would like to be for their photos. Even with the most strategically planned timeline, events can run late, which may leave less time for romantic portraits. A "practice run" before the wedding day helps couples to fall into place naturally when photographed at the wedding because they already know what to expect from their photographer.

An engagement session will also bring attention to awkward poses and a person's most flattering (or unflattering) angle in advance so that the photographer can capture them at their best on their wedding day. For instance, some people who don't know what to do with their hands may make a fist or stiffen up if they're nervous. The engagement session is your chance to identify these tendencies in advance.

After Stephanie photographed their engagement session and wedding, Amanda and Henry Ngo reflected on their engagement session:

> Without a doubt, the engagement session was a huge step towards making us feel ready and comfortable on our wedding day. Since we had already gone through the experience of taking romantic shots with Stephanie, and were familiar with her style and cues, the process on our day felt like a breeze. It truly helped us stay calm and happy during our wedding. With only about an hour to spare for bridal party photos and a strict timeline of events on the big day, I would highly recommend any couple considering an engagement session to do it. It allowed us to feel more confident which ultimately led to photos we are absolutely in love with.

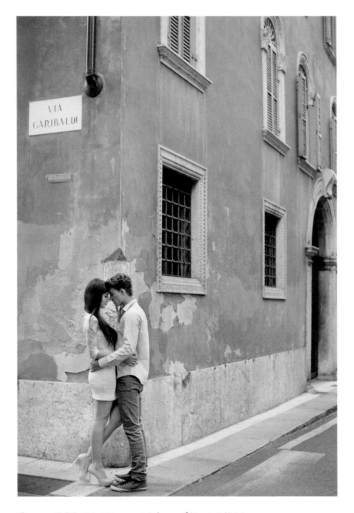

Canon EOS-1V, 50mm 1.2 lens, f/2 at 1/250 sec.
Kodak Porta 800

Because photographers spend a lot of time with a couple on their wedding day, often more than other vendors and sometimes even more than family members, it is important that couples feel comfortable with their photographer. Ashley and Tyman Stevens reflected on their engagement session, saying that their session gave them the opportunity to get to know Stephanie better and vice versa: "Weddings are an extremely intimate day, and already knowing our photographer put us at ease. It was just like having another friend or family member around." Your goal is to not be "just another vendor," or a stranger, but someone that they can trust with documenting one of the most important days of their life.

Leila Khalil, owner of Be Inspired PR, has worked in wedding marketing for ten years and considers engagement sessions a must before the wedding:

> It's so fun to look back on the period of your engagement because, before you know it, everything is different! Engagement photos are also perfect to use at all the events leading up to the wedding day as well as the big day itself. Bridal showers, rehearsal dinners, and dessert bars all look amazing with professional photos on display.

If your clients are interested in booking you for their wedding, help them understand how an engagement session can really benefit the wedding photos too. The engagement session is a way to get to know your couples more and a great chance to strengthen client rapport. Clients whom you have built genuine relationships with will enthusiastically refer you to their friends and family and are more likely to come back to you to document other major life events, like maternity and family photos.

"This image was shot in open shade. I stood on a nearby chair to get some height on the couple and focused on her eyelashes."

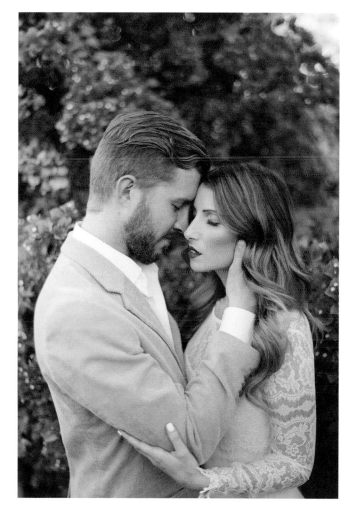

Contax 645, 80mm Zeiss lens, f/2 at 1/250 sec.
Fujifilm Pro 400H

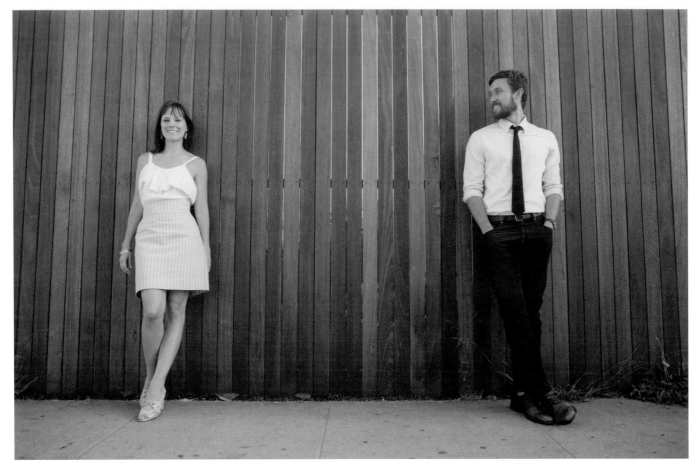

Canon EOS 5D, 24-70mm 2.8 lens, ISO 250, f/3.5
at 1/800 sec

Integrating Engagement Sessions into Your Wedding Packages

Depending on how long you have been shooting and your local market, you might consider including the engagement session in your wedding package or offering it as an à la carte session. In order to sell the engagement session, you need to show prospective clients the value that it adds to their wedding photography coverage. They need to understand that not only will they receive beautiful images that document an important and exciting time in their lives, but that their wedding images will also benefit from the engagement session. If you choose to include engagement sessions in all

of your wedding packages, make sure you account for the costs involved. Including the engagement session doesn't mean that you should ever work for free; be sure adjust your prices to reflect the amount of work that you're doing.

Another strategy to book more engagement sessions is by offering them to couples who have inquired about your services for their wedding date, only to find that you are already booked for that date. Instead of simply sending them off with referrals to your peers, suggest shooting an engagement session with them since you won't be available for the wedding. They may jump at the chance to still be able to work with you, even if it is on a smaller scale. Increasing the amount of romantic sessions shot during the year will give you more time to fine tune your directing skills while getting to know each of your clients more in-depth. In addition to building strong relationships with your couples to ensure future bookings, engagement sessions also give you an additional opportunity to sell prints, albums, and other products to increase your revenue. The "show to sell" concept applies to all of the engagement session products that you offer. Having tangible examples of coffee table albums, custom guest signing books, and print displays to hand is an effective way to sell your clients additional items to add on to their total package. Seeing these products will hopefully get your clients excited about all of the potential ways they can enjoy their photos and create a desire for add-on items they had not previously considered.

> "When starting out, many photographers include a 'complimentary' engagement session with their wedding packages with the cost of the session built in. Other options include listing the session at a reasonable rate to make it an easy addition. For clients who want to hire you only for the engagement session, I would recommend pricing these sessions differently. I offer several choices based on the number of images the client will receive. For instance, the first option will include only the session with the opportunity to purchase prints and high resolution images. The second option will include five high resolution images, the third will include ten images, the fourth will include 20 images and the final option will include the full collection. The first option is the most economically priced; however, couples almost always upgrade once they see their photos. Most of my couples will end up splurging on the full release of images and even adding large canvas prints, fine art prints, and engagement albums to their order.

"These images create a very sweet and romantic series when placed together. Diptychs and triptychs look amazing displayed on a client's wall and can convey a visual story better than a stand-alone image."

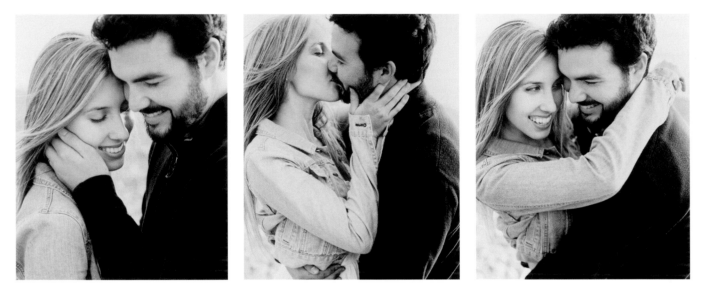

Canon EOS 5D Mark III, 50mm 1.2 lens, ISO 320, f/2.8 at 1/400 sec

Preparing Your Couple for the Shoot

Your initial meeting is also a good time to encourage your couples to go the extra mile to make their engagement shoot beautiful. Since most people aren't used to being photographed, they may not realize that little additions, like getting their hair and make-up done professionally, can really enhance their photos. Many clients will need to be subtly encouraged to have this done, but will be very pleased with the outcome. Brides will appreciate the opportunity to see how their hair and make-up translates onto photographs. The experience will also give them a better idea of how much

time they should allow for getting ready on their wedding day. Encourage your clients by letting them know that getting their hair and make-up done is a very normal part of creating professional looking photos. Use words that aren't forceful and lightly recommend that they approach the photo shoot in the same manner that many of your couples do in order to get the most out of the experience. The way you approach your initial meeting, as well as your shoot, will set the tone for your relationship with your couple—so be friendly and excited.

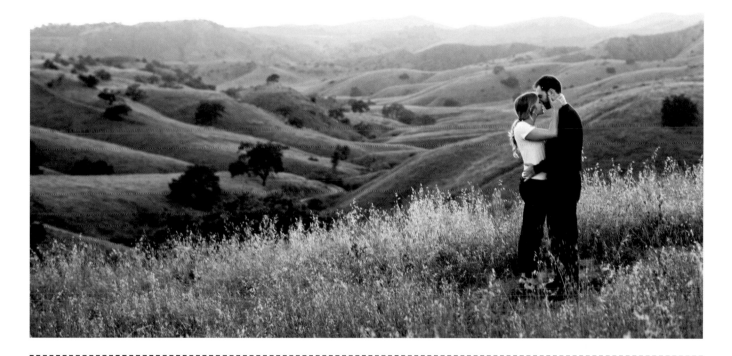

"Images that feature stunning
landscapes and negative space
make perfect large canvas prints."

Canon EOS 5D Mark II, 50mm 1.2 lens, ISO 640, f/2.2 at 1/200 sec

20 13

(101) PHOTOGRAPHY TIPS

this modern romance

stephanie williams photography

Here is a sample spread from my photography tips packet that I send out to all my couples. It was created by graphic designer Brian Rau, and is a mixture of engagement session and wedding day tips peppered with some of my favorite portfolio images.

ENGAGEMENT SESSION

- Engagement sessions last about an hour and a half, and I usually schedule to start the session two hours before sunset, so we can have a good mix of light.

- While we have a lot of favorite spots to shoot at, including nature inspired, urban and artsy/colorful, we are always up for finding new, unique spots. We'll get great images no matter where we shoot, but definitely scroll through some of my past engagement sessions on my blog to see which location style is more "you".

- You can have up to two outfits, and I definitely encourage couples to have fun with it. Always bring a couple of options and some accessories; we can go over wardrobe and what goes best with the location beforehand.

- If you are having trouble picking outfits, pinterest.com is a great source of inspiration. There are many pin boards of just engagement outfit inspiration! If budget allows, you can even hire a stylist, like Merci www.mercinewyork.com.

- It is always a good idea to get your make-up and hair professionally done for the session. A good make-up artist will know how to flatter your features for the camera and you will look and feel that much more amazing during your session. I would even recommend using this time to do a test run with your wedding day hair and make-up artist.

- You can bring props if you want – something that might make your session more personal and uniquely you. From colorful balloons to a sweet little rowboat, we'll be up for almost anything, so don't be shy if you have a fun idea. If you want to run a creative idea by us, just let us know.

- Remember to be playful and have fun at the session...the more natural and comfortable you are with each other and your photographer, the more the images will be a true reflection of your relationship...hold hands...laugh...and kiss a lot!

- We have many mid-week dates available throughout the year, however, if you can only do weekends for your session due to your work schedules, we would definitely recommend booking early. Available weekend dates are limited and book up very quickly.

Even if your couple choose to forego getting their hair and make-up done, the idea itself will encourage them to put more thought into the session. When people feel good about themselves, it shows through in photographs. When your couple feel at their best, by looking styled or bringing props that fit their personalities, the photo session will blossom. Thoughtful planning by the couple is a vital part of the photographic collaboration and will help them take the shoot more seriously.

Your meeting is a great time to suggest a few other tips regarding wardrobe, location, props, and styling. Possibly mention a few inspiring locations to shoot at to help your clients visualize the experience and get excited. Once your client has booked a session with you, you can send them additional information, like an engagement session tips packet that reiterates a few of your initial suggestions for a successful engagement shoot. An engagement tips packet is a subtle way to provide your clients with a list of things that they should do to prepare for their session without the recommendations feeling forced. Most couples will be grateful for any advice that will enhance their photo shoot, and will follow through with any suggestions that will make their

Canon EOS 5D Mark II, 50mm 1.2 lens, ISO 320, f/2.8 at 1/320 sec

images more breathtaking. Remember, the goal of your recommendations is to make them look and feel better about their images and the entire photo shoot experience.

--

Be Genuine

Genuine interest in your couple, along with an authentic desire to get to know them better, is crucial to establishing good client rapport. If you find you are lacking in this area, there are plenty of resources to help you build this necessary skill. Reading books like the 1936 classic *How to Win Friends*

and Influence People by Dale Carnegie is a good place to start. If you come across as professional on every level and are confident in your craft, you will have more control over your clients' overall experience. Whether you are recommending locations and props or choosing the exact time of day to shoot, couples will be grateful for guidance from their photographer. In truth, the session is not about the props, the clothes, or the location, but about celebrating your couple and their love. Yet, learning to use all of the tools that you have as a photographer will help you create memorable, distinct images that your clients will cherish for the rest of their lives.

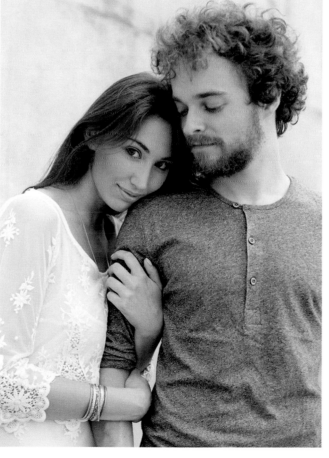
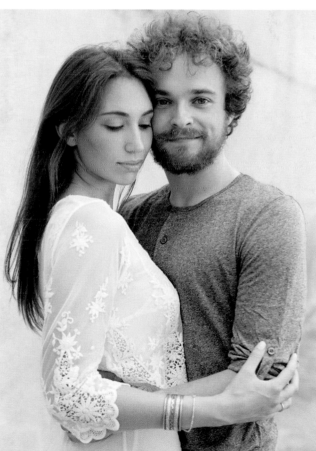

Both images shot with Canon EOS-1V, 80mm 1.2 lens, f/2 at 1/250 sec. Fujifilm Pro 400H

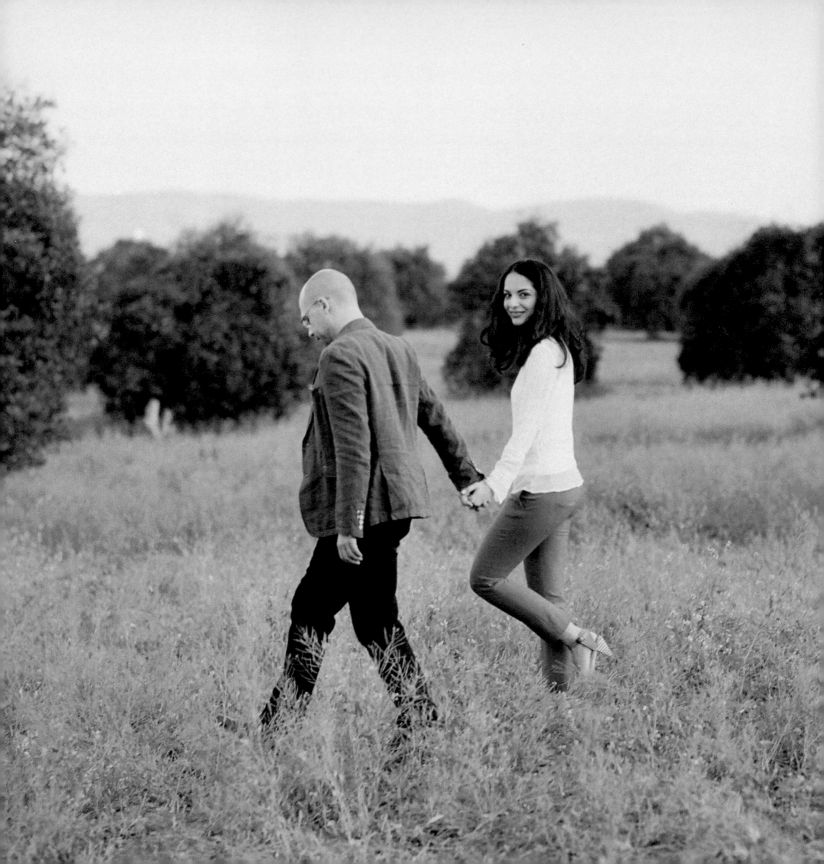

Choosing Your Equipment

Often photographers find themselves pulled toward a slew of different media, but don't realize that choosing a camera is really about fulfilling their creative vision in a professional manner. There is no right or wrong choice in a camera as long as it fits into your workflow and branding. Fashion photographer Rodney Smith elegantly stated:

> For the people who write me and ask for answers, or who are looking for the right process to make better pictures, I implore you to realize that there isn't any ONE right answer. There is only your particular answer to be found and only you can find it. This is no easy task.

Choosing a Camera

Experimenting with different cameras is a delightful way to discover the type that works best for you. Test shoots aren't just an opportunity to try out new locations, models, and styles—they can help you decide what kind of camera you want to invest in. Use test shoots to explore the different styles that you are drawn to and the kind of equipment that makes those images possible. Get inspired by history's most renowned photographers. Perhaps you are fascinated by dramatic, high-contrast images or by clean, modern lines. If you are curious about shooting with film, but have traditionally shot with a digital camera, a test shoot can be a great opportunity to find out how to use a film camera in

"A camera is simply a tool in your hands."

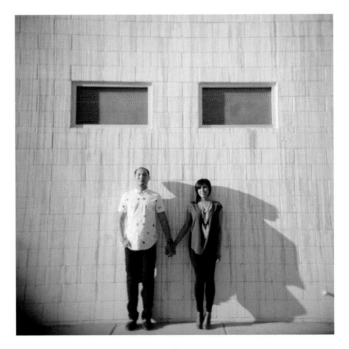

Holga 120N set to shade, Fujifilm Pro 400H

> "Test shoots are the perfect time to work on your shoot flow and try out new camera equipment in a realistic setting. When I first started shooting film in addition to my digital coverage, I used test shoots to practice loading film quickly and fully familiarize myself with the Contax 645 focusing and metering system. The 35mm Canon EOS-1V camera was easier to adjust to, since the settings, button and wheel placement were similar to my digital Canon 5D Mark II. I also used these sessions as a way to test different film types and film labs, so I could have my desired look completely figured out before offering these services to paying clients."

combination with a new style, location, and lighting concept without the expectations of paying clients.

Explore different types of lighting and find a look that represents you. If you want to shoot with a Holga camera or explore negative space, be sure to include those looks from test shoots in your portfolio. Again, remember that you want to maintain congruency in your brand and image. If you advertise a portfolio on your website featuring a certain image quality, it's important to always provide your clients with consistent product. Try to find a balance between what you love to shoot and your clients' expectations.

Consider renting different cameras while you are reinvigorating, test shooting, or pioneering your brand. Avoid buying a camera simply because another photographer is touting it as the best on the market. Give yourself space and time to investigate different types of cameras—film, digital SLRs, 35mm, medium and large format, toy cameras, instant cameras, twin lens reflex, and rangefinders are all viable creative options in today's market. A camera is simply a tool in your hands. It is through a refined eye and knowledge of light and composition combined with proficient use of your equipment that you will produce your finest images. While there is a standard of equipment quality for the wedding industry, it is your understanding of light and photography that qualifies you as a professional.

Choosing Your Equipment

Even more valuable than the specific type of equipment you use is a thorough, practical knowledge of how your camera gear works. While you may not need as much equipment for an engagement shoot as you would for a wedding or a commercial shoot, it is critical to be completely comfortable with the camera and lenses that you do use. A detailed, functional understanding of your camera and all of its settings is necessary in order to achieve your artistic vision while still focusing your attention on your subjects and their overall experience.

While this book will cover some technical photography knowledge, it will serve you best if you already have a basic understanding of photography along with the ability to shoot your camera in manual mode. There is no shortcut method to learn about your camera and equipment. Read your camera's manual front to back and dedicate a good chunk of time to exploring all of your settings and functions. Every camera has different settings and potentially varying light metering systems. Photograph an assortment of subjects and colors under different lighting conditions to get to know the

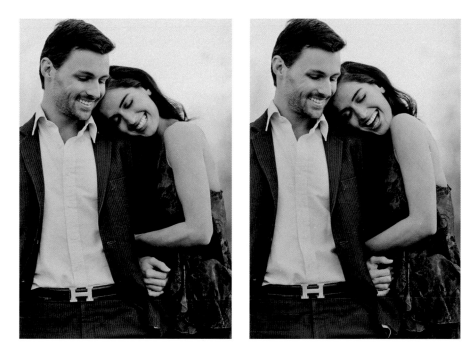

Canon EOS-1V, 85mm 1.2 lens, f/2.8 at 1/250 sec. Fujifilm Pro 400H converted to black and white in post-processing

way your camera reads a scene. For example, your camera's metering system may overexpose a scene when photographing a subject in all black; you should fully understand how your camera meters and 'sees light,' so that you are able to compensate accordingly and accurately expose your photos. When shooting with clients, you want to be able to focus your attention on composition and direction without being flustered by unknown camera functions or settings. Give your photography the unhindered opportunity to flourish. Be fully involved when shooting engagement sessions—allow yourself to focus on your couple, the scene, and creative composition during an engagement shoot.

It's critical that you arrive at every engagement session prepared. Preparation goes beyond charging your batteries, formatting memory cards, and scouting locations. As a professional photographer, you should always have a backup camera with you. Your clients have made certain investments on the shoot day—they have potentially taken time off from work, secured a location or hired a stylist and gotten their hair and make-up done. Should an unexpected misfortune

occur (a camera fails or a lens takes an unfortunate spill), meticulous preparation and foresight will save your shoot time, your clients' investment, and your reputation as a professional. The bare minimum that you can do to mitigate adverse circumstances is to always bring a backup camera, extra batteries and CF cards, and carry liability and equipment insurance. Some locations, especially historic sites and museums, will not allow a photographer to shoot on the property or obtain a permit without liability insurance.

Even though you may be carrying less equipment on you for an engagement session, theft or equipment damage is always a possibility, and insurance is relatively inexpensive. Hill and Usher (www.hillusher.com) has a photographer's insurance package that covers damage, theft, and liability. Several photography organizations also offer low-cost coverage, like the Professional Photographers of America (PPA) that includes indemnification insurance and $15,000 worth of equipment insurance as part of the membership costs. There are no real reasons to not have these professional precautions in place. While many photographers have been

--

"Backlit images or images with a lot of bright negative space will read too bright with your camera's light meter and will end up underexposed unless you compensate."

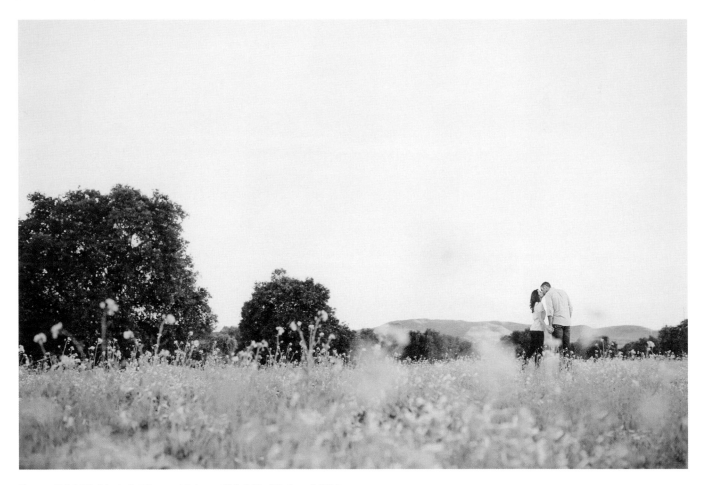

Canon EOS 5D Mark II, 50mm 1.2 lens, ISO 500, f/3.5 at 1/500

in business for a long time without taking these steps, something inevitably goes wrong, and it is ultimately the photographer's responsibility. Horror stories abound of lost memory cards, broken or stolen equipment and, always, heartbroken clients. By taking action to protect yourself and your clients against the natural misfortunes of everyday life, you can ensure the safety of your clients' photos, your gear and your business.

Canon EOS-1V, 50mm 1.2 lens, f/2 at 1/250 sec. Fujifilm Pro 400H

Digital vs. Film

The photographic community is constantly debating which approach is better, digital or film, especially since there has been a recent shift back to film in the wedding industry. Both formats can be powerful tools when used skillfully and deliberately, and both digital and film based photography can be used to communicate your vision during an engagement shoot. If you are just starting out in photography, choosing to focus on one medium that accurately reflects your lifestyle, time constraints, and workflow will serve you better than trying to master both digital and film. There are benefits and challenges to both types of photography.

Both film and digital photography require financial investments. Although it requires more of an initial invest-

"Both images were shot in open shade on a bright sunny day in the desert. The left image is shot with film and scanned by Richard Photo Lab, while the right is digital capture with no post-processing."

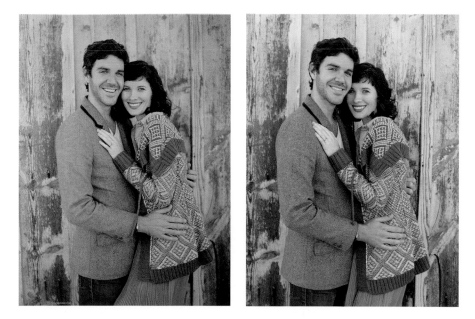

Left image is Contax 645, 80mm Zeiss lens, f/2.8 at 1/250 sec, Fujifilm Pro 400H, while right image is Canon EOS 5D Mark III, 50mm 1.2 lens, ISO 400, f/2 at 1/800

"Here the film image is left untouched and the digital image on the right has had just a slight color balance and contrast adjustment."

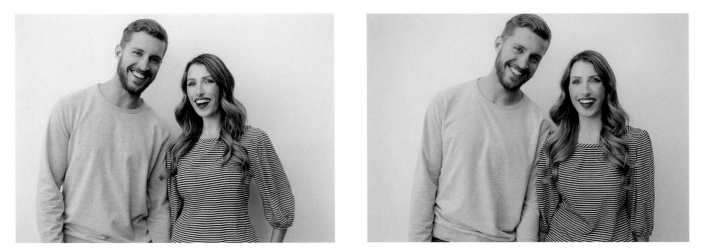

Left image is Contax 645, 80mm Zeiss lens, f/2.8 at 1/60 sec, Fujifilm Pro 400H, while right image is Canon EOS 5D Mark III, 50mm 1.2 lens, ISO 800, f/3.5 at 1/500 sec

ment, digital capture gives less experienced photographers the freedom to experiment without the costs associated with each film shoot such as film roll and lab processing. Digital capture allows a photographer to experiment and receive feedback with unique compositions, moving subjects, and changing light without the worry of wasted film. Although digital photography offers greater control with immediate, in-camera awareness of exposure through histograms, film is the hopeless romantic of the photographic family. With its dynamic tonal range, soft feel, and rich grain, film possesses an organic quality that is very forgiving for skin tones.

The natural look of film is not easily replicated. When certain film stocks are overexposed, the resulting pastel tones and delicately detailed whites cannot be mimicked in digital capture. But the film devotee will face a steep learning curve without the help of immediate image feedback. Film advances your photographic education quickly, forcing you to become

a better, more diligent photographer. You are required to slow down, focus, and meticulously frame every shot. There are no images on the back of your camera to distract or prompt you, so you must be fully attentive to your subject and your camera's settings. You are also confined to the ISO speed of the film you have loaded. You may also have to additionally prepare for your session by loading multiple film backs or work with an assistant to help you change film rolls while on a job, if you cannot change film as quickly as you'd like to shoot. Having an assistant on a film based shoot can help you maintain an even flow to the session, ensuring that you create a seamless experience for your couple. While shooting film may mean more preparation and technical skill, photographers are rewarded with a distinct look and unparalleled depth. The consistent color and tone of each roll is achieved by sending your film to a professional lab instead of spending hours post-processing.

⫸→ "There is something about the organic look of film that has always appealed to me. Although I began learning and shooting digital in 2005, I made the decision to start shooting film a few years ago. I now shoot in a hybrid style with both film and digital cameras. My engagement sessions are mostly shot with 35mm and medium format films, while my wedding coverage is about 40 percent film. I still find digital cameras superior in low light environments, fast-paced situations, and candid coverage. I don't shoot film above 800 ISO at this time because of the amount of grain, but this is purely subjective. Also, I feel that because of the nature of film grain, images shot with film appear better in print. Most of my couples have a hard time telling the difference between film and digital images, but the trained eye can still tell even after the digital image has undergone a lot of post-processing."

"This colorful wall was very bright and saturated with color, however, when I overexposed the film by a stop, the colors become softer and more muted."

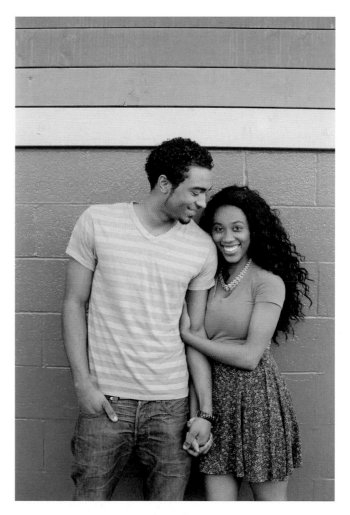

Canon EOS-1V, 50mm 1.2 lens, f/2.8 at 1/250 sec.
Fujicolor Pro 400H film

--

Shades of red and skin tones look amazing with film. I especially love red lipstick on film.

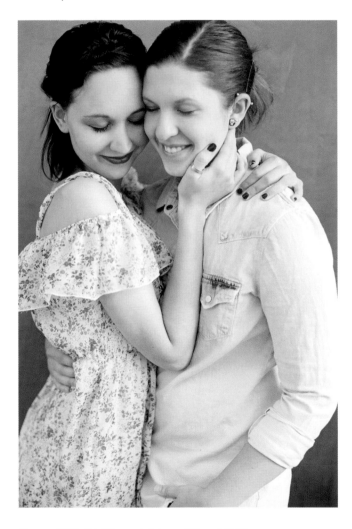

Canon EOS-1V, 50mm 1.2 lens, f/2 at 1/125 sec.
Fujicolor Pro 400H

If you already have a business shooting digital photography and want to incorporate film into your offered services, you can always introduce film coverage as an add-on. Even a set of Holga shots or Polaroids are viable and valuable additions in this creatively driven market. Bear in mind that adding film into your photography packages will introduce a significant cost to you because the actual expenses of shooting and processing film are quite high. Make sure that this cost is reflected in your pricing. Many photographers choose to only shoot film because of the time involved in a digital workflow. If you are culling and editing everything yourself instead of outsourcing, you will be required to spend more time in front of a computer. The cost of your time is not considered by many photographers, but it is your greatest resource and should have a great value!

Generally, film photographers develop close relationships with the labs and technicians who process the film and deal with color and exposure, working with you to achieve the look that you want to brand yourself with. Working with a top lab is crucial to achieving the best film processing results. Working with the same technician regularly will help them become familiar with your work and the processing style that you're looking for. A top end lab will have a high quality scanner and knowledgeable technicians that are capable of producing immaculately processed and color corrected film, in addition to creating high resolution film scans. Test shoots are imperative when working with film, paying close attention to settings and taking meticulous notes on the environment, film speed, type of light, time of day, and camera settings in order to fully understand how to construct your best images.

Digital cameras can produce sharp, high resolution images that, while they are post-processing labor intensive, allow for flexible image editing. Shooting RAW files allows for greater versatility in exposure, contrast, and color balance. Moreover, there is an extraordinary peace of mind that comes with shooting digital imagery: the ability to review your photos during your shoot, capture more images, and to a greater degree, adapt your ISO to changing light conditions. These features can be very alluring, especially if you are a fledgling photographer or find yourself shooting in fast-paced environments like weddings.

Shooting with a digital camera offers the ability to shoot multiple frames in a row, allowing photographers to capture multiple exposures for that "perfect moment" without the fear of wasting film. When shooting digital images, your exposure needs to be exact or just slightly underexposed. Overexposing skin tones can ruin a digital image by rendering the skin white and completely devoid of color, texture, and digital information. It is possible to brighten an image in post-processing, especially when shooting RAW, but if a part of your subject in the image is overexposed, the white information was never recorded onto the digital file, making it impossible to recoup. On the other hand, overexposing certain film stocks, like Fuji Pro 400H, creates more pleasing skin tones and a beautiful pastel palette. When shooting film, your images need to be exposed exactly, or overexposed. Underexposed film is very hard to salvage. Always err on the side of overexposing your film rather than underexposing it.

The digital capture process is very different from film. Film has a greater dynamic range than digital, meaning that it can smoothly record the depth and gradient variations in highlights and whites. In addition to its wide-ranging ability to capture brighter tones, film also has a greater capacity in recording and reproducing colors like red and green than digital cameras. Digital photography is convenient and fits well in our increasingly fast-paced world; however, sometimes being able to slow down with a film camera can make a difference in how you shoot and the kind of quality and work you produce.

Lenses

Engagement sessions, along with other portrait sessions, require significantly less gear than weddings. In order to achieve high quality images, invest in lenses with good glass, meaning a well-built lens with fast auto-focusing and excellent color rendition. A lens that has a maximum aperture of f/1.2–2.8 is generally preferred. A wide open aperture allows more light to enter your lens and creates a greater depth of field. Paired with lovely light, this wide aperture creates a buttery "bokeh" effect (the aesthetic quality of the out-of-

"I love the look of medium format film paired with the Zeiss glass."

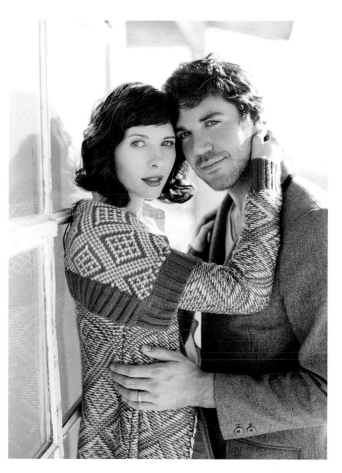

Contax 645, 80mm Zeiss lens, f/2 at 1/500 sec.
Fujifilm Pro 400H

focus areas of the image) and a softer look that aligns with the current romantic style of the wedding industry. Try out lenses or rent them before you buy so that you can make your own comparisons on sharpness, bokeh, color rendition, and contrast.

If you are looking for an all-purpose lens to launch your glass collection, choosing a 50mm lens that opens up to an aperture of 1.2 to 1.4 will improve the quality of your images and minimize distortion while still offering the flexibility to move easily between portrait and landscape images. Besides, using a prime lens will force you to move your feet, creating a sense of intimacy in close-up romantic portraits or a vast perspective from a farther distance. Prime lenses tend to have less distortion, chromatic aberration (magenta and green color fringes on the edges of your subject), and less back focusing issues than zoom lenses because they have fewer moving parts. High-end zoom lenses, like Canon's EF 24-70mm f/2.8 IIL USM lens, that minimize many of these issues, are quite expensive, but well worth it if you want excellent image quality.

While there is no absolute answer when it comes to what type of lens is best for portraiture, most fashion photographers shoot with focal lengths no closer than 85mm. These preferred lenses are chosen because they create more facial compression and less distortion. It is also easier to separate the subject from the background without having to shoot with a wide open aperture. The further the lens is from the subject's face, the more realistic an image is created without distorting the nose and ears. Many portrait photographers choose a focal length between 70mm and 85mm because it creates great close-up images while still allowing for the photographer to shoot full-length photos.

Finding a good lens takes time and can be expensive. Renting professional equipment while building your business is a cost-effective way to discover your style, create professional quality images, and make sure that you're using a lens that will serve you and your particular brand. If you're planning on buying a new lens or camera, renting it first will let you take it for a test drive before you invest in a costly piece of glass. There is the concern that rental camera equipment may be more beat up from overuse, lack of

> "For most engagement sessions, I only carry two lenses on me. I use the Canon EF 50mm f/1.2 L and Canon EF 85mm f/1.2 L lens most of the time, and can swap them with the digital Canon EOS 5D Mark III and 35mm film camera, the Canon EOS-1V. I bring out my Contax 645 or toy cameras like the Holga depending on the theme and style of the engagement shoot. I find having just two focal lengths forces me to move around and see different angles. It also saves my back from carrying too much weight on my shoulder!"

calibration, or lack of servicing, so always test the gear before you take it with you to an engagement session.

Buying lenses with superior quality glass will always be reflected by the sharpness and color of your images. Consider buying a lens hood for each of your lenses if it isn't included. In addition to protecting your lens in case you bump it, lens hoods can keep unwanted stray light from entering your frame and washing out your images. Lens hoods can be especially helpful if you are shooting a subject in shade or back light by shading your lens from light while still allowing it to fall on your subjects. Finally, be sure to service your lenses and equipment regularly and be aware of any signs of reduced

--

"I tend to prefer prime lenses that force me to move my body for composition. I have to physically move closer for an intimate portrait and tighter crop or farther away for a wide landscape."

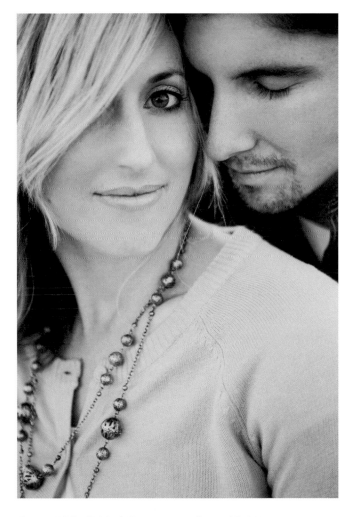

Canon EOS 5D Mark II, 50mm 1.2 lens, ISO 800, f/2.8 at 1/250 sec

sharpness or back focusing. Pay special attention to the calibration on your lenses after any jostling, like a long plane ride, by checking the sharpness of your lens and noticing if the autofocus is having trouble focusing. Your equipment will need to be sent in for a maintenance checkup periodically to keep it in tip top shape.

--

Stephanie's Camera Bag

Photographers have a lot of choices and options when it comes to gear these days. I began my photography career shooting with Canon equipment and still do for the most part. Every major professional photography brand has the high caliber equipment necessary for shooting great engagement sessions, so really it's about using what is comfortable for you. Remember that these are just tools in your hand. Your eye for light and composition along with how you direct your subject are the most important aspects. Here is an equipment list of what's in my bag.

Canon EOS 5D Mark III

This full frame digital camera produces excellent color and high resolution files. I shoot RAW files for maximum editing latitude. One of the biggest improvements I have seen in this camera compared to the Mark II is the AI Servo tracking focus. It is absolutely spot on and tack sharp. I also love the ergonomic design and the way the camera feels and sits in my hands.

Canon EOS-1V

My go-to 35mm SLR film camera. It uses all the same Canon EF lenses that I use with my Canon 5D Mark III. It doesn't produce the same "creaminess" of the Contax 645, but is perfect for engagement sessions and faster paced environments to get film's lovely color palette. The cost of processing 35mm film is also less expensive than medium format processing. I end up shooting about 8–10 rolls of 35mm film for an engagement shoot.

"I use the Fuji Instax to take some instant photos at most of my engagement sessions and then I photograph the prints in the environment. For one, it makes for a great creative challenge at each session, and two, my couples love to take home some tangible prints from their session."

Contax 645

This medium format film camera is my go-to for gorgeous, creamy, soft film images. I usually shoot with the 80mm f/2.0 Zeiss lens and keep the aperture at f/2.0 for that gentle, dreamy look. This camera uses 120 or 220 film, and I usually bring at least 20 rolls of Fuji 400H with me when shooting film.

Canon EOS 5D Mark II

I keep at least one backup camera with me, even for an engagement shoot. You never know when your camera may fail, so being prepared with backup is important.

Fuji Instax Wide shot with a Canon 5D Mark II

Canon EF 50mm f.1.2 L USM Lens

For most of my engagement sessions, I will alternate between using the 50mm 1.2 and 85mm 1.2 lenses. The 50mm is a fast focusing and very sharp lens, perfect for getting closer to your couple during an embrace, singling out details that feature creative compositions of hands and feet. I also use it for wide landscape shots.

Canon EF 85mm f/1.2 L USM Lens

This lens produces the most gorgeous color and bokeh, and the focal length is perfect for flattering portraits. This is definitely my preferred lens for traditional and romantic portraits. I also use this lens for walking shots, but the autofocus is a little slow. It is also a very heavy lens.

Canon EF 70-200mm f/2.8 L IS Telephoto Lens

This lens is bulky and heavy, so I don't use it too much during an engagement session, but I do use this lens quite a bit during candid wedding coverage. It is really great for walking shots or creating amazing compression in a portrait or landscape image.

Fuji Instax Wide

I love this instant film camera and bring it with me to all my sessions. I have an ongoing personal project where I take about five creative instant images of the couple. I then photograph the instant image in the environment, and let the couple take home some instant images from their session.

Canon 45mm f/2.8 Tilt Shift Manual Focus Lens

I don't use this lens very often, but you can create some stunning art pieces by playing around with the planes of field and selective focus. It is a tricky lens to get acquainted with and it has to be manually focused, so it can slow you down at a shoot, but the results can be very lovely.

Canon EF 24-70mm f/2.8 L II USM Lens

I don't usually bring out my 24-70mm to an engagement shoot, but it can be great for focusing on individual compositional elements, like hands or eyes. Also, if there are children or pets involved in the shoot, the 24-70 is a great lens for subjects who don't stay perfectly still. This is another lens that gets a lot of action at a wedding.

Holga

I use this medium format toy camera for a lot of personal images, and I bring it out occasionally for engagement sessions when the "lo-fi look" will fit the couple and the styling. It is definitely quirky and you never know quite what you will get due to light leaks and vignetting, so I use it sparingly for those who will appreciate it. It uses 120 medium format film and can shoot in a 6x6 square format or a 6x4.5 format.

Shootsac Lens Bag

It is the perfect size for an engagement session and holds my lenses, cards, and batteries securely. The only downside is the thin strap and weight on your shoulder and neck area. Getting a wider strap or a guitar shoulder pad is recommended.

Film

I bring about 20 rolls of 35mm color film and five rolls black and white and 10–20 rolls of 120 film. I won't necessarily use all of it at one engagement session, but having extra is always a good idea. I like the look of overexposed Fuji Pro 400H as well as Kodak Portra 400 and 800 and Ilford FP4 Plus black and white, however, I am always experimenting with different film stocks. In the process, I found that I did not like the saturation and color pop of Ektar or Velvia, but love the muted tones of Portra and overexposed Fujifilm Pro 400H. My goal is to deliver about 100 film images to my clients. I also bring some packs of Fuji Instax Wide film in case I want to shoot instant images.

CF Cards

I bring at least six 8GB compact flash (CF) cards to a shoot, although I may end up only shooting with two of them. If you are shooting RAW files, it is important to have CF cards with fast writing speeds. Usually, the only time I take rapid-fire shots is when the couple is walking toward or away from me or when an unexpected candid moment occurs. I use Lexar Professional 400x 8GB UDMA cards. I have never had an issue with writing speeds and uploading files to my computer is relatively fast with a Firewire card reader.

Props

I have a stash of props in my garage, from umbrellas to large balloons, and I will bring one or two of them if I feel they might fit with a certain theme or style. I definitely never want to "push" props on people, but if they ask, then I'm happy to bring some things to the shoot.

Backup Batteries

I always bring fully charged backup batteries for the cameras I'll be using.

Flash

I shoot with natural light exclusively at engagement sessions, so I do not use a flash, but I have two Canon 580 Speedlite 580EX II flashes in my camera bag if I need one in a pinch.

Reflector

Since I shoot engagement sessions in natural light and don't have an assistant with me, my reflector stays in my car. I look for "natural reflectors" in the environment, like light bouncing off of a building or a light colored object.

Canon EOS-1V, 50mm 1.2 lens,
f/2 at 1/60. Fujifilm Pro 400H

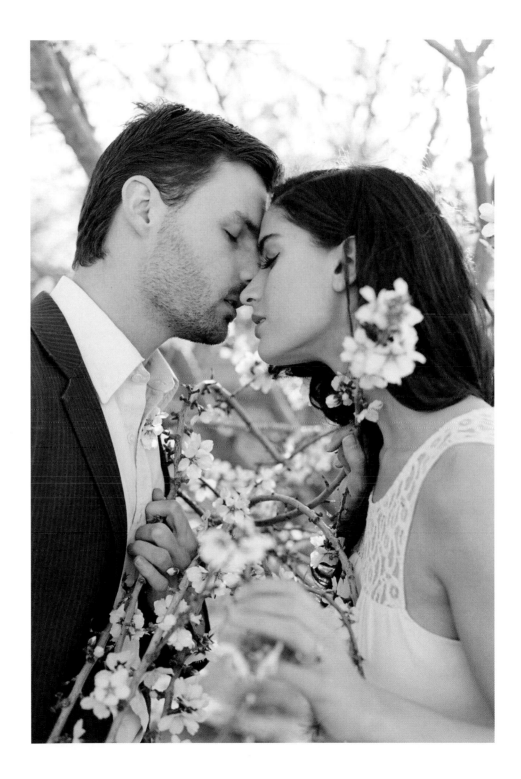

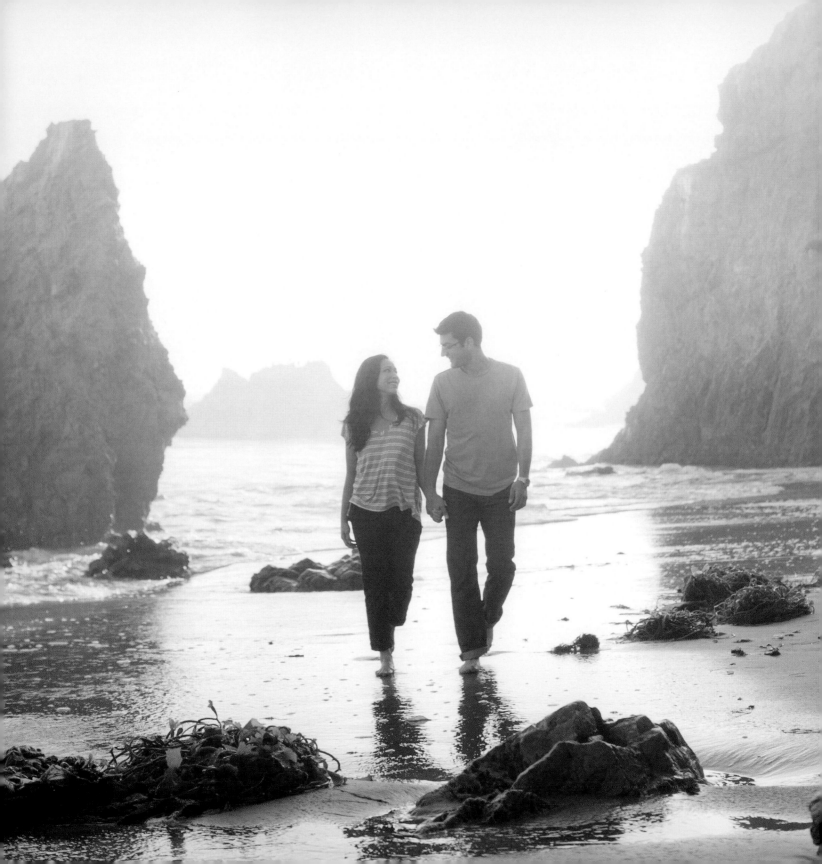

On Lighting

Light makes photography. Embrace light. Admire it. Love it. But above all, know light. Know it for all you are worth, and you will know the key to photography.

George Eastman, founder of
the Eastman Kodak Company

From the days of pinhole cameras to today's technologies that can detect photons nearly as well as the human eye, light has enamored photographers, inspiring the technology that enables them to actualize their imaginations. Changing from moment to moment, light requires study and intimacy. In order to make truly striking images of your couples, you must know how to light them. Light colors the world—learning to gauge its strength, origin, and how it will light your subject is one of the most magical elements of the photographic journey. Unlike weddings, where you may have to shoot in less than ideal conditions, like harsh midday sun, the time of day that you shoot your engagement session is completely up to you. Early morning and late afternoon are your best times to find soft, beautiful light that is central to creating romantic images. There are many different types of light that occur in varying conditions. Once you have learned to identify types of light you will encounter during your engagement shoot, then you can begin to play with light creatively, developing your style and using light to reflect the romance and joy of the moment.

Searching for Soft Natural Light

There is always more to learn about light; it is an ever-changing force of nature and you will ever be its student. Whether you want to refresh your perspective on natural lighting, focus on using available light more often, or are simply new to "seeing" light, paying close attention to the light in your everyday surroundings will help make you a better photographer.

Engagement sessions are a celebration of love and romance, and as such, soft light that uplifts and enhances your subjects is often preferred. When photographing couples and people in general, seek out the most flattering light. The most romantic light is most often found in the very early morning, the very late afternoon, or from soft window light. While photographers have an abundance of artificial lighting options, this chapter will focus specifically on available or natural light. Each photographer should determine the type of light that suits their style. Shooting in diffuse, natural light while opening your lens to its maximum aperture will help create an organic dreaminess to your photos, a quality quite suited to engagement photography.

Teach yourself to look for the best light everywhere you go. You are a photographer even when you don't have a camera with you. When you aren't shooting, train your eye to see how light falls on faces at different times of the day and

"The light at the very end of the day is so soft it can create a subtle dimension as a side light. For this image I was standing over my couple as the sun was sinking in the horizon to the right of my camera."

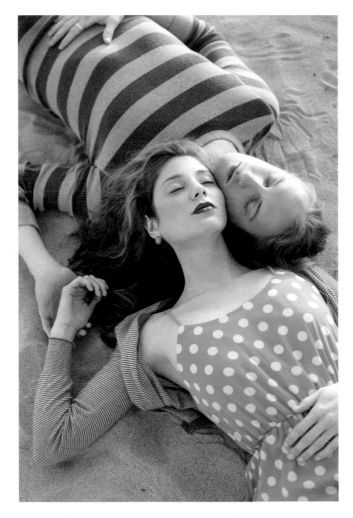

Canon EOS 5D Mark III, 50mm 1.2 lens, ISO 400, f/2.8 at 1/320 sec

where it comes from. Take note of where the sun is in relationship to your surroundings. Spend time researching light by taking an afternoon walk and noticing when you see light that you love. Amplify your awareness by looking for halos or rims of gold that light up the hair of a passerby from behind or soft window light that falls gently on a friend's face as you're having lunch. By choosing to notice details and follow light with your eyes all the time, every day, it will become second nature. Learning how to find the most flattering light in any given scene is an integral part of honing your skills as a photographer.

"I look for available, natural light everywhere I go. When I'm shooting, I look at where the sun is, its angle, and what in my surroundings could be the perfect natural reflector or open shade scenario before I even consider placing my subjects into the scene. Once this has become second nature, you will start to fine tune your knowledge of light and its many qualities. There is always something new to learn or notice about light every time you go out on a shoot; you are always its student."

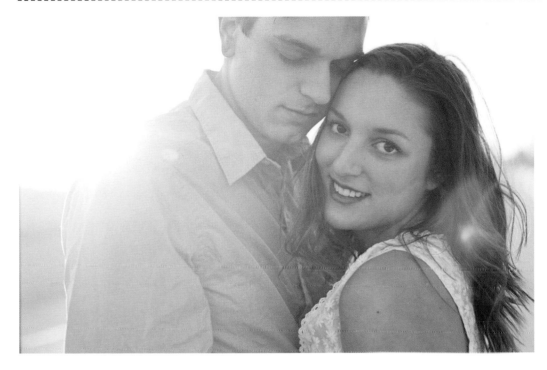

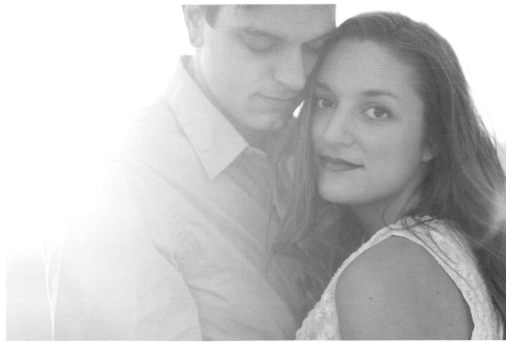

"Both of these images were shot during the last ten minutes of daylight right before the sun sunk below the horizon. The sun was behind his right shoulder, and I allowed just a little bit of the light to peek around the shoulder to create a dynamic flare and warmth. Both images are shot with the same 50mm 1.2 lens and similar settings and have not been retouched."

The top image is Fujicolor Pro 400H film shot with the Canon EOS-1V and the bottom image is shot with the Canon EOS 5D Mark III, ISO 400, f/2.5 at 1/1000 sec

Ideal Lighting Scenarios

Beginning your engagement session a couple of hours before sunset will give you time to warm your clients up to the shooting process before the best light of the day—the golden hour. The glowing evening light just before sunset is often referred to as the "golden hour" or "magic hour" and is many photographers' favorite time to shoot. Utilizing the afternoon light leading up to sunset will ensure that your clients are comfortable in front of the camera and help you discover what your best poses with each individual couple are. You will make a lot of gorgeous photos during the serene afternoon light, but your most prized images will generally be shot towards the end of the session, when your couple is more relaxed and the light is at its best. Both digital and film will capture the charm of the fading afternoon light as it surrounds your couple beautifully.

Types of Light

Back Light

Back light is when the sun is behind or at an angle above your subject. For warm, flattering images, back light your subjects so that the light wraps delicately around their faces and bodies. For digital, expose for their skin tones and always check your histogram to make sure that you are not over- or under-exposing the skin tones. For film, expose for the shadows to achieve the best skin tones.

Don't be afraid to wait for the best light. Soft and romantic images are often the last images that you'll make, when the sun is low on the horizon and your couple are more relaxed and comfortable to show more intimacy. Remember that it is okay to play with your style. For instance, if you like a lot of flare and light in your lens, shooting at this time of day and letting just a little bit of the sun peek into the lens or shooting without a lens hood will help you achieve that look. It's easiest to experiment with light when you have a thorough understanding of what creates each different look.

"The strong sunlight of the desert was directly behind my couple as they walked towards me. I exposed for her skin and let the sun cast a golden halo around my subjects."

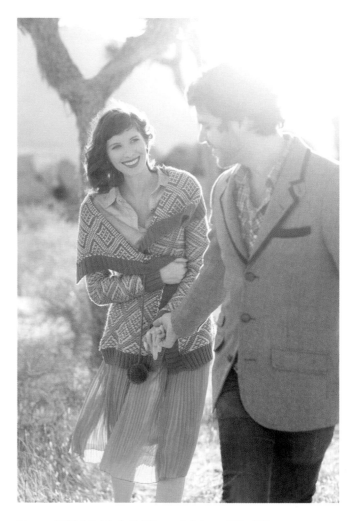

Canon EOS 5D Mark III, 85mm 1.2 lens, ISO 400, f/3.2 at 1/1600 sec

"These two images show just a few of the different looks that can be achieved during the prized 'golden hour.'"

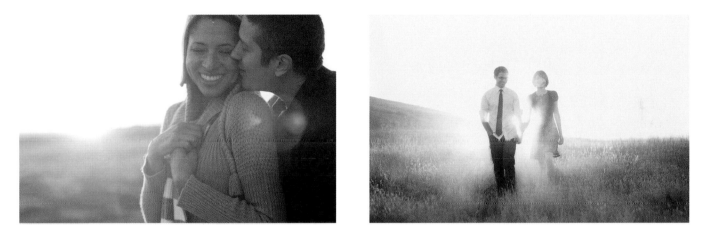

Left image, Canon EOS 5D Mark III, 85mm 1.2 lens, f/2.8 at 1/2000 sec, ISO 500. Right image, Canon EOS 5D Mark III, f/4.0 at 1/800 sec, ISO 320

Golden Hour

Golden hour is the soft, warm light an hour after sunrise or an hour before sunset. Golden hour is your most valuable shooting time. Let your clients know that this is when you will be making the best photos and insist upon including this time of day in your shoot. The magical light that falls on your couple during golden hour is not as harsh or high contrast as midday sunlight, which is why its softness is an essential part of engagement photography. When the sun is low on the horizon, the sun's rays have to travel further to reach your location. As the light travels through miles of dense air, the blue light scatters and you are left with soft orange and yellow hues, creating long shadows and warm vivid tones. Images shot during golden hour have a whimsical look to them, with subjects often outlined in gold when the sun is directly behind them.

The light during golden hour is very adaptable to different lighting arrangements and poses. Don't be afraid to place your subjects directly into the warm, early evening light of golden hour. This light produces warmer skin tones, your couples won't squint when looking in the direction of the light and it can help evenly capture the landscape around them. Be conscious of the fact that the light during this time will change rapidly and you must pay close attention to your settings as the light fades as quickly as the sun disappearing behind the horizon.

"When your subjects face the light during sunset, a lovely warm glow is cast on their skin."

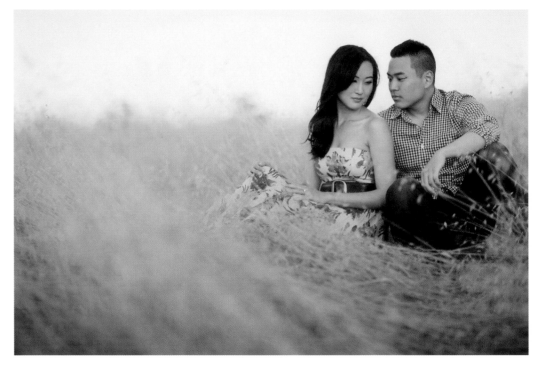

Canon EOS 5D Mark II, 85mm 1.2 lens, ISO 100, f/1.4 at 1/320 sec

Open Shade

Open shade is when you place your subject in an area protected from the sun, like the shade of a building or in front of a tree line. The light after the sun dips behind a building or a mountain, or the ten minutes after the sun goes below the horizon, will produce the same non-directional light as open shade.

When shooting in open shade, be extra attentive to your surroundings. Scouting locations ahead of time is an important part of finding ideal lighting, especially in urban settings. When shooting in shade, you are essentially escaping harsh light while still trying to bounce all nearby light into your frame and onto your subject. This light will be impacted by differences in your surroundings such as light versus dark

colored foreground, green foliage or brightly colored walls. The ambient light in the shaded areas may take on the hue of its surroundings, so try to compensate for a colorful background by finding a light and neutral foreground. Finding places to shoot that have engaging backgrounds but light, neutral tones in front of your subject will help bounce light onto your couples without tinting them with unnatural colors. Any bright orange, red, green, or other colorful surface in front of your couple, including your own clothing, may reflect back onto them, creating an unflattering skin hue.

If you are shooting in nature, look for shaded areas that have an open sky near the tree line. If you are completely engulfed in the shade of trees or deep in the woods, you will

"This image was shot in open shade during a very bright time of day. The warm, textured wall behind my subjects blocked the sun, and the same color wall was behind me as well, so the warm tones were reflected onto the couple."

"Sunrise is also a very lovely time of day to shoot. I don't shoot in this light very often, since most of my couples, and myself, would rather not be up that early in the morning. Sunrise light is cooler in temperature but is very soft and beautiful. It can be the perfect time of day to go to a popular location, so you can get some intimate images without crowds of people. Also, since the sun is at a different point in the horizon, certain locations and backdrops will only look best at sunrise, when you can backlight your couple at the right angle in your composition and environment."

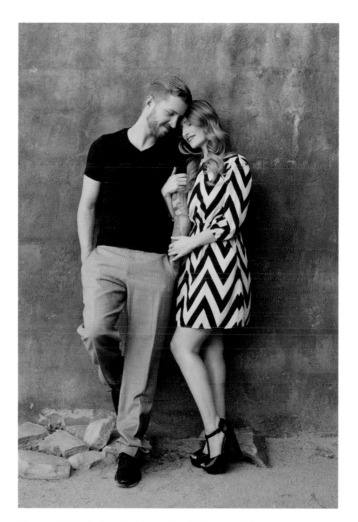

Canon EOS 5D Mark III, ISO 400, f/3.5 at 1/320 sec

--

"I often look for white or light colored walls or anything that can bounce light back onto my subject. This white alcove created the perfect bounce to create the portrait shot on the opposite page."

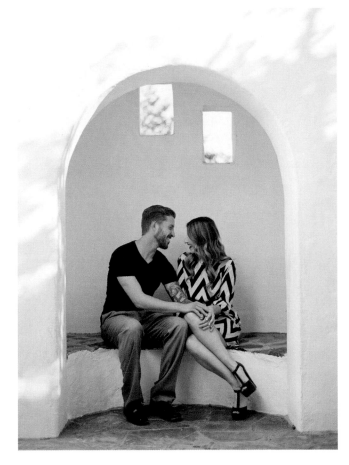

Contax 645, 80mm Zeiss lens, f/2.8 at 1/125 sec. Fujifilm Pro 400H

have a hard time getting enough light on your subjects' faces and will have to deal with an unwanted green tint to the light from the light reflecting off of leaves and grass. To create bright, even-toned images in open shade, place your subject in the shaded area nearest to the sunlight. Shooting at the beach or desert on light-colored sand and stones will have the same effect, brightening up your couple's faces as if you were holding a reflector below them.

When photographing engagement sessions in an urban environment, look for a shaded area that has a bright neutral colored surface close by, like an adjacent white wall. Shooting your subjects in the shade of a building can prove a bit dark for bright, charming photos, but if that building has a neutral, light-colored pathway or wall nearby, you can light up the scene by placing your subjects so that the light reflects off of the ground below them or the nearby wall. Try placing your subject just inside a doorway, on the shady side of a tree, or any other structure large enough to shade them while still allowing the surrounding sunlight to permeate the scene. If you find yourself without much shade, you can always tighten your frame and put only their faces, hands, feet or any other part of your subjects that you would like to photograph into whatever shade you can find until the sunlight softens.

Side Light

This is when the sun is lighting your subject from the side at a 90 to 45 degree angle. Side light is best used during golden hour or with diffuse window light. This type of light can be challenging and is most flattering on people with fine bone structure, as it will highlight the cheekbone, jaw, and nose. Avoid using side light if your clients have larger facial features or rough skin, as it will bring unwanted attention to them. When lighting a couple with side light, it can be challenging to light them both while keeping them on the same plane. Often one subject's face will have to be slightly in front of the other, or else one person will be more illuminated than the other.

"The quality of light that bounced around a white alcove created this perfect lighting scenario for a stunning portrait."

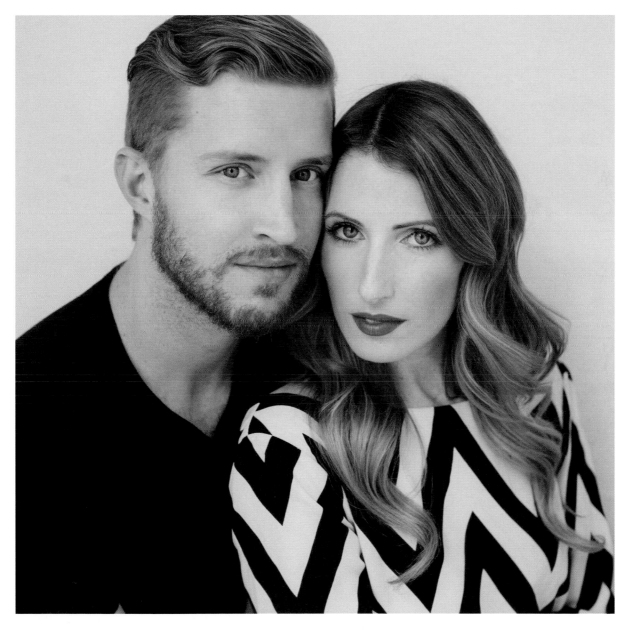

Canon EOS 5D Mark III, 85mm 1.2 lens, ISO 400, f/3.2 at 1/400 sec

--

"Open shade will also occur after the sun has set or has gone behind a mountain range or tall building. In this scenario there is ambient light, but no direction to the sunlight. The light quality usually falls pretty quickly, so you only have 10–15 minutes to use it."

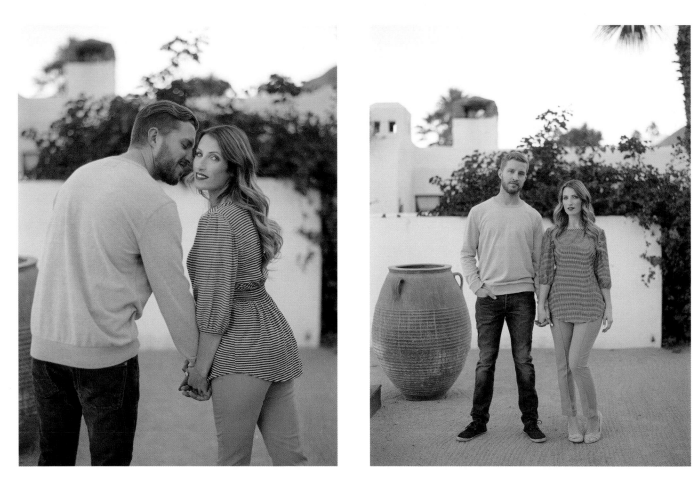

Contax 645, 80mm Zeiss lens, f/2.0 at 1/125 sec. Fujicolor Pro 400H

"The diffused overcast light was coming in through the arches on the left and bouncing off of the warm tones in this location. This scenario created a very soft side light. I asked the young man to look to his right, to lessen any shadows on her face."

Canon EOS-1V, 50mm 1.2 lens, f/2.8 at 1/125 sec

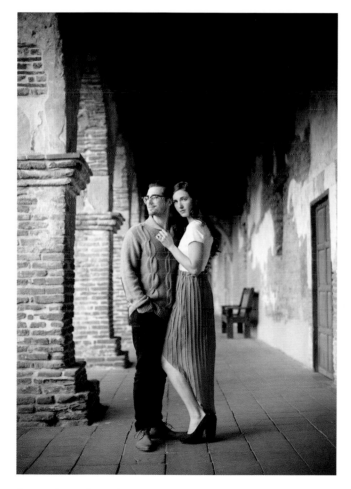

Canon EOS 5D Mark III, 80mm 1.2 lens, ISO 400, f/2.2 at 1/320 sec

"There are several large, north-facing, floor-to-ceiling windows camera left, which cast a soft dimensional light onto this couple."

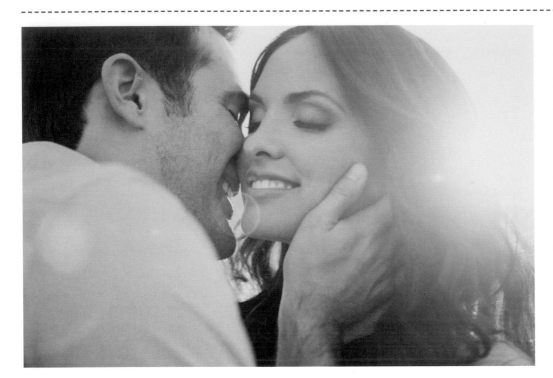

Canon EOS 5D Mark II, 50mm 1.2 lens, ISO 100, f/2.8 at 1/400 sec

"Flare can add a burst of light and warmth in an image and help convey a joyous love between your couple. For this image, the sun was directly behind my subject's heads. I exposed for the skin tones and set my exposure manually, and then composed my shot with the focus on her eyelashes. With my focus locked, I leaned slightly to the right to allow a burst of light to come through her hair."

Window Light

This is when you position your subject next to a window with indirect sunlight coming through it. When window light comes into a room from an indirect light source, meaning that the sun is not shining directly through the window, it is diffuse and very suited to engagement portraits. North-facing windows or diffuse (with a white curtain, scrim, or overcast day) south-facing windows are your best choices for optimal light. You'll want to avoid direct sunlight coming through the window, since it can be just as harsh, high contrast and unflattering. Try to find a larger floor-to-ceiling window or a room with multiple windows for best light quality and availability. Let the light seep in through the window gently, so that it lights up your subjects' faces and bodies softly and creates a subtle dimension to the image. You'll have to keep your subjects very close to the window, especially if the light

is not very strong. Mixing light temperatures will ruin a great photo, so make sure that there aren't any other artificial lights on in the room or near your subjects. Your eyes may only detect a slight difference in the type of light, but your camera will record the different light temperatures as very different colors. Introducing another light source, like tungsten mixed with daylight, will create uneven light and imbalanced color. Shooting with film does mitigate mixed lighting situations a little, but it is best avoided.

Place your subjects so that the light lands mostly on their faces. If you place them too close to you, with most of

the window light behind them, you won't have enough light to illuminate their faces, which is an important element of romantic portraiture. Try and be across the window from them, so that you aren't getting extra light in your lens and you are allowing the maximum amount of the diffuse window light to fall on them. If you find yourself with a window that is receiving direct sunlight, use a light, white material to soften the light—sheer window curtains are your best option, but any light, white material that can diffuse the bright sunlight will work.

Flare

Flare is when you let the sunbeams directly into your lens, creating sunbursts or flares. Lens flare can be a fun way to add a lot of warmth to your images. It has a romantic look, reminiscent of bright, happy summer days. Letting a little bit of lens flare into your shots can make them sweet and joyful. Always use a lens hood, especially while shooting with the intention of capturing lens flare. If you don't use a lens hood when incorporating flare, your shots will be washed out, with less than ideal contrast and saturation. Place your subjects with the sun behind them and then frame your image and manually set the exposure for the skin tones. When you move just slightly to allow a bit of sun to come into your camera lens, you can create some lovely flares of light. Putting the sun directly behind your couple's heads as they kiss or between them as they hold hands next to each other can be a great way to incorporate lens flare. Every lens and aperture setting will affect the look of lens flare, so play around with different lenses and your angle toward the sun to see what kind of lens flare you can get into your images while still maintaining contrast and saturation. The end of the day is a perfect time to incorporate lens flare into your photos since the color and tone of the flare will be most vivid, and will avoid washing out the contrast of the image, especially if you also use a lens hood.

Overcast Skies

While overcast skies can help diffuse what might otherwise be hard, direct sunlight, they require you to pay extra attention to your surroundings. Since there is not much direction

to the light, cloudy days will darken earlier and may cause dark circles under your subject's eyes from the shadow of their eyebrows. If you're shooting on an overcast day, plan to start and end your session earlier than you would on a sunnier day and try to shoot at a location with lots of reflective, neutral surfaces—like a sandy beach. Getting up above your subjects, on a low wall or a step ladder, and guiding your couple to tilt their faces up toward you and the

"If it looks like it will be rainy on the day of the engagement session, I will try to reschedule the session to a warm and sunny day.
When rescheduling isn't an option, we try and make the most out of the weather. As long as there is available light, I will use it. For light rain, I tell my couples to bring cute umbrellas, wear warm jackets and rain boots. It creates some really unique images.
We may even move indoors for a while, so I may take a shot through the window of a coffee shop or at their home as they snuggle on a sofa by the window. I also love shooting in fog and mist, where you can create really beautiful, moody images."

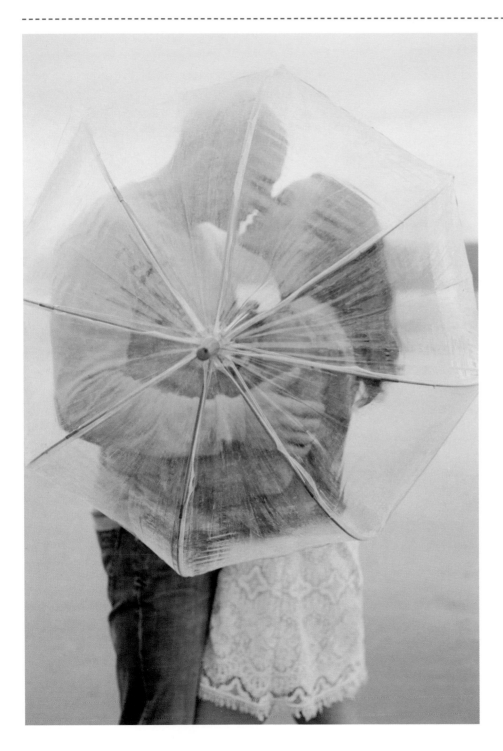

"Since this couple couldn't reschedule their engagement session, we planned to shoot even though rain was in the forecast. We planned for rain with umbrellas and rain boots and a warm textured blanket. The rain was very light, and the overcast sky gave off a soft gray muted light. The pink tones were added in post-processing using Red Leaf Studios Film Shift, Soft Pink action at 50 percent."

Canon EOS 5D Mark III, 50mm 1.2 lens, ISO 400, f/3.5 at 1/500 sec

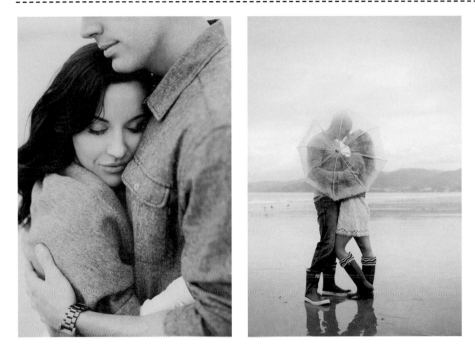

"Kissing in the rain is awfully romantic."

Left image, Canon EOS 5D Mark III, 50mm 1.2 lens, ISO 640, f/2 at 1/1000 sec; right image, Canon EOS 5D Mark III, 50mm 1.2 lens, ISO 400, f/3.5 at 1/500 sec

light will help you get an even, bright light on them despite the darkened day. When the skies are very overcast, there is not enough light bouncing off of your surroundings to light up your couple's faces. If you make sure that there is a light surface below you or if you are slightly higher than your couple, you can still achieve good quality lighting. Another technique would be to shoot with film and expose for the shadows. This technique illuminates the eye while creating a luminous effect on the rest of the face and turns the image from dull to bright and glowing.

Unconventional Lighting

The harsh light of midday is never an attractive time to shoot an engagement session. Be firm when you schedule the time of day to shoot, because it can make or break a session. Harsh lighting is high contrast and unflattering, enhancing lines and shadows on your subject's face. If you absolutely must shoot

with harsh light, a location with plenty of open shade and indoor window light options will be best.

Hard Light/Direct Sunlight

Direct midday light is unflattering, high contrast and harsh. Hard light will bring out blemishes and lines and cause your subjects to squint when looking toward it. Don't shoot your couple in direct light when the sun is high overhead. Foreheads scrunch, eyes crinkle, and shadows from brow lines will cause your clients to have dark, sunken eyes. Avoiding this light is an important part of timing your shoot.

Mottled or Dappled Light

Direct light that is filtered through leaves and branches is often spotty—creating patchy, uneven exposures. If you find yourself under a beautiful canopy of trees, make sure you place your couples entirely in the shade or with their backs

"Once you have a grasp of lighting, you can use unconventional lighting techniques to your advantage. I don't shoot silhouette shots often, but they can be beautiful works of art when done correctly."

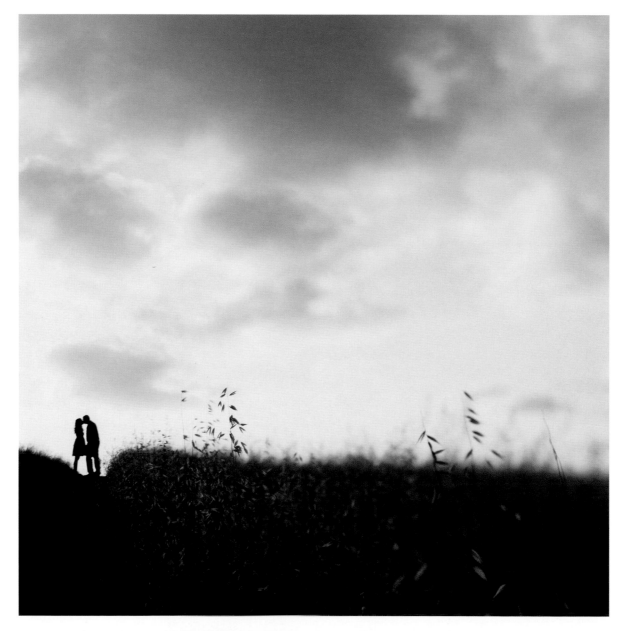

Canon EOS 5D Mark II, 45mm 2.8 tilt shift lens, ISO 100, f/4 at 1/1600 sec

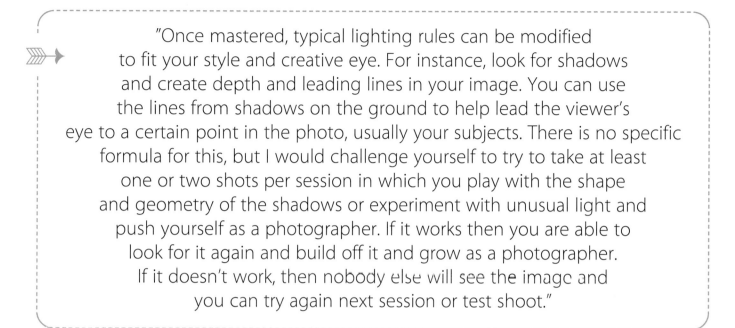

"Once mastered, typical lighting rules can be modified to fit your style and creative eye. For instance, look for shadows and create depth and leading lines in your image. You can use the lines from shadows on the ground to help lead the viewer's eye to a certain point in the photo, usually your subjects. There is no specific formula for this, but I would challenge yourself to try to take at least one or two shots per session in which you play with the shape and geometry of the shadows or experiment with unusual light and push yourself as a photographer. If it works then you are able to look for it again and build off it and grow as a photographer. If it doesn't work, then nobody else will see the image and you can try again next session or test shoot."

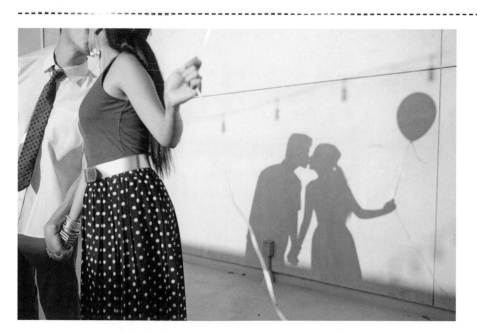

"Look for shadows and interesting light."

Canon EOS 5D Mark II, 24-70 2.8 lens, ISO 400, f/3.2 at 1/6400 sec

to the sun so that the mottled light isn't unevenly falling on their faces, bodies, or clothing. A little bit of dappled light looks fine when it is a part of a blurred out background, but if it's early in the day, the difference in light between the shade and brightly lit background may cause too great a difference in exposures, causing the background to be blown out from overexposure.

Uneven Light

If one of your subjects is lit and the other is in shadow, the slight difference in light distribution on your couple will be obvious in your photos and should be avoided unless you are using it intentionally to create drama. As mentioned before, scouting locations in advance and choosing the time of the shoot should make it easy to avoid split lighting.

Using Your Surroundings as Improvised Tools

As mentioned throughout this chapter, you can use many aspects of your surroundings to improve the lighting in your scenes. There are always tools in your natural environment if you look closely. Always look around your shoot area for light-colored floor surfaces and walls to use as a reflective surface. A light-colored surface or even a light-colored shirt that you are wearing can effectively bounce light back toward your subjects.

Capturing Light, Digitally and on Film

Film and digital can give different results in similar environments. Digital images are best when exposed exactly or even slightly underexposed. Extremely bright areas will not have any digital information in them when you capture them in your camera. If you can't expose exactly, it is better to slightly underexpose, in order to gather all the image information possible, and bump up the brightness in post-production rather than risk losing part of your image in-camera. This is why it is vital to have a thorough understanding of how to read your histogram and meter a scene. Using your histogram when getting your exposure correct in-camera is a part of correctly understanding how to use your camera. It doesn't matter which metering mode you select as long as you understand how your camera's meter is reading the scene so that you know when to compensate in your exposure. In contrast, film capture improves when negative film is overexposed. Fuji films achieve lovely pastel colors when overexposed two stops and Kodak films look best at about one stop overexposed. Film outperforms digital in harsh and direct lighting while digital is more flexible in low light.

"The soft hazy light in the harbor was used to create these two images. The day was almost completely overcast, but the light still had some direction. In the left image, the couple were facing the soft diffused sunlight and, in the right, it was to the left of my subjects. Both images were shot with Ilford FP4 plus 125 black and white film."

Left image Canon EOS-1V, 85mm 1.2 lens, f/2 at 1/60 sec; right image, Canon EOS-1V, 50mm 1.2 lens, f/3.5 at 1/125 sec

Scouting and Location Selection

Opening your eyes to the beauty that exists in your everyday surroundings is a profitable treasure hunt. Location scouting is your opportunity to adventure around—seeking out hidden inspiration in natural areas, allowing yourself to wander with purpose. Playing tourist in your own town will refresh your perspective on photography and train you to seek out unusual beauty in places that may be out of your normal routine. Scouting the perfect location will set the stage to make the most out of the engagement session.

Inspire Yourself, Inspire Your Clients

Great photos require work and investigation. Find locations that inspire you artistically and also reflect your couple's individuality. Your clients will appreciate the extra effort you invest in seeking out a beautiful setting that suits their personalities. Creating intimate images that actually reflect a couple's relationship is part of a growing trend in making portraits more personal.

Jen Campbell, editor and creative director of the popular wedding blog Green Wedding Shoes (www.green weddingshoes.com), has noticed a dramatic shift in the number of couples who are personalizing their engagement shoots by shooting in meaningful, unusual locations:

As recently as a few years ago, engagement sessions were typically comprised of traditionally posed portraits in the couple's neighborhood. These sessions didn't really offer us a sense of the couple's personality. However, now couples are venturing out of their immediate neighborhoods, and comfort zones, to find unique locations for their shoot. I've featured engagement sessions staged in locations ranging from fields, train stations, favorite stores, museums, local fairgrounds and, sometimes, to a particularly meaningful vacation spot for a couple, which can be a nice way to sneak in a mini vacation.

By seeking out locations that are not frequented by other photographers, you can create a unique brand that doesn't look tired or overdone. Consider dedicating a day every couple of weeks to exploring your community and surrounding areas for new locations. Be willing to travel outside of your county and off the beaten path. When you really start looking, you will discover amazing hidden gems that you never knew existed. The extra effort that you put into location scouting will be noticeable and your couples will feed off of your excitement. When you're inspired, your couples will feel inspired also—a perfect fusion of originality, energy, and beauty.

"I keep in mind how my images will be presented and make sure to take detail shots of the location and stand-alone landscape shots. This allows me to pair my images in blog posts and in the album design and creates a rich visual story."

All images shot with Contax 645 on Fujifilm Pro 400H

"This wind farm in the desert created a graphic element, perfect for a wide landscape shot."

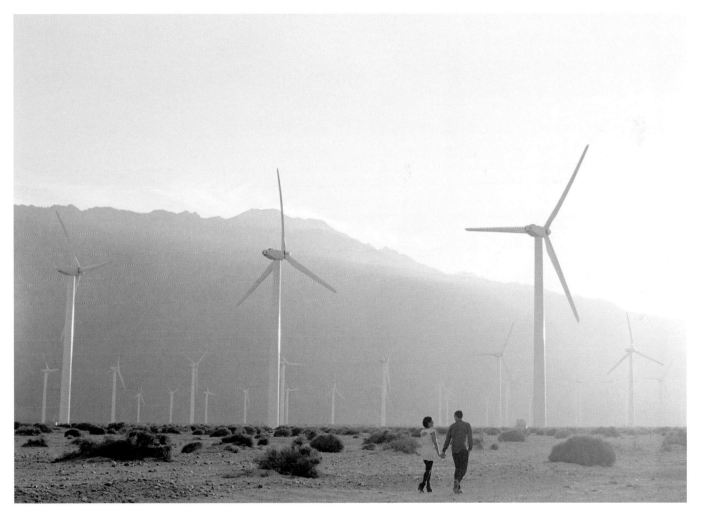

Canon EOS-1V, 50mm 1.2 lens, f/3.5 at 1/125 sec. Fujifilm Pro 400H

"Always be on the lookout for unique visual elements in your surrounding that can frame your couple or create visual interest."

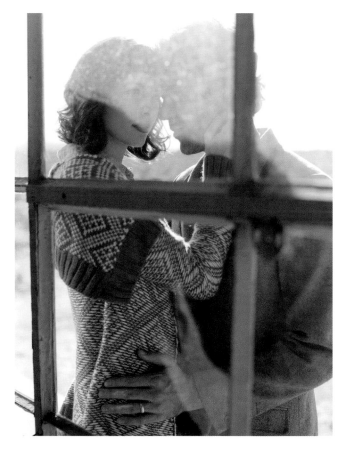

Canon EOS 5D Mark III, ISO 400, f/3.2 at 1/4000 sec

Research, Pre-planning, and Exploration

Setting the stage for an enchanting engagement session necessitates a certain innovation. Central to creating images in locations that elicit a natural sense of romance is putting in the time to find them. Try including location scouting as a part of your work routine. By discovering unusual location sites, you will be investing in your image as an innovative and explorative photographer. Do a little online research before you head out on a scout. Opening up Google Maps and visually searching for clear spaces—parks, fields, lakes— will help you find ideal environments that you never knew existed. Museums, botanical gardens, state parks, historic sites, farms, and urban areas with great architectural designs are all good starting points. Get familiar with your neighborhood and enjoy the process of discovery. After you've done a little footwork by looking online and making a few phone calls, physically go to the places that pique your interest during the time you plan on shooting. Try to make sure you are investigating potential locations during the time you plan on shooting, in order to see how the light will look during your session. Find the path that the sun is traveling along and locate where it will be setting on the horizon, so that you can see where the best light of the day will be originating from and what your background options will be. In an urban setting, look for backlit alleyways or for light reflecting off of large buildings to act like giant reflectors. Both urban and forest settings can get dark very quickly leading to poor light quality. Make sure that you scout the area and take notice of impediments like large buildings that will obscure the sun. It is important not to overdo a particular location or use a location where other photographers shoot regularly. Shooting in relatively unknown locations will help your couple feel special while keeping your portfolio from looking like everyone else's. Originality will always be a beacon in a sea of repetition.

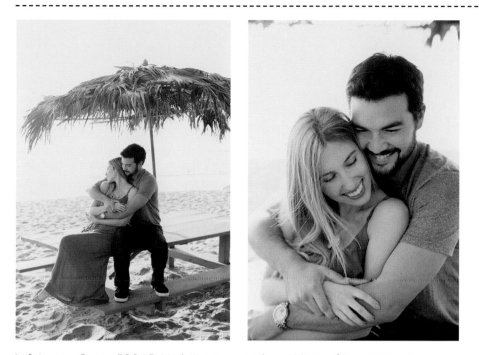

"This couple loved the beach. The natural cabana and casual dress created the feeling of being on vacation or on their honeymoon in some tropical paradise."

Left image, Canon EOS 5D Mark III, 50mm 1.2 lens, ISO 640, f/2.8 at 1/3200 sec; right image Canon EOS 5D Mark III, 50mm 1.2 lens, ISO 640, f/2.2 at 1/5000

Lifestyle Shoots

Showcase your couple's lifestyle by shooting them in personal locations or doing the activities that they love. Photographing your couples in their home and around their neighborhood can be a great way to personalize engagement sessions. Ask your couples to tell you a little bit about what they like to do together. Perhaps they ride horses, are rock climbers, or love to hike. Many people have some sort of activity or hobby that is special to them and photographing them in their element is a personal and original way to tell their story.

Wedding PR specialist Leila Khalil has noticed a great trend toward more personal and casual engagement photography. She notices that:

for a while it was all about the rustic and vintage styles in engagement sessions. Now we see a lot more "everyday" settings. Having photos in their homes or at a special spot with a much more casual feel is becoming much more popular. Location is key.

Photographing your couple while they are baking cookies, cooking dinner, or relaxing by a fireplace with a glass of wine will give them an opportunity to be comfortable in their element while showcasing their lifestyle. Engagement sessions that include a personalized, storytelling element will be forever remembered by your couple as a beautiful glimpse into a very special time in their relationship.

"Now we see a lot more 'everyday' settings. Having photos in their homes or at a special spot with a much more casual feel is becoming much more popular. Location is key."

Canon EOS-1V, 24-70mm 2.8 II lens, f/2.8 at 1/125 sec.
Fujifilm Pro 400H

"If your couple met each other at a coffee shop, then shooting a scene with them enjoying some lattes and each other's company helps to tell their own personal love story."

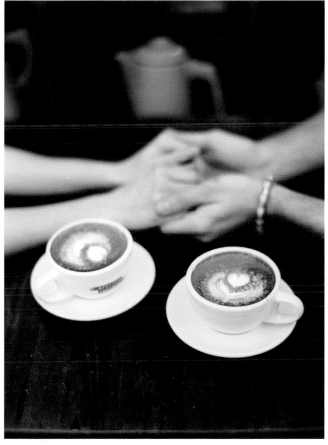

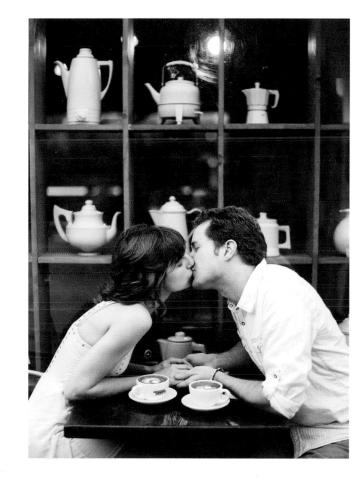

Both images shot with the Contax 645, 80mm Zeiss lens, f/2 at 1/60 sec. Kodak Portra 400 film

What to Look for in a Location

Less is often more when location scouting. Regardless of the type of setting you seek out, an ideal location is free from too many visual distractions. Finding clean, quiet, and relatively secluded locations that also feature a variety of background options will enhance feelings of intimacy at your engagement sessions. A quiet setting will help your couple feel comfortable displaying their affection for each other in front of your camera. Heavy foot traffic or loud noises will lessen the sense of intimacy that you are trying to cultivate. Many couples will feel uncomfortable kissing and being close to each other when there are a lot of onlookers. Crowds of people or bustling streets full of cars can also distract you as a photographer and make it difficult to create a clean image without a busy background.

Choosing a location that emphasizes your couple will help you focus on guiding them into romantic poses instead of becoming distracted by background elements. If you are too concerned with making sure that everything lines up in the background, you won't be directing your attention at what matters—your couple. Sometimes all you need is your couple and the golden afternoon light. For instance, an empty wheat field or a stark beach will provide a simple, clean setting that will allow you to focus your attention on your clients, highlighting their relationship through romantic posing and physical gestures.

When initially discussing location options with your couple, it's important to have a few places in mind. Scouting ahead of time will allow you to offer your clients options that suit their personalities but also provide you with good light and composition choices. Providing options, but not too many, will make choosing one spot much simpler, as sometimes having too many choices can make decision-making harder.

Finding more than a few unique locations to shoot at is an important part of planning your sessions and creating your brand. Where you shoot impacts your client's demeanor, the style of your photo, and your brand. Find locations that suit your shooting style. For romantic portraiture, serene, open spaces can allow the image to focus on your couple while achieving a soft style. Coastlines, deserts, forests, mountains, and fields are stunning natural backgrounds for an engagement shoot. When searching for the perfect urban environment, look for spaces that have interesting textures but aren't too busy visually. Urban areas tend to be chaotic, so finding a little nook that is both out of the way and doesn't have a lot of people walking around will help you create a peaceful environment for your shoot. Let your couple be the focus of the image.

> "One of my couples, Andrea and Eric Cathey, love the outdoors and shared their first kiss at Joshua Tree National Park while camping. It was only natural that Joshua Tree would also be the location for their engagement session! Not only were they at home among the giant boulders and raw desert landscape, but the location had special meaning for them as well. It gave their engagement images another layer of storytelling and memories that they can pass on to their children and grandchildren."

--

"Even an urban area usually considered 'ugly,' like a freeway underpass or industrial alley, can become the perfect location under the right lighting conditions. These locations are often free of crowds and onlookers as well and can become a secluded setting for an engagement session. Make sure to do plenty of scouting ahead of time to make sure a location isn't dangerous, off limits, or 'sketchy.'"

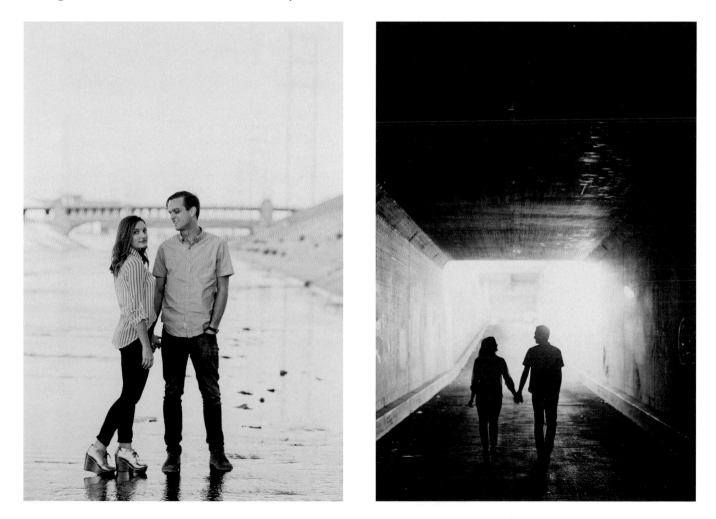

Left image, Canon EOS 5D Mark III, 85mm 1.2 lens, ISO 400, f/2.2 at 1/3200 sec; right image, Canon EOS 5D Mark III, 85mm 1.2 lens, ISO 800, f/2.2 at 1/160 sec

"I'm very drawn to nature's beauty and am always looking out for blooming trees and flowers. They can bring in a lovely bit of nature, even in an urban environment."

Canon EOS-1V, 50mm 1.2 lens, f/2.8 at 1/250 sec. Fujifilm Pro 400H

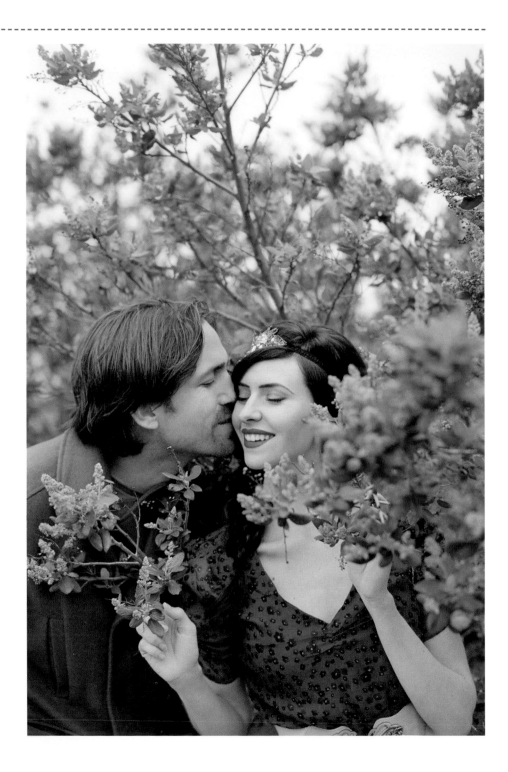

"I always have several locations in mind—a few tried and true and one or two new locations I've been wanting to shoot at. My couples usually want me to ultimately pick the location. I don't want to overwhelm them with choices, so I simply ask them if they prefer a nature inspired, urban, or colorful location and whether or not they would want to incorporate props or a fun activity into their session. From their response, I can recommend the best spots or pitch them a few novel ideas. I often just select and shoot at one location instead of driving around to several during an engagement session. I find that moving locations can interrupt the flow of the shoot and can take away from the conversation and rhythm that develops."

Canon EOS 5D Mark II, 85mm 1.2 lens, ISO 100, f/1.2 at 1/2000 sec

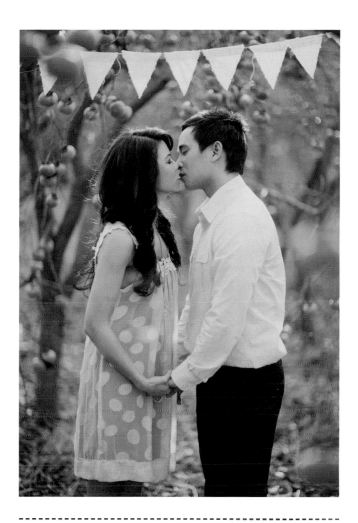

"I stumbled upon this private persimmon orchard while hiking with my dogs and introduced myself to the owners. We arranged a special fee for me to shoot on the property during the persimmon harvest. Several of my couples were very willing to pay the fee for this unique location."

--

"Be aware of your local environment, noting how the seasons change the look and feel of a location. Here in Southern California, wild mustard flowers begin to bloom in the spring. I love recommending shoot locations with seasonal blooms to my clients."

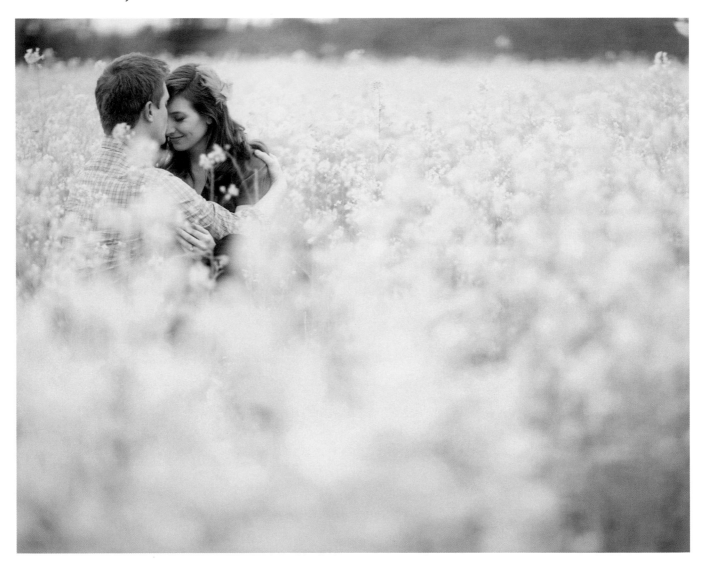

Canon EOS 5D Mark II, 85mm 1.2 lens, ISO 250,
f/1.2 at 1/2500 sec

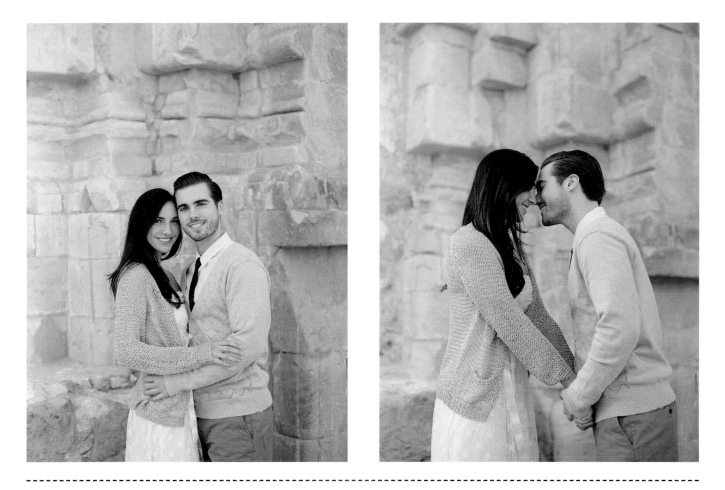

"I look for old worn textures and clean backgrounds when location scouting. This old stone mission wall is the perfect combination."

Both images shot with Contax 645, 80mm Zeiss lens, f/2 at 1/125. Fujifilm Pro 400H

On Permits

Remember to inquire with prospective sites about their photography policies—do they require permits or other forms of permission to shoot there? Doing the footwork early is professional and will ensure a smooth engagement session, avoiding embarrassing situations that prevent you from shooting where you want. Of course, there is always the "ask forgiveness, not permission" mentality, but you don't want to be kicked out of a place without a backup plan or be fined for not having a permit. Also, getting kicked out of a location will waste shooting time and bring the whole energy of the shoot down.

"This boutique hotel allowed us to shoot on the property since the couple booked their largest suite. The location had plenty of beautiful backdrops and vignettes all in one small location."

Contax 645, 80mm Zeiss lens, f/2.8 at 1/125.
Fujifilm Pro 400H

Many of the best locations will be on private or state land and will require a permit. While some locations may not actually enforce their permit regulations, you don't want to be caught there on the chance that they do. In general, you will need to get your permits a couple weeks in advance and they will usually require that you show proof of liability insurance. A little bit of research is always the first step when you find a location that you like—sometimes you only need to inquire with the owner to ask for permission to shoot.

Remember that when shooting in locations that require a permit, you can add the permit price into the cost of your session. Although your clients will be paying for the permit, you will usually be the one doing the footwork to obtain it. Offering your clients a choice between locations that require permits and those that do not will give them the chance to choose whether or not they want to pay for the location.

Travel Fees

Your time is valuable and charging a fee for shoots that require a significant amount of travel time is a fairly standard procedure. It is often easier to assign a specific rate that encompasses all of your travel expenses, including transportation and time, instead of attempting to itemize your expenses. Designate a distance that you are willing to travel without charging an additional travel fee, then consider what your standard fee is for local sessions that are still within a few hours. Major travel should receive custom quoted prices. If you are traveling by plane or train, estimate the cost of your ticket and your time. Presenting this as a single price is often the easiest option for both you and your client.

"This location was chosen by the couple,
since they dream of one day owning
their own lavender farm. The visual lines
of the lavender beds created a beautiful
graphic element."

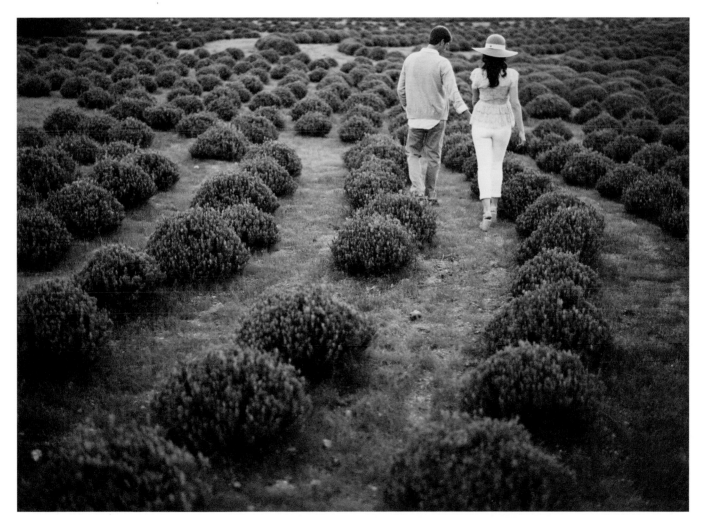

Contax 645, 80mm Zeiss lens, f/2.8 at 1/60. Fujifilm Pro 400H
converted to sepia in post-processing

Finding Beauty Everywhere

One of the most important things to remember when scouting for your engagement sessions is to be open-minded. No matter where you live, there are always going to be beautiful, unique places to shoot. It's really just a matter of exploring your environment with fresh eyes. Taking the time to pay close attention to the places you go will transform how you view them. Look at every place you go to as a potential location, searching for perfect light and unique backgrounds. Spend your afternoons wandering around your region and you will discover that beauty is everywhere, as long as you are willing to look.

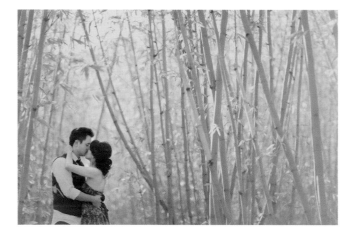

"Botanical gardens often allow portrait shoots for a nominal fee. You can find exotic looking locales, like a bamboo forest or succulent garden, all at one location."

Both images shot with Canon EOS 5D Mark II, 50mm 1.2 lens, IDO 400, f/2.5 at 1/250 sec

"This vibrantly colored wall was found in a shopping center. When the bride told me she loved bright colors, I knew just where to take them."

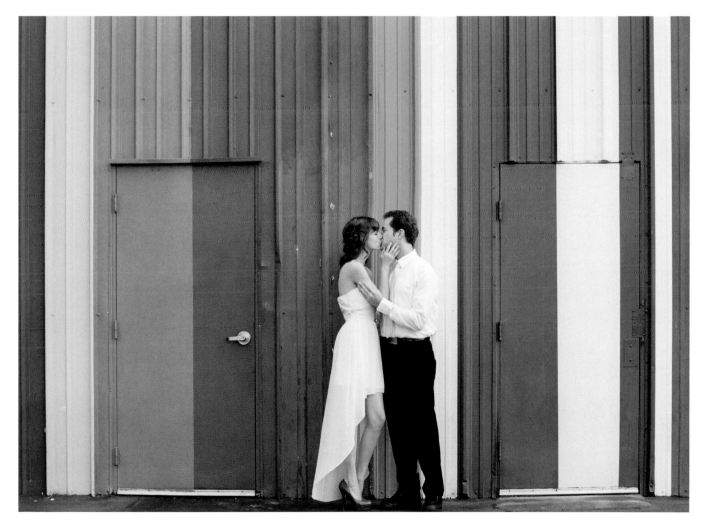

Canon EOS-1V, 50mm 1.2 lens, f/3.5 at 1/125 sec

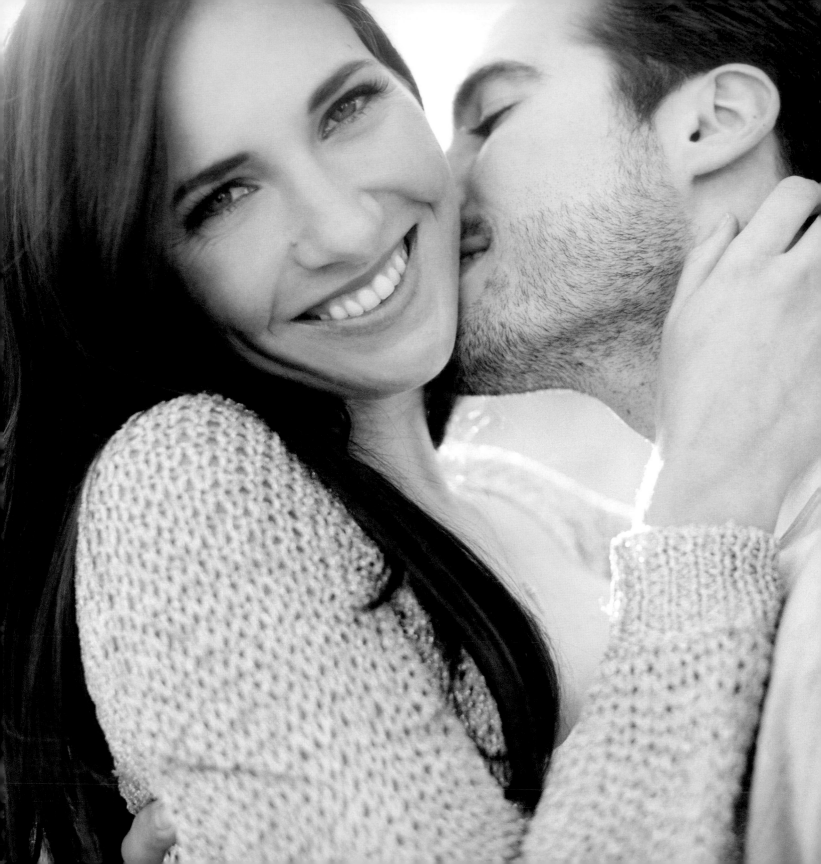

The Art of Directing and Creating Flow

A great photograph is one that fully expresses what one feels, in the deepest sense, about what is being photographed.
Ansel Adams

A successful engagement session hinges on your constant awareness of how the couple are actually feeling. As the photographer, you are the one orchestrating and creating their experience. Truly beautiful photographs are produced through authentic feelings. On the other side of your camera is a pair of unique individuals, wildly in love and probably very nervous. Remember this as you concoct a social elixir of tone, body language, and vocabulary to draw the beauty of their relationship out into the open, where you can capture it. The camera's gaze can be disconcerting; a little bit of empathy and understanding will help ease your clients into showing their true personalities while facilitating a comfortable and creative expression of love.

The Approach

Approaching an engagement session with a genuine interest in your subjects is extremely important. Prepare your equipment ahead of time so when you arrive at the shoot, you can focus on the couple. Arrive early, leaving your problems, stresses, and concerns elsewhere. From the moment you meet your clients, you are strengthening the foundations of your

"I love shooting people and couples—it is my favorite part of being a photographer. I am able to leave all my life stressors, problems, and personal thoughts aside and fully be 'in the moment' and focused on my subjects. I could be having the most stressful week or be completely tired and dragging my feet to a shoot, but once I start, shooting is really invigorating. I'm often surprised at how energized and excited I get. It is a very addictive feeling!"

"Building up trust and rapport over the course of an engagement session will allow you to capture authentic expressions and more relaxed body language."

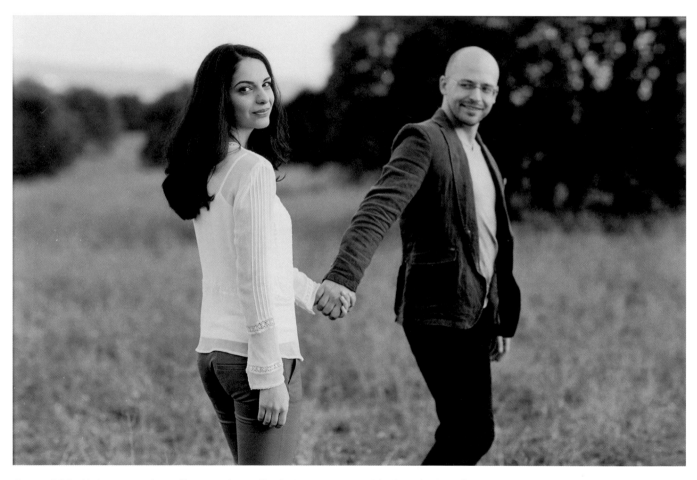

Canon EOS-1V, 85mm 1.2 lens, f/2.8 at 1/250. Ilford XP-2 super 400 black and white film

"Even if we shoot with several different outfits and backdrops, I want the whole shoot to feel cohesive in terms of color palette and processing."

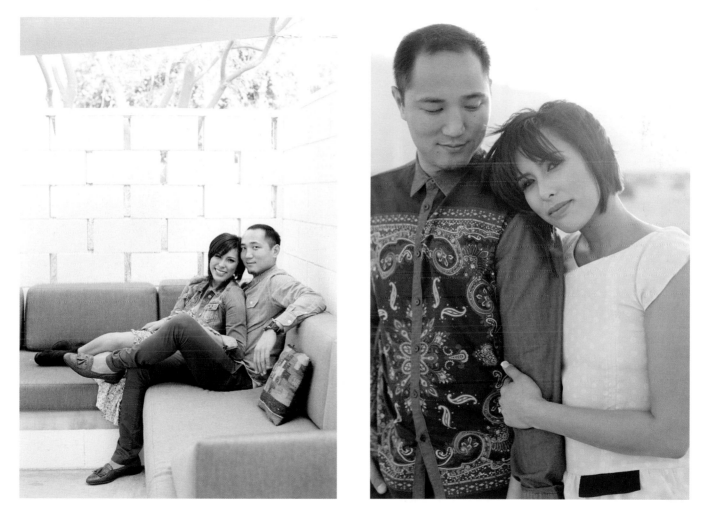

Both images shot with Canon EOS-1V, 50mm 1.2 lens. Fujifilm Pro 400H

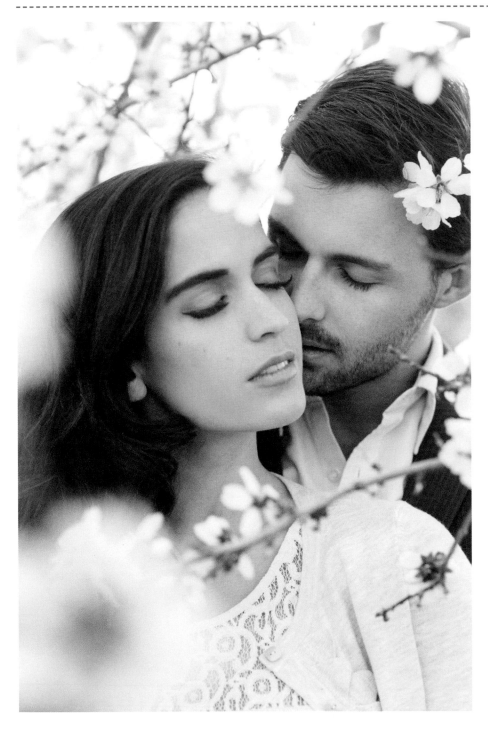

"Romantic fashion campaigns (like Ralph Lauren's 'Romance' fragrance) and editorials are great sources of inspiration."

Canon EOS-1V, 50mm 1.2 lens, f/2 at 1/125 sec. Fujifilm Pro 400H

relationship. Building a good relationship with your couple will not only provide you with amazing engagement photos, but also condition you to shoot better romantic portraits at the wedding. Enter into the engagement session with an inviting and friendly demeanor, focusing on giving your clients a positive experience. Real life couple Stephanie and Jesse Lovejoy found having gentle verbal direction during their shoot very helpful:

> It was a perfect blend of direction and suggestion. Which is exactly what we'd want. Let emotion drive us to a certain point, then help us hone how things look from a photo standpoint. I think Stephanie is a really honest soul and person; I venture a guess that she tailors her communication approach to each client. With us, she was exactly what we wanted her to be, and made us feel comfortable every step of the way.

Your Vision

Coming to a shoot with an idea of what you want to accomplish benefits both you and your clients. It is important to scout your location in advance, especially if you are not confident in your ability to assess light on the go. Have an idea of what you want to accomplish and let your clients inspire the rest.

It may be helpful to review the session's flow in your mind the night before. Imagine how you will be directing your couple as if it were already happening. Visualize yourself speaking clearly as you mentally walk through the entire shoot, from the moment you meet and create a comfortable space for the couple, all the way through various poses you might suggest. Yoga classes are a great place to listen to the cadence and flow of an instructor guiding a group into body placement with both precision and a soothing, calm demeanor.

Flip through a magazine for images that inspire you and keep them in a binder. Ask yourself what you could say to a couple to guide them into that particular pose. Spend some time verbally describing the images that strike you

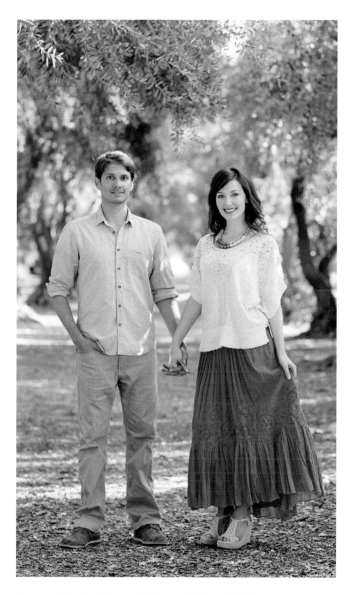

Canon EOS-1V, 50mm 1.2 lens, f/2.8 at 1/125 sec. Fujifilm Pro 400H

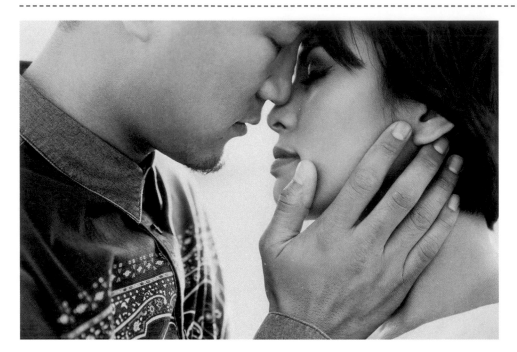

"Find the connection."

EOS 5D Mark III, 24-70mm 2.8L II lens, ISO 400, f/3.5 at 1/500 sec

and determine how you would give direction out loud, then bring that creative dialog to the shoot. Look to magazines, movies, and advertisements that portray sweet romance. The movie *The Notebook* had several memorable and romantic scenes and it became the inspiration for many engagement photographs in the blogosphere.

Find the Connection

Genuine interest in your couple is essential. If you don't know how they met, ask. Most couples enjoy sharing their story. The more you learn about your clients, the more likely you are to connect with them. You may come from different backgrounds or age groups, but if you look for a connection, you will find one. That connection may be the movie you saw last week or somewhere you have traveled to. Asking about the wedding is a great conversation starter that is pertinent and exciting for all of you. Even if you don't feel like you have

much in common with your couple, you can use the wedding and their relationship as a springboard for conversation. There is no limit to the common ground that you can find. If you haven't met in person yet, consider using a social network like Facebook to get a better idea of who they are, their style, and how they like to represent themselves in photos. If you do choose to become Facebook friends with your clients, make sure that either your personal page is work appropriate or consider having a separate page for your photography profile.

In addition to being a technically proficient photographer, you will be able to create better photos and a stronger business if you are socially adept when dealing with people. Engagement photography has just as much to do with the art of interaction as with direction. Improving communication and connection is just as integral to the art of engagement photography as is learning about composition and light. Bettering your ability to get along and enjoy a conversation with strangers, while making them feel at ease, is a skill worth mastering as a wedding and engagement photographer.

"View the engagement session as a way to connect with your clients on a deeper level and build a lasting relationship. The more they like you as a person, as well as a photographer, the more enthusiastically they will refer their friends. In this era of social media and impersonal dialog, strong personal connections will help create a stronger business and ample referral base for you in the long run."

"You can make more friends in two months by becoming interested in other people than you can in two years by trying to get other people interested in you."

—Dale Carnegie, *How to Win Friends and Influence People*

"By finding a connection and conversing with your couple, it will be easier to get genuine expressions of laughter."

EOS 5D Mark II, 50mm 1.2 lens, ISO 400, f/2.8 at 1/1250 sec

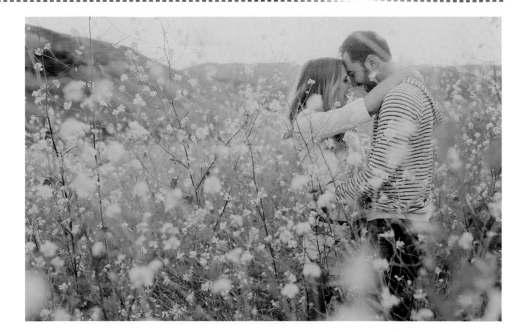

"When your couple trusts you and your vision, they will even climb boulders to get that perfect shot."

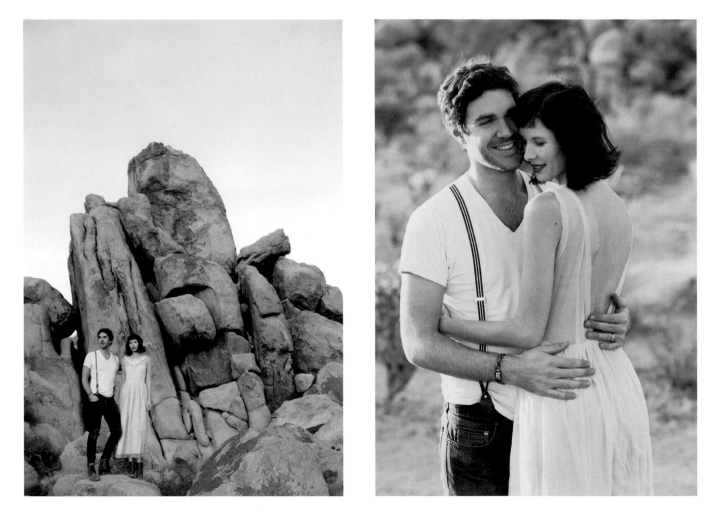

Left image, EOS 5D Mark III, 50mm 1.2 lens, ISO 400, f/3.2 at 1/640 sec; right image, EOS 5D Mark III, 85mm 1.2 lens, ISO 400, f/3.2 at 1/400 sec converted to black and white with Red Leaf Studio's action, Film Shift—Black and White Neutral

Setting the Mood through Tone and Language

Essential to every photographer's tool belt is a colorful and descriptive vocabulary. Your voice and body language are some of the most compelling instruments you have to guide your clients toward your vision. Every sweet smile and gracious head tilt owes its existence to the photographer in a small way. To a certain degree, your subjects will always be mirroring you. Smiling and laughing will induce playfulness, while speaking in softer tones will encourage a more romantic mood. This is where your clients' personalities can shine.

Since your clients will generally reflect whatever type of energy you bring to the engagement session, be aware of your body language and what you want to bring to the shoot. If you are enthusiastic and high energy during a fun, playful round of images, your couple will pick up on your passion. Conversely, if you want to evoke a more intimate romantic mood, keep your voice soothing and your energy calm. If you are shooting with a second shooter or as a husband and wife team, you can use your interaction with your partner as an example of how you want your clients to pose. Some photographers are comfortable actually touching and physically guiding their subjects while others are not. Use your own discretion and be yourself. Engaging your couple with inspirational words, easy directions, and phrasing that evokes specific emotions or actions will invite them to slip into the moment. If you are genuinely inspired by an image, let your clients know. Verbally sharing your enthusiasm and constantly giving genuine, positive feedback will help the couple to relax and be excited about the shoot too. Using specific and descriptive words when suggesting a pose is an important part of communicating your vision clearly. Be sure to describe how you want the couple to do something instead of simply commanding them with a single verb.

Phrasing

Certain phrases and words are meant to elicit sweet, soft, and romantic gestures. The words "big bear hug" will usually bring a different, more specific response than if you say, "give each other a hug." Good directions tend to be specific and gentle. They allow the couple to understand what you're looking for and to follow your directions at ease. Suggestions like "maybe gently hold the back of his neck with your right hand" or "could you turn your nose a little more towards me" will be best received. No one wants to be constantly barked at with a string of commands, but people generally like receiving direction and guidance.

Constant and genuinely positive feedback will help them to feel good about themselves and the shoot as a whole. Encouraging the couple by telling them when a photo looks good, when they are posed perfectly or moving in the right direction will help them feel more comfortable and positive. People are often concerned that they look awkward or unattractive in front of the camera. As long as your feedback is assuring and genuine, your clients will begin to trust it and brighten up with every supportive word.

"Give her a hug" vs. "Give her a big bear hug"

"Now kiss" vs. "Now softly kiss" or "Give her a little kiss on the cheek"

"Face each other" vs. "Hold each other close and gently lean your foreheads together, then close your eyes and take a deep breath."

"Hold each other" vs. "Really embrace each other" or "Wrap your arms around each other"

"Sit down together" vs. "Cuddle together the way you would on the sofa"

"Move your hand to his arm" vs. "Cradle his forearm with your right hand"

"Walk down this path together" vs. "Hold hands and smile at each other as you walk toward me"

"The words 'big bear hug' will usually bring a different, more specific response than if you say, 'give each other a hug.'"

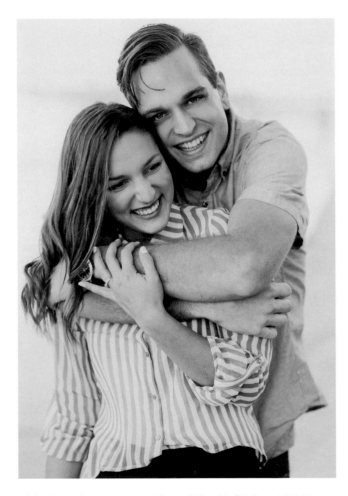

EOS 5D Mark III, 85mm 1.2 lens, ISO 400, f/2.2 at 1/2000 sec

Suggesting that your couple do a "camera kiss," where their lips barely touch each other without puckering, can help your clients create the look of a kiss without the unflattering angles that true, deep kissing can produce. Encouraging your couples to almost kiss, then hold it for a second, will help you capture the sweet moment at the beginning of a kiss and usually produce a lot of authentic laughter to capture afterwards.

Postures and Flow

When beginning your shoot, look closely for signs of nervousness and tension. Romantic images are relaxed and comfortable. During your shoot, look for body language that shows that your couple are at ease. Relaxed shoulders, softly opened hands and fingers, and loose jaws reflect a tranquil mentality. If you notice your couple are looking tight or nervous, softly encourage them to relax their shoulders and lengthen their necks. The more you shoot and keep an eye out for these body language signs, the easier it will be to verbally correct for them during future shoots. If you find your couple begin to chat too much because they feel relaxed, encourage them instead to smile and laugh to attain natural, happy photos without the awkward open mouths that come with talking.

Each couple fit together differently. Building on their existing physical relationship will create authentic poses. Keep them moving and avoid making them stand in one position for too long. If you provide lots of positive feedback and transition fairly quickly from one situation to the next, you will keep them distracted from naturally occurring self-consciousness. Every couple will need a little bit of guidance to help them look their best. No matter how a couple are holding each other, collapsed necks and chins that are turned too far down will detract from the image.

Every photographer must develop their own shoot flow. It takes a little bit of time to get your couple warmed up, so find something simple and easy to start with, like a traditional portrait that their parents might enjoy. Once you get some of the more standard poses out of the way, you will find more

"I notice body language and especially hands. I want their hands to look relaxed and natural."

Canon EOS-1V, 50mm 1.2 lens, f/2.8 at 1/250 sec. Fujifilm Pro 400H

Canon EOS-1V, 50mm 1.2 lens, f/2.8 at 1/250 sec. Fujifilm Pro 400H

"I usually start out with shooting traditional portraits first, so lots of smiles and looking at the camera to start out. Then, as the shoot progresses, I try more intimate and romantic direction."

Canon EOS-1V, 85mm 1.2 lens, f/2.8 at 1/125 sec. Fujifilm Pro 400H

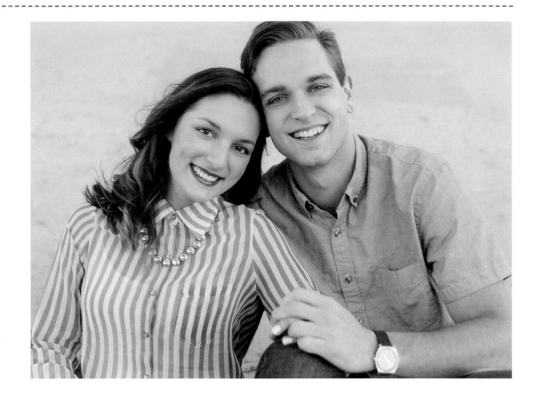

opportunities to get creative. It's important to get in traditional portraits that your couple and their family will buy as prints before shooting your more creative images. Conventionally, a full body shot of your couple, along with a waist-up shot and a head-and-shoulders crop, all of which have full eye contact and bright happy smiles from your couple, will be considered standard poses.

Try following your initial portraits with a movement-based image, like walking and holding hands. This type of transition provides a nice way for your couple to start interacting with each other. At this point, you should be watching your couple to see what they do naturally. This is your chance to note certain awkward physical tendencies by paying close attention to their hands, shoulders, necks, and feet. Are they clenching their hands or holding tension in their neck and shoulders? You may have to ask them to relax or elongate their necks or give their hands a job, like holding the hem of her dress, putting his hands in his pocket, or softly holding each other. As the shoot progresses, watch for signs of nervousness from their body language so that you can suggest gentle corrections.

The key to achieving natural looking poses is for the couple to become increasingly more comfortable in front of your lens and for you to be progressively more aware of how they naturally fit together and what angles will look best. Suggest simple postures and movements so that you can see how they fall together naturally. Sometimes, they will spontaneously do something that will inspire you or their body language will be perfect but you may simply need to instruct better hand placement or a gentler touch.

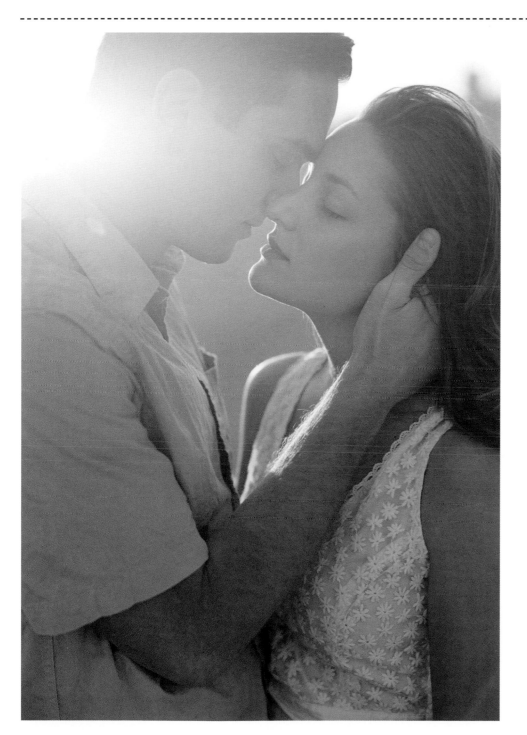

"Romantic images are reserved for later in the shoot, when the couple have become more comfortable in front of the camera."

Canon EOS-1V, 50mm 1.2 lens, f/2 at 1/125 sec. Fujifilm Pro 400H

"If your couple appear too nervous or are getting too still in one spot, get them walking! I asked this couple to go on a stroll through the orchard arm-in-arm."

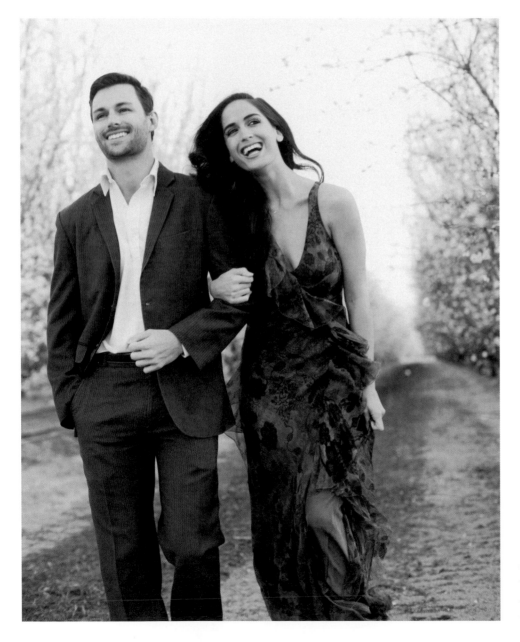

Canon EOS-1V, 50mm 1.2 lens, f/3.5 at 1/125 sec. Fujifilm Pro 400H converted to black and white in post-processing

Contax 645, 80mm Zeiss
lens, f/2 at 1/125 sec.
Fujifilm Pro 400H

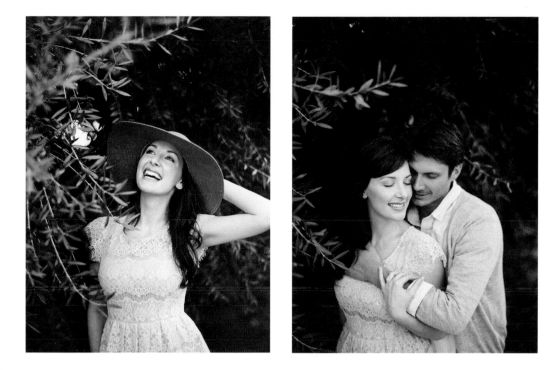

"I approach an engagement shoot like any budding friendship . . .
you grow more intimate over time. The structure and flow for most
sessions is the same. I first start off shooting with a longer lens, like the
85mm or 70-200mm, and begin with more traditional portraits,
then get them moving or doing something, like a walking shot.
Then as the couple become more comfortable and the initial jitters wear
off, I can move in closer with a 50mm lens. I don't usually ask the couple to
kiss until we are at least 30 minutes into the session. As the session progresses,
I direct them into more romantic body language. I also try to keep a
consistent flow during the shoot. In between shots, or as we're walking
to another scene, I constantly engage them in conversation and give
them positive feedback to keep the momentum going."

"Give your couples room to also be themselves. While I was getting extra film from my car, this couple started playing around and balancing on the rocks. I encouraged what they were doing and instructed them to walk toward the sunset."

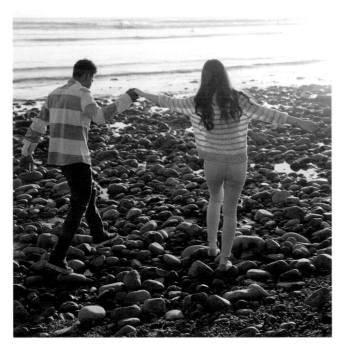
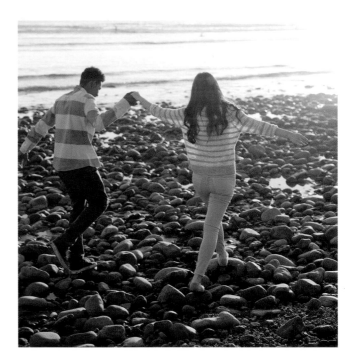

Both images shot with Canon EOS 5D Mark III, 50mm 1.2 lens, ISO 400, f/2.8 at 1/4000 sec

"Often women want to appear more slim and petite while men like to have an emphasis on broader shoulders."

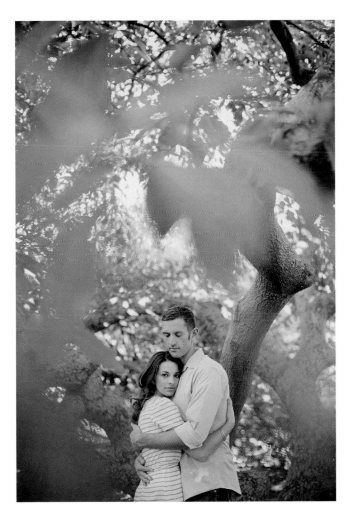

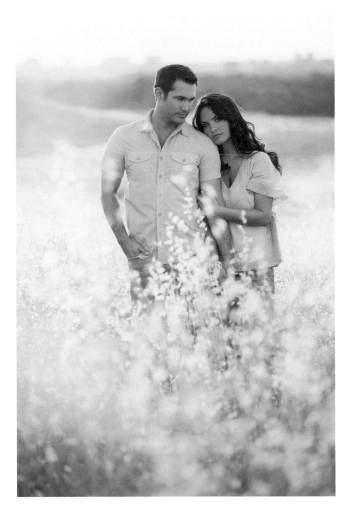

Left image, Canon EOS 5D Mark II, 50mm 1.2 lens, ISO 640, f/2 at 1/200 sec; right image, Canon EOS 5D Mark II, 70-200mm 2.8 lens, ISO 400, f/2.8 at 1/500 sec

Angles

Subtle guidance into basic natural movements produces relaxed, romantic images that shine a light on the romance between the couple. If a certain pose isn't coming out the way you'd like it to, keep the shoot and energy positive by moving on quickly without making your couple feel like they aren't doing a great job at the session. Genuine positive feedback, even when an image isn't working the way you want it to, will help the shoot move forward and help your clients feel comfortable enough for you to achieve the images you are looking for.

Be mindful of the angle from which you shoot your couple. Often women want to appear more slim and petite while men like to have an emphasis on broader shoulders. Portraits from the waist up look best when shot from a slightly higher angle. Bring a small stepladder to your shoot or look for chairs or low walls in your environment to stand on to achieve this. If a person has a particularly round face, they will often look best when shot at a slight angle while people with prominent noses will usually be most happy with photos that don't feature their profile. Shooting women square on

"Getting height and shooting down at your couple with tighter crop is almost always a flattering angle."

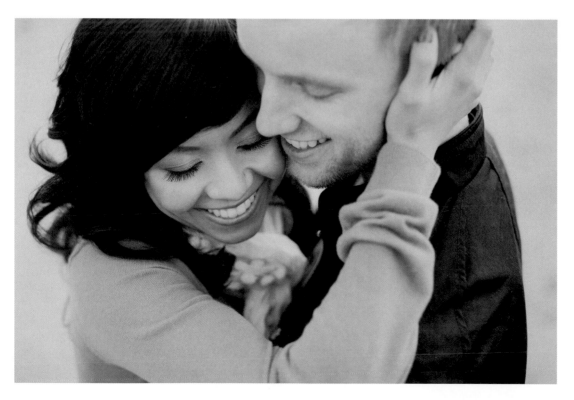

Canon EOS 5D Mark II, 50mm 1.2 lens, f/2.5 at 1/400 sec

"I'm a romantic at heart and tend to create a world with very idealized love."

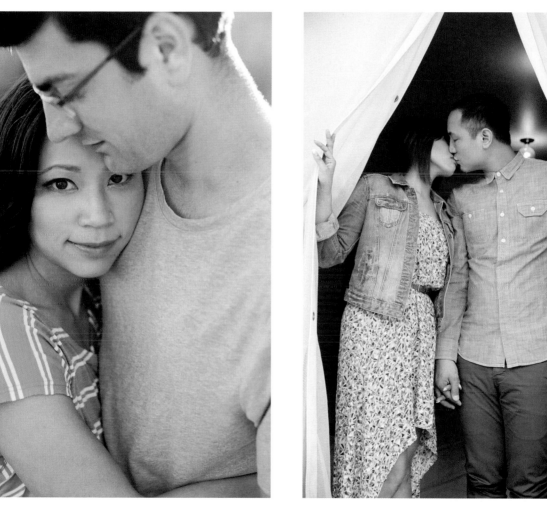

Both shot with Canon EOS-1V, 50mm 1.2 lens.
Fujifilm Pro 400H

will emphasize their width, so try suggesting that she turns her hip or shoulder toward you for a more flattering portrait.

When shooting full body portraiture, remember that if your camera is at their waist level, you will be lengthening them, so try shooting from a bent down angle or a crouch. If you are shooting with a wider lens, be aware that whichever body part is closest to your lens will appear unnaturally bigger than the rest of their body.

If a man is balling his hands into fists because he is nervous, suggest that he puts his hands in his pockets or encourage him to shake out and relax his hands to loosen up. Giving him something to do with his hands, like holding his fiancée around the small of her back, can help alleviate awkward hands. Common physical tensions and postures that couples often do, like kissing with their eyes open, puckering when they kiss, or turning their chins into double chins, can be eliminated simply by making a small verbal note or educating your couples early on in the shoot as to what is the best "camera kiss." Kisses that look best on camera are relaxed, without puckering or squished noses. If you notice that your subject is holding her arms out too wide out of fear of showing chubby arms, gently suggest that she relax her arms and shoulders.

Love, laughter, joy, silliness, and serenity are just a few of the beautiful emotions that lovers express when feeling relaxed with each other. Allowing one person to show affection to the other, for instance, a man cradling a woman's face in his hands or stroking her cheek, will always stir up feelings of love and romance.

Be Yourself

While there is much to be said for setting a mood with your voice and directing with a certain verbal style, those tips are only helpful if you are genuine. Different photographers will achieve different images, depending on their personality and style. This is a part of what makes your photography unique. Your imagery should excite you. As the Oscar Wilde adage goes, "be yourself, everyone else is taken."

The same concept applies to your clients. Your goal is to bring out your clients' true personalities, guiding them into poses and scenes that are the most accurate representation of their relationship. If they are the romantic type, gently guide them into sweeter poses; if they are goofballs, nurture their sillier, playful side. Always encourage your clients to be themselves and ask them questions. Discovering aspects of their personalities will lend to a true photographic reflection of what makes their relationship special.

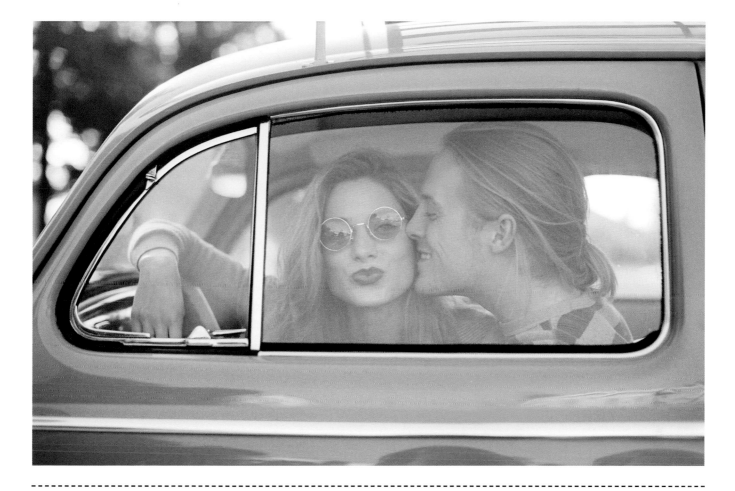

"If they are the romantic type, gently
guide them into sweeter poses;
if they are goofballs, nurture their
sillier, playful side."

Canon EOS-1V, 50mm 1.2 lens, f/2.8 at 1/125 sec.
Fujifilm Pro 400H

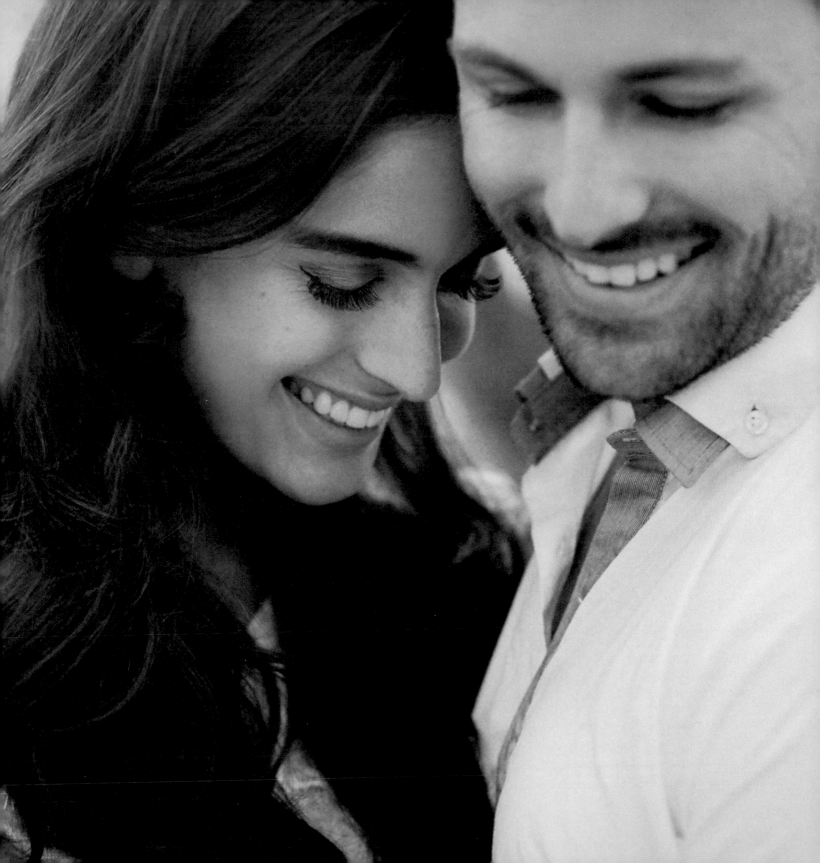

CHAPTER 6
Composition and Color

This recognition, in real life, of a rhythm of surfaces, lines, and values is for me the essence of photography; composition should be a constant of preoccupation, being a simultaneous coalition—an organic coordination of visual elements.

Henri Cartier-Bresson

Composition is your storytelling tool. How you arrange the elements in your photograph is the difference between dynamic, intriguing images and dull snapshots. In order to develop a tuned and innate sense of composition, study works of art spanning history. Taking the effort to look through timeless classic paintings and imagery of iconic film masters will help train your eye to note a certain compositional aesthetic that you can incorporate into your imagery.

Composition needs to become second nature so that you can pay full attention to your couple's experience. Developing expertise in any area takes time and practice. If you spend too much time during the session composing an image, you may lose the authenticity of the moment—and the romance you are trying to capture may elude your lens. Through studying the work of artists that you find inspiring, you can rewire your mind to view images differently and seek out strong compositions quickly. Look at a photograph by a compositional sage such as Henri Cartier-Bresson and ask yourself what works in this image, how is it balanced, and what compositional elements is he using? With enough exposure to balanced, well-composed art, it will gradually become more apparent in your viewfinder. While looking to other photographers in your genre will help you gain an understanding of how to emulate their style and create better romantic portraiture, it is vital that you also look outside of the wedding industry for compositional inspiration. Studying the work of famous directors and cinematographers can help you notice patterns in their compositional styles and apply this awareness to your own work. For instance, if you watch a poetical period film like *Bright Star* (2009) you would notice a strong use of the rule of thirds and soft north-facing window light. On the other hand, a movie like Wes Anderson's *Moonrise Kingdom* has a strong use of symmetry and color palette. Almost every frame in this movie could be a beautiful photograph.

If you need to improve your use of color, try taking a painting class to learn more about color wheel theory or look to other sources like interior design or illustrators. The behind-the-scenes footwork that you put into researching and learning about composition through the work of the masters will show up in your own work as it transforms into your intuition. The beauty of photography is that you can be completely self-taught—you have the freedom to learn and explore this medium through experimentation and study. Look at the work of master painters and ask yourself why they chose to compose or balance the image in certain ways. How do they use color? How is the subject's body language, and what does it convey? How do they paint a visually rich story?

"For this image, I saw the landscape composition first, then asked my couple to hike up to the top. I love how the landscape and immense boulders are the main element in the image, yet the couple still stand out completely."

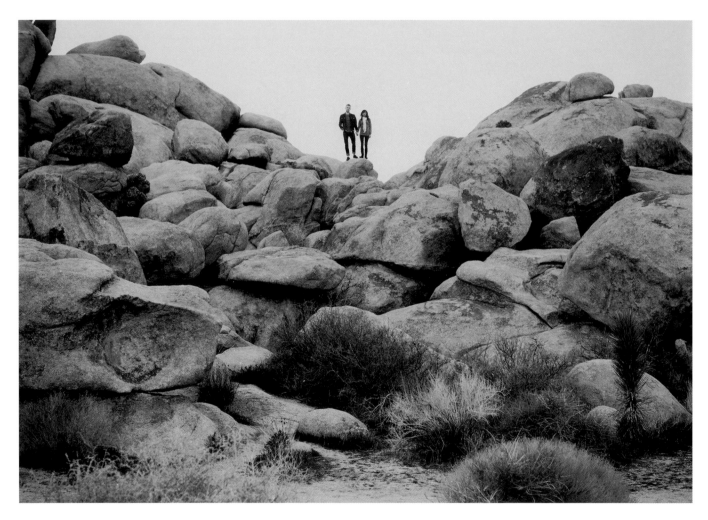

Canon EOS 5D Mark II, 50mm 1.2 lens, ISO 640, f/4.5 at 1/320 sec

"Shooting through or around elements in your environment can create a sense of privacy and reinforce an intimate moment. In this image, I used the leaves of the tree in the foreground to frame my couple. The shallow depth of field blurred the leaves and framed my subjects nicely."

Compositional Masters and Inspiration

Inspirational photographers: Henri Cartier-Bresson, Irving Penn, Diane Arbus, Tim Walker, Deborah Turbeville, Paolo Roversi, Rodney Smith, Helmut Newton, Ansel Adams.

Master painters: Johannes Vermeer, Alessandro Botticelli, Rembrandt Van Rijn, Vincent Van Gogh, Jules Joseph Lefebvre, Edvard Munch, Pierre-Auguste Renoir.

Amazing directors: Wes Anderson, Sofia Coppola, Jane Campion, Stanley Kubrick, Terence Malick.

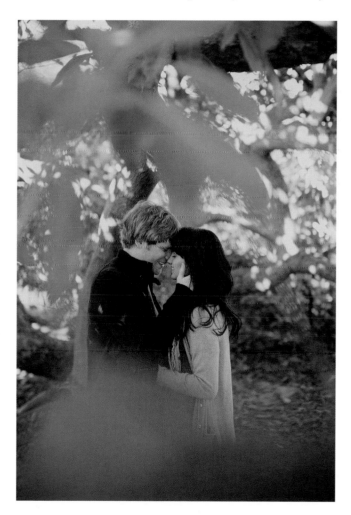

Canon 5D Mark II, 50mm 1.2 lens, ISO 400, f/2 at 1/100 sec

"In this image, the larger trees in the foreground create a framing element and a sense of balance. The couple are placed in the bottom third of my frame."

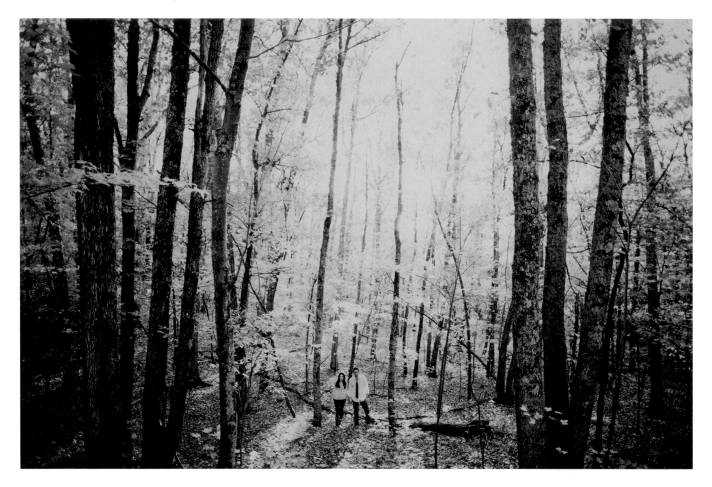

Canon EOS 5D Mark II, 24-70mm 2.8 lens, ISO 800, f2.8 at 1/500 sec

Balance and Rule of Thirds

Within the frame of your lens, you have the opportunity to define the world as creatively as you like. By paying attention to the placement of key elements in your image, like your couple (and in more tightly cropped images, their eyes, hands, and mouths), along with background and foreground details, the horizon, and any props, architecture, or landscapes involved, you can design an image that is easy on the eye and maintains a sense of visual interest and balance.

The rule of thirds is a basic compositional concept that serves as a guideline for creating balanced, engaging images. The rule divides your frame into nine equal boxes comprised of four intersecting lines, two horizontal and two vertical. In general, the rule of thirds suggests that you place the most interesting facets of your image along the lines and intersections. Use the rule of thirds to create leading lines, place your couple amid natural framing and along the areas of the image that the eye is most drawn to. The rule of thirds is less of an actual formula and more of a guideline to help you make images that are balanced, have depth and visual interest. In romantic portraits, placing the eyes along the line that represents the top third of the image will draw attention to this soulful part of the body. Every image, whether it is a tightly cropped portrait or a wide landscape orientation, should have a sense of balance. Trust your instincts and don't be afraid to experiment with your composition.

"Sometimes an engagement portrait can be just as powerful when you focus on their hands and body language instead of their faces."

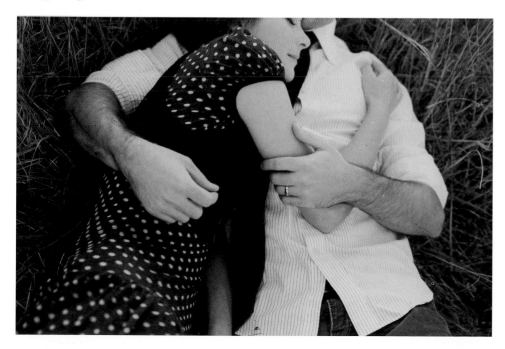

Canon EOS 5D Mark II, 50mm 1.2 lens, ISO 400, f3.5 at 1/250 sec

--

"For traditional romantic portraits, place the subjects' eyes in the top third of the image and make sure they are both on the same plane. This will ensure their eyes are in focus even when using shallow depth of field."

Canon EOS-1V, 85mm 1.2 lens, f/2 at 1/250 sec. Fujifilm Pro 400H

Lines and Symmetry

Create depth by noticing the foreground of your image. When looking at a photo, the eye is naturally drawn along lines in it. Is there a way that you can use your natural landscape to create lines that lead the eye toward your subjects? Try using fences, stair railings, tree lines, or paths to lead the eye toward your subject. Are there trees or poles growing out of their heads that you didn't notice? Is the horizon straight? It is equally important to look for elements in your environment that may be detracting from your couple or creating an overly busy scene.

In addition to leading lines, look for natural frames in your setting—is there a textured window frame or doorway that you can place behind your couple or a pair of trees that

"In general, my goal is to have my subjects' eyes in focus or at least one person's eyes in a more close-up, intimate portrait. For traditional shots, it is imperative to get both subjects' eyes in focus, while close-up, romantic images have a little more creative freedom. You may be able just to focus on the nearest eyelashes or single out lips or hands to be the main focus. It is important to have several different compositions, angles, and crops to tell a visually rich and interesting love story."

"The lines of the orchard lead your eye toward the couple. The subjects are placed in the center bottom half of the frame for balance and symmetry. Enough room is left intentionally at the top and bottom of this image for an 8x10 crop."

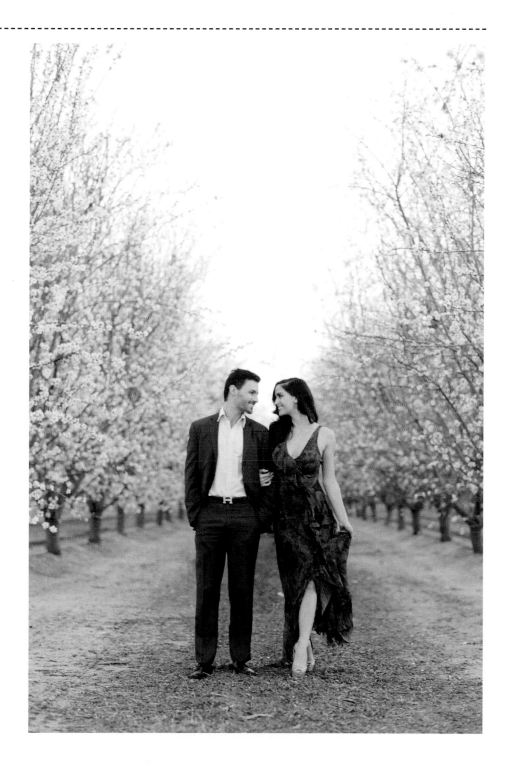

Canon EOS-1V, 50mm 1.2 lens, f/2.8 at 1/125 sec. Fujifilm Pro 400H

"Also look for architectural frames in your environment, like doors, columns, windows, and arches."

Both images shot with Canon EOS-1V, 50mm 1.2 lens. Fujifilm Pro 400H

"The focus here are the hands, however, I made sure to crop in mid-thigh on both subjects as well so there wouldn't be any awkward cut off joints."

Canon EOS-1V, 50mm 1.2 lens, f/2 at 1/250 sec. Fujifilm Pro 400H

you can place them between? In order to create a greater sense of privacy in an image, try placing something in the fore-ground of your image—with your couple still as the focus—in order to create a sense of discovery, a feeling that perhaps the viewer has stumbled across a private, loving moment.

When cropping images in-camera, try to be extra aware of where you cut off your couple's bodies. Cropping can help direct the viewer's attention to a specific idea that might be lost if too much of the scene is shown. Try not to cut people off at the forehead (unless it is a tight cropped intimate image) or joints, especially their knees, ankles, and hands. Sometimes you may want to cut off bigger parts of the image in order to focus on certain elements of their relationship in order to portray the personality better, such as focusing the shot simply on their hands as they are holding each other or their shoes as they are standing next to each other.

Different compositions and frames will convey very different feelings. Tight, closely cropped portraits of your couple's upper bodies and faces will produce feelings of

intimacy while wide, landscape-based portraits that use a lot of negative space (open sky or other empty feeling scenes) will provide a sense of seclusion. Utilize negative space to direct the eye toward your subject by placing them in a scene where they are surrounded by a relatively texture-free area. Surrounding them with sky, placing them at the very top of a hill that takes up three-quarters of the frame, or placing them where they seem small in comparison to the blank area around them can create visual interest and draw the eye directly to your subjects.

Symmetry, used in conjunction to the rule of thirds or not, can add extra interest to your photo. It is defined as similar or equal parts of your image facing each other, creating balanced proportions. Seeking out symmetrical images begins by looking for patterns—often found in lines, but also in natural shapes. While you may be placing your subject along the grid of thirds that you are imagining as you frame your image, be aware of smaller symmetrical aspects of the image. By making sure that the image is balanced and symmetrical

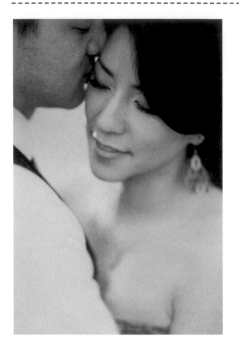

"Different compositions and frames will convey very different feelings. Tight, closely cropped portraits of your couple's upper bodies and faces will produce feelings of intimacy while wide, landscape-based portraits that use a lot of negative space (open sky or other empty feeling scenes) will provide a sense of seclusion."

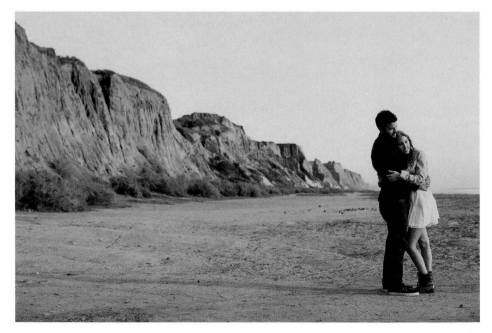

Left image, Canon EOS 5D Mark II, 85mm 1.2 lens, ISO 400, f/1.2 at 1/2000 sec; right image, Canon EOS 5D Mark III, 50mm 1.2 lens, ISO 320, f/3.5 at 1/3500 sec

"This image has elements of symmetry, framing and rule of thirds. The two identical wreaths emphasize the symmetry in this image."

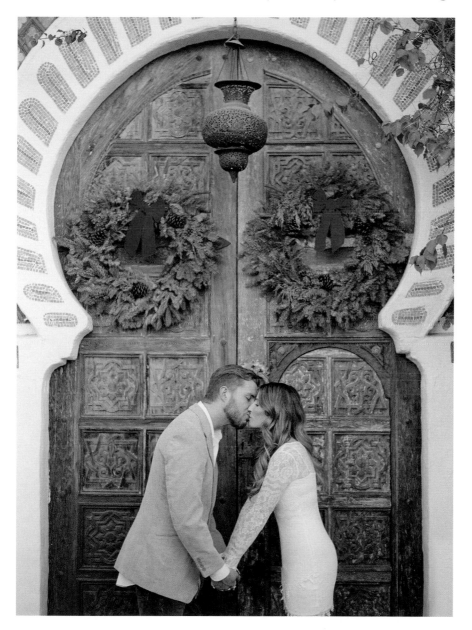

Contax 645, 80mm Zeiss lens, f/2 at 1/60 sec. Fujifilm Pro 400H

in a horizontal frame, you can play with composition vertically and vice versa. There is no real right or wrong, but symmetry is an additional element to look for when creating clean images. By making the lines in your image neat, even with each other and equal, you can better draw attention to the subjects, depending on how you place them in the symmetrical setting.

If you are focusing on an editorial-based engagement shoot, look around for ways to tell their story. A well-rounded story is rich in detail with plenty of interest and truth, so there should be many different compositional elements and strategies included in their coverage. A lot of composition is experimental and comes with time. Trust your instincts, explore different types of framing and dedicate time to reflect upon your images later by asking yourself what you like

about them and what you could do differently next time to create a more interesting photograph. Consistently reviewing your work is a big part of developing a more innate sense of composition in your photography.

Mix it Up

By the time you finish your shoot, you should have a wide variety of compositional styles and crops to choose from. These photos are going to be used in a number of ways—from save-the-date magnets to large canvas prints—and your couple will want to have enough variety in the photos you produce to fit with their various pre-wedding needs. Imagine that you want to provide them with a photo for their

"Lines can lead the eye toward your subject or frame your subject to create more visual texture."

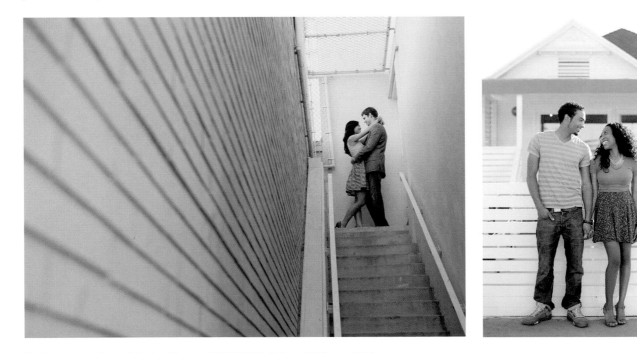

Both images shot with the Canon EOS 5D Mark II and 50mm 1.2 lens

"The use of negative space in an image creates the perfect area for text for save-the-date cards, posters, album covers, and magnets."

Here are just a few examples with graphic design by Melody Thomas from Mink Cards (www.minkcards.com)

"Remember that at least a few traditional portraits are requested by family and that if they request an 8x10 or other cropped image ratio, that will affect your original composition. I make sure to have a variety of crops for these kind of requests."

grandmothers, for their parents, for their friends, for their living room and for their bedroom. Each requires a different feel to it and they range from intimate portraits to traditional ones.

The Role of Film, Digital, and Different Lenses in Composition

Some types of composition are suited to certain lenses better than others. Avoid using a wide-angled lens when shooting close-up portraits to avoid distortion. If you do end up shooting portraits with a wide-angled lens, avoid cropping too tightly or placing your subject in the corners of the frame, as that will add extra distortion to their figure. Engagement

sessions are an optimal time to practice shooting with prime lenses, since you are trying to create intimate, romantic photos. Physically moving your body around will help achieve an undeniable sense of authenticity. It is important to note that you bring your own emotions into the shoot.

When you are close to your couple, your emotions and energy will impact them. If you are shooting a wide, landscape-based image with a 50mm lens, your couple will feel secluded and that will be apparent in your image and composition. By moving your body farther away from your couple, you can gain a new perspective on your composition. Relying too often on a zoom lens doesn't force you to change your position and see all the compositional opportunities around you. Using a focal length greater than 70mm is the most true to the eye's perspective, the most flattering to your subjects, and will eliminate distortion with tightly cropped portraits. A 70–200mm lens, although it is a zoom, can

Left image, Canon EOS 5D Mark II, 45mm 2.8 tilt shift lens, ISO 500, f/2.8 at 1/1000 sec; right image, Canon EOS 5D Mark II, 50mm 1.4 lens, ISO 200, f/2.8 at 1/400 sec

"This location already had lovely landscaping and composition built in. I used the leading path and colorful barrels in the background to frame this couple."

Contax 645, 80mm Zeiss lens, f/2 at 1/125 sec. Fujifilm Pro 400H

provide you with the most flexibility to shoot walking and movement-based images while still providing your couple with enough space to be comfortable expressing intimacy.

A Note on Film and Digital Composition

Since shooting film can be costly, many photographers construct their images very carefully before snapping a picture. Shooting digital allows you to practice playing with light and composition freely, taking as many photos as you want without financial repercussion, while shooting film inspires a very thoughtful approach to composition. Regardless of whether you choose to shoot digitally or with film, giving yourself the freedom to experiment will play a pivotal role in helping to develop your own style.

Color Coordination and Palettes

Begin noticing the way colors interact and their role in your photography by taking note of how colors are paired together in classical paintings, interior design, and nature. Looking through design magazines will help you identify how color and form interplay in a more abstract way. This will influence you differently than simply looking at another photographer's work. You may not always have control over all the colors in your photography, but you do have control over where you place your subjects and how the colors surrounding them interplay with their clothing and props. Look for color pairing opportunities at your location while you are scouting and advise your clients on their wardrobe based on what you think will look good in the scene. If you are shooting somewhere historic with sandy tones and rustic buildings and want to create an image with a muted pastel palette, you could suggest that your couple wear delicate pastels and earth tones to meld with the muted palette. Or, in contrast, if their wardrobe has

"Color played a huge role in this shoot. The cream, brown, turquoise, and gold tones were carried through all of the wardrobe and different locations."

Contax 645, 80mm Zeiss lens, Kodak Portra 400

a pop of color, placing them in a muted background will emphasize that burst of color. This is where getting to know your couple more in depth will help you emphasize their personality through the combination of wardrobe and location. There are lots of websites that focus on color palettes and combinations that can be used to inspire your clients' wardrobe and help you match your scene to your clients. Some colors photograph better on film than on digital. Red, for instance, doesn't read very well in digital photography but looks beautiful on film.

Styles

Labels are thrown around by photographers in the industry rather indiscriminately these days, so taking a moment to understand what each term generally means will help you define your style clearly. Bear in mind that often these styles blend and you do not need to pigeon-hole yourself with a singular label. Learning to describe your photography accurately will give your clients a glimpse into what sort of images they will be receiving and can help prevent disappointment and misinterpretation.

Each style of photography requires a different approach and skill set, however, a great photographer will be able to deliver quality work in all areas.

Fine Art

Fine art photography celebrates the photographer's vision and is heavily influenced by the photographer's direction and choices. These images feature beautiful, dramatic lighting and careful composition, with subjects often posed and manipulated by the photographer. Fine art images feature intentional composition and utilize classical artistic strategies in balance, symmetry, composition, and lighting. This style of shooting is perfect for engagement photography and can blend well with editorial and lifestyle photography.

Photojournalism

Photojournalism depicts a real life scene as it happens without manipulation of the setting. It makes the most of available light, even if it isn't the prettiest, and captures the moment with a sense of honesty and without too much intervention from the photographer. Capturing a spontaneous moment of laughter at an engagement session without interfering and instructing your couple to laugh can help you document what Henri Cartier-Bresson coined, "the decisive moment." This style is very vital in candid coverage at weddings, but doesn't allow for much direction to be given at an engagement session.

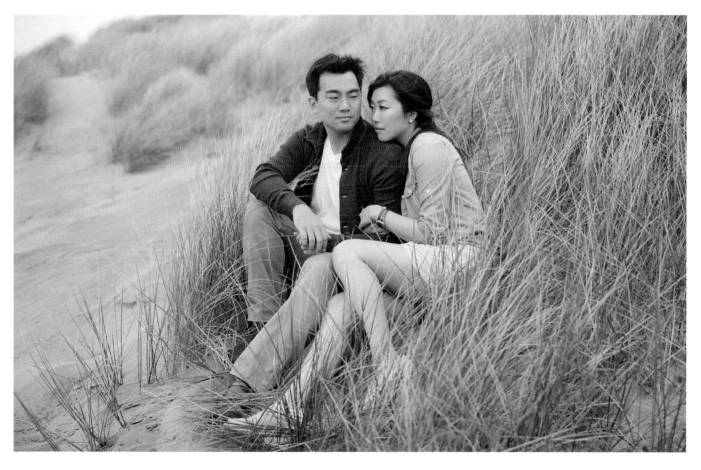

Canon EOS-1V, 50mm 1.2 lens, f/2.8 at 1/250 sec. Fujicolor Pro 400H

Editorial

Editorial photography is generally focused on emphasizing a story. Editorial photographers will also manipulate a scene in order to best convey a particular idea and evoke emotions through a descriptive, underlying storyline. Editorial style is seen most often in stories for magazines. Utilize editorial photography when creating a storyline for your couple that depicts an adventure they are on or some other element that conveys their personality in combination with a narrative. Blending storytelling elements will create rich visual layers at an engagement session.

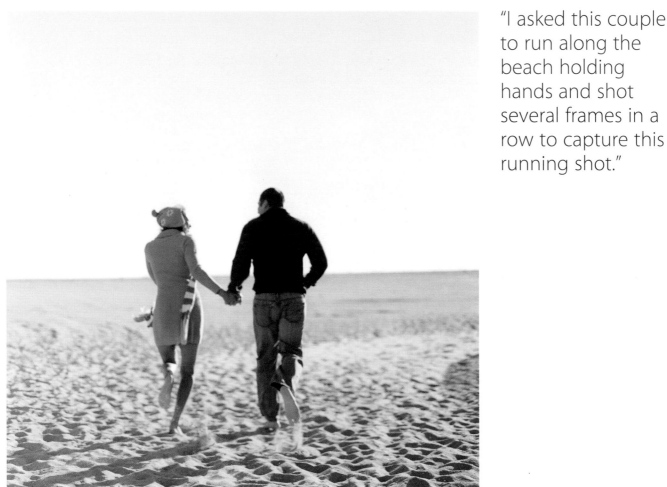

"I asked this couple to run along the beach holding hands and shot several frames in a row to capture this running shot."

Contax 645, 80mm Zeiss lens, f/3.8 at 1/500 sec. Kodak Portra 400

Facing page: Canon EOS-1V, 50mm 1.2 lens, f/2.8 at 1/125 sec. Fujicolor Pro 400H

Lifestyle

Lifestyle photography doesn't necessarily impart a storyline, but instead focuses on a particular lifestyle or cultural element. Like editorial photography, it emphasizes the little details, capturing a feeling that comes with a couple's lifestyle. The location, activity, and type of clothing can instantly convey more about that couple and how they live. Lifestyle photography strives to document the feelings of what makes your couple unique.

Fashion

Fashion photography focuses on mood and style and blends both lifestyle and editorial photography to create rich, interesting images. It generally has a strong aesthetic, featuring complex images that are heavily styled.

Commercial

Commercial photography refers to selling a certain product and the focus is all on that product. This label does not apply when photographing real life couples for their wedding or engagement session.

Ultimately, developing a good sense of color and composition goes along with developing your voice and vision as a photographer. It requires study and experimentation. When in doubt, simplify your image as much as possible. Find ways to show the love between your couple without distraction. Sometimes the most stunning photographs capture a quiet *je ne sais quoi* without complicating the image. The best photographers in the world have received negative reviews about their work, but it is their willingness to take risks and discover their vision that allows them to stand out from the rest. Looking to other sources of inspiration will help round out your perspective as an artist and enable you to be an integral part of moving the photography industry forward through innovative thinking and fearless art making.

Canon EOS-1V, 85mm 1.2 lens, f/2.8 at 1/250 sec. Fujicolor Pro 400H

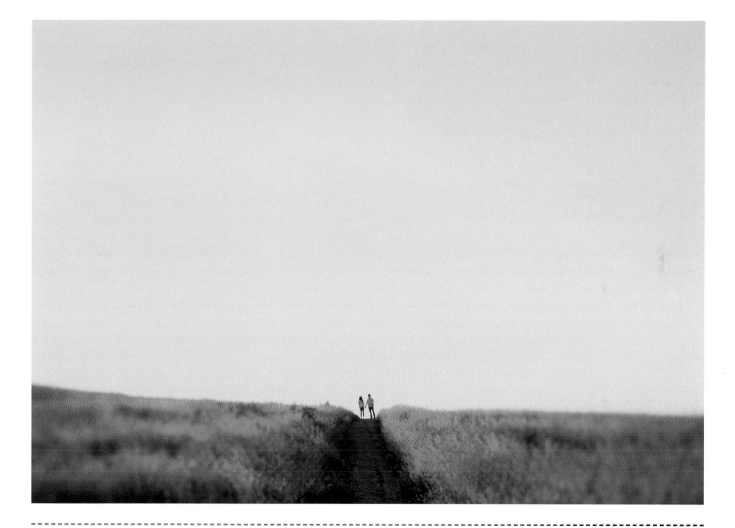

"Extreme compositions and use of
negative space, used sparingly, can
be a lovely addition to engagement
session coverage."

Canon EOS 5D Mark II, 45mm 2.8 tilt shift, ISO 400, f/4
at 1/800 sec

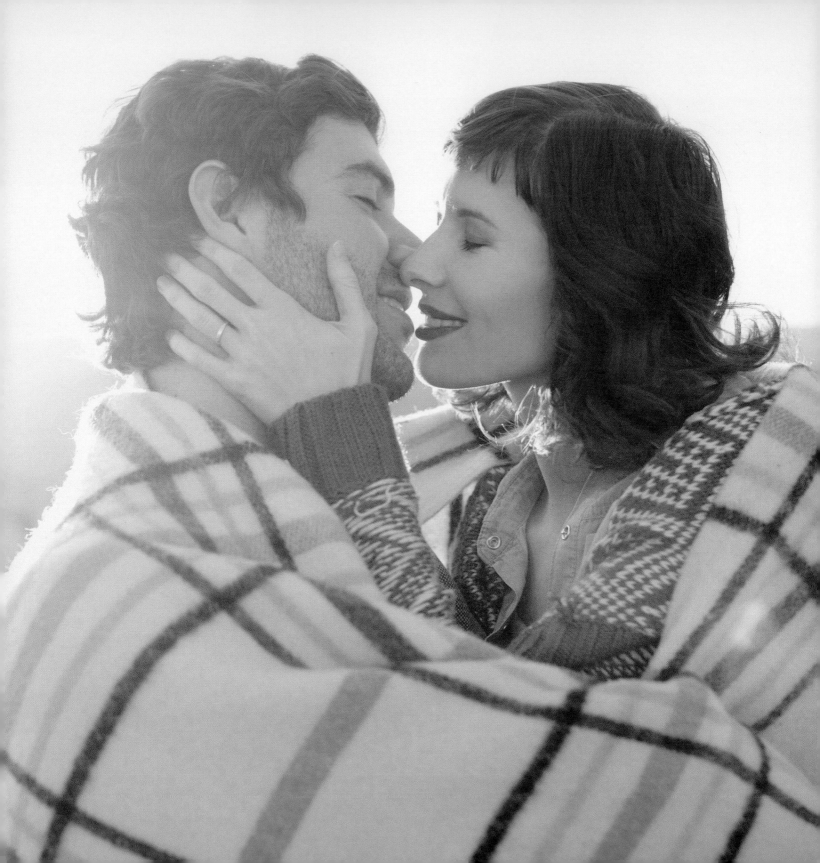

Current Trends in Engagement Photography

While engagement photography has traditionally been completely tied to the wedding industry, and the two often go hand in hand, there have been major shifts in romantic portraiture over the past couple of years as photographers shoot more non-traditional sessions. There was a time, not too long ago, when engagement photography was often shot in a studio setting—couples posed against backdrops that doubled for high school senior portraits. Over the past 25 years, engagement photography has gained major momentum and become a fairly essential facet of the wedding industry. **Kathryn Storke Grady of the blog Snippet and Ink,** noted that

> one big change is that more and more couples seem to be approaching their wedding design with an editorial eye, and are also choosing photographers who tend to shoot in an editorial style . . . instead of just shooting a happy couple in a lovely place, a lot more effort is going into the production of an engagement session.

Rapid changes in technology have created a savvy, creative and knowledgeable consumer. Today's brides- and grooms-to-be are very aware of the shifting trends in the industry, advances in technology, and creative influences and are in close contact with blogs, websites, apps, and web-dominated portfolios.

The emergence of changing social norms now makes romantic portraiture available not only to newly engaged couples, but to couples with children that are getting married, same-sex couples, and couples who simply want to document their love, married or not. In its early days, engagement photography was just another chore in the wedding planning process, lacking in creativity and enthusiasm. Now couples are taking advantage of the session as an opportunity to make portraits that really reflect their lives, so they can put these images on their walls and be proud of them for generations to come. Engagement sessions have come to represent a snapshot into a very important and exciting time in life, and as such, couples are looking to create images that they can pass on to their children and grandchildren.

As a photographer trying to build a brand in the digital age, it is vital to learn to market yourself on the Internet and to pay attention to those leading the industry.

> Ten years ago many top professionals relied on referrals and an occasional magazine ad for their bookings. These days savvy business owners have to market themselves effectively online while they build and maintain name recognition through social media platforms like Facebook, Twitter, Pinterest, and so on. Similar to the transformation that film photographers underwent to learn digital technology, today's wedding professionals need to learn how to successfully market themselves online. Potential clients expect to see a well developed website or blog, and a social media profile, from the professionals they choose to book and interact with.

Blair deLaubenfels, JuneBug Weddings

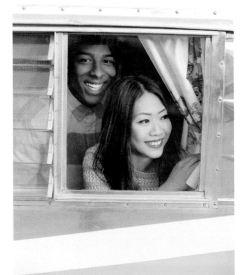

"This engagement session had a strong color palette and theme throughout the wardrobe and props. The peach Shasta trailer and retro table and chairs were rented from Archive Vintage Rentals (www.archive rentals.com).

All images shot with Canon EOS-1V and 50mm 1.2 lens. Fujicolor Pro 400H film

Trends do more than just change, they evolve. Next year's engagement photography trends will likely be built off of this year's prevailing trends. NPR defines a trend as "a prevailing tendency that is gradually gaining momentum and might have long-term implications. It's different from a fad, which is a short-term burst of interest or way of being." Thinking innovatively and regularly reflecting honestly on your work, your brand, and your business while paying attention to trends via bridal blogs and social media will help you keep up and work toward being a leader in the creative community of the engagement and wedding industry.

"It's very interesting, because about every two years there tends to be a shift in how we all work and interact within the wedding industry. Currently, brides really love online image inspiration from sites like theknot.com and Pinterest.com" (Rebecca Crumley, TheKnot.com). Bridal blogs encourage trends to cycle through by constantly displaying fresh ideas and consumer inspired creativity. Styles have changed and continue to shift very quickly.

Project Wedding (www.projectwedding.com) editor Katelin Gallagher noted that:

as the wedding industry shifts, so does the style of engagement photography that so often precedes it. With regard to wedding planning, the early 2000s saw a major shift from traditional ballroom affairs to creative, unique, personal, and DIY style weddings. During this time brides and grooms really began to assess which parts of tradition resonated with them and which parts didn't. Thus, there was a rebellion of sorts and rightfully so. Now that we've moved into a new decade, we're seeing a return to tradition, formality, and classic elegance. This time, however, couples are doing it on their terms. There is a greater consciousness around professional creativity, more thoughtful budgeting, and a renewed sense of finding meaning in tradition. With regard to the professional industry, the biggest change has been the emergence and subsequent staying power of a dozen or so exquisitely published sites and blogs. Wedding professionals have more opportunities than ever to showcase their work and reach a specific clientele.

"This couple wanted to convey a relaxed, California beach lifestyle."

Canon EOS-1V, 50mm 1.2 lens. f/2.8 at 1/500 sec. Fujicolor Pro 400H

"Popular trends drive style and wardrobe and location selection."

Both images shot with Canon EOS-1V and 50mm 1.2 lens. Fujicolor Pro 400H

"This couple have impeccable style. The unique gold hairpiece and well-styled wardrobe are elements that bridal bloggers and their readership love to see."

Both images shot with Canon EOS-1V and 50mm 1.2 lens. Fujicolor Pro 400H

Scrutinizing the constant evolution of photographic style, wedding design, fashion and art will keep you on your toes in the fast-paced and ever-changing world of engagement and wedding photography. By going onto bridal blogs and looking to fashion advertisements, you can stay ahead of the game. Fashion trickles down into the wedding industry and trends that are seen in the fashion world can be expected to re-emerge into weddings.

Bridal Blogs and Social Media

Bridal blogs and social media have played a pivotal role in engagement photography. With sites featuring editors' favorite engagement sessions, submitted by both photographers and couples, they have provided artists with unprecedented exposure and provided couples with real life inspiration.

By sifting through various bridal blogs, you can get a true feel for what current industry trends are. Chapter 10 will discuss bridal blogs and how to get published in more detail, but here we will discuss how bridal blogs influence the evolution of the wedding industry. In the past few years, bridal blogs have been a strong force in moving the industry forward—paying attention to their content and style will help you grow with the industry and, hopefully, inspire it.

Photographers have a huge impact on how trends in engagement and wedding photography emerge. If a photographer has the opportunity to work with a creative couple and make some slightly out of the ordinary and exciting images, they can spark an entire trend with that session if it is featured and reposted on blogs and social media. With creativity and innovation, photographers have the ability to be trailblazers in a vibrant, bustling industry. Engagement and wedding photographers can communicate with editors more freely than ever before, providing themselves with greater opportunity to reach larger audiences.

Canon EOS-1V, 50mm
1.2 lens, f/2.8 at 1/250 sec.
Fujicolor Pro 400H film

Future brides devour the content displayed in popular wedding blogs. They view inspiring images, discover DIY ideas, and formulate the style for their wedding and their engagement photos. Bridal blogs tend to only show the most innovative engagement sessions because their readership demands fresh creative content. It is important to note that while a bridal blog may consider certain props and styling "played out," that doesn't mean that these stylized elements aren't worth shooting, especially if it's something your clients are interested in replicating.

Props, Then and Now

The use of props exploded a few years ago, when bridal blogs began featuring quirky sessions featuring a slew of fun and colorful additions that couples could use to stylize their images. Popular looks included big balloons, picnics and banners featuring the names of the couple, their wedding date, or a cute phrase. Couples would often incorporate as many props as they could into the session, somehow making time for four or five stylized elements that didn't necessarily match with each other. Photographers and couples were all so excited about this new use of props, that they would overdo it—shooting a couple holding balloons in one shot, vintage suitcases in another, followed by oversized cutesy sunglasses and so forth. These quirky touches added a dose of fun to the shoot, helping couples feel more involved and unique, but lacked a certain restraint.

The current trends in using props are leaning toward still utilizing cute additions to your shoot, just in a slimmed down and personalized way. The use of props is now tailored to a specific couple and their style or story.

Paige Appel and Kelly Harris, owners of the event design house Bash, Please (www.bashplease.com) and co-creators of the ultra hip bridal fair, The Cream Event,

"I love the emerging trend of shooting couples at home and in more casual settings. It brings another level of intimacy into the images."

Both images: Canon EOS 5D Mark III, 50mm 1.2 lens, ISO 400, f/2.8 at 1/640 sec

--

"Large balloons have been a really big trend the past few years. They are relatively inexpensive and graphically beautiful and never cease to add a bit of whimsy. Even though they may be overdone, I still love to shoot with them as props."

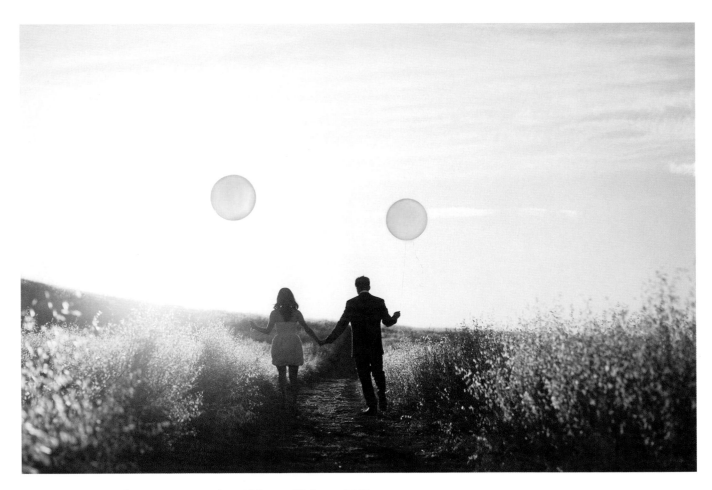

Canon EOS 5D Mark II, 24-70mm 2.8 lens, ISO 100, f/3.5 at 1/5000 sec

"Along with balloons, picnic scenes were very popular in 2010 and 2011."

Top image: Fuji Instax Wide shot with Canon EOS 5D Mark II; bottom image: Canon EOS 5D Mark II, 50mm 1.2 lens, ISO 100, f/3.2 at 1/500 sec

Canon EOS-1V, 80mm 1.2 lens, f/3.5 at 1/1000 sec. Fujifilm Pro 400H

noted that current engagement session style they see show-cases "unique locations, kitschy props, themed sets, curated fashion, [and is] more artistic in design and photography."

Home atmospheres, real life activities, and unique stories are finding a new place in engagement photography as an addition to the selective use of props. If your couple want to use props, suggest finding one or two small items or concepts that excite them and reflect their personalities, or use props that are an active part of their daily life. Impersonal

props still have their place when used sparingly, however, because of their visual appeal.

While bridal blogs may not be interested in featuring another engagement session that has a couple holding an oversized yellow balloon, these images are still graphically engaging and may be exciting for your couple. One major prop, like a vintage Vespa or a row boat, could be used to portray a fun, travel, or lifestyle feel without overshadowing the couple themselves.

Natural Styling and Other Emerging Trends

Some couples are also choosing to forego props and are leaning toward more naturally styled sessions that showcase the couple's lifestyle.

Lara Casey, of *Southern Weddings*, hopes to see a continuance in the trend toward timeless imagery rather than styled, posed sessions. "Organic images last a lifetime," she says.

Jacqueline Weppner from Merci New York says that:

Just like with styling, I've seen engagement session photography refocus back on the couple and their love for each other. And to me, that trifecta of great light, great chemistry, and fabulous wardrobe makes for one truly beautiful engagement session. I hope that engagement sessions continue to evolve as a necessity of the wedding process. In addition to the stunning end result of having photos to cherish for a lifetime, the actual shoot is just such a special, intimate and heartfelt moment. It's a beautiful memory to bring with you on your wedding day.

Naturally styled shoots that focus on color palettes and fashion instead of kitschy props are just now beginning to emerge. Combined with selective, yet simple, styling, engagement shoots are starting to really focus on the closeness between the couple, with styling serving as an accent to the relationship.

Lucia Dinh Pador of *Utterly Engaged* **magazine** predicts that engagement sessions will become "more intimate and more lifestyle driven [as well as] more authentic, intentional and more meaningful" in the industry as a whole.

There are still plenty of inspired niches and themes to explore with couples that are excited by more creative

"Love and real moments never go out of style."

Canon EOS 5D Mark III, 85mm 1.2 lens, ISO 400, f/3.5 at 1/400 sec

"No matter what the prevailing trends are, make sure you also put the focus on the couple's relationship and connection with each other."

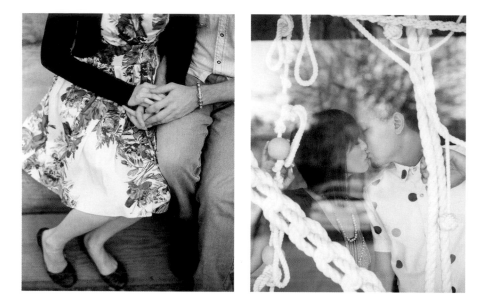

Left image: Contax 645, 80mm Zeiss lens, f/2.0 at 1/125 sec. Kodak Portra 400; and right image: Canon EOS 5D Mark III, 24-70mm 2.8 lens, ISO 400, f/2.8 at 1/250 sec processed with Alien Skin Exposure 4 filter

engagement sessions. Vintage inspiration is still really popular, due to the recent popularity of period piece movies and the British royal wedding. Media influences weddings and engagement sessions quite a bit, so look for 1920s inspired fashion as a result of movies like *The Great Gatsby* (2013) and shows like *Downton Abbey.*

While trends seem to be fleeting, there are certain areas of the industry where they linger. New York, California, and certain parts of the South are great drivers of fresh inspiration for weddings and engagement sessions, and their concepts often trickle through to the rest of the country. Europe is beginning to value wedding photography in a way it never has before. Look for European influence to play a big role in weddings, and engagement sessions subsequently, in the United States, and vice versa. Perusing European fashion and weddings will help you see future trends in American weddings because there is an emergence of a more worldwide viewpoint in the industry.

Focusing your energy on sharpening your skills and continuing your education as a photographer will ensure that you stay in tune with current trends. If you maintain a constant influx of creative information by reading books on art, business, fashion, interpersonal relationships, personal growth, you will always be in a state of growth and change. Photographers tend to falter in their careers when they feel creatively stagnant. Finding your own voice is the most challenging aspect of being an artist, yet it is the one thing that will help you shine. Trends will come and go, but if you seek to make photos that will last for generations, your photography will speak volumes of an heirloom love story that stands the test of time. Let every day challenge and inspire you in some way and you will avoid the quiet stagnation that silences art.

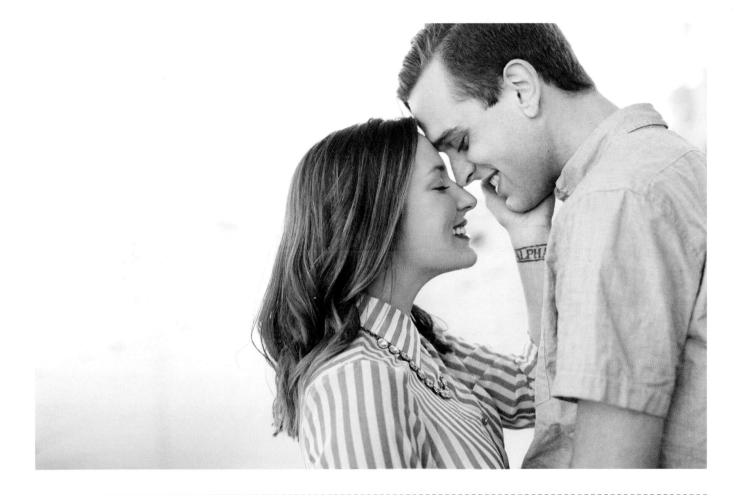

"Trends will come and go, but if you seek to make photos that will last for generations, your photography will speak volumes of an heirloom love story that stands the test of time."

Canon EOS-1V, 85mm 1.2 lens, f/2.2 at 1/125 sec. Fujifilm Pro 400H

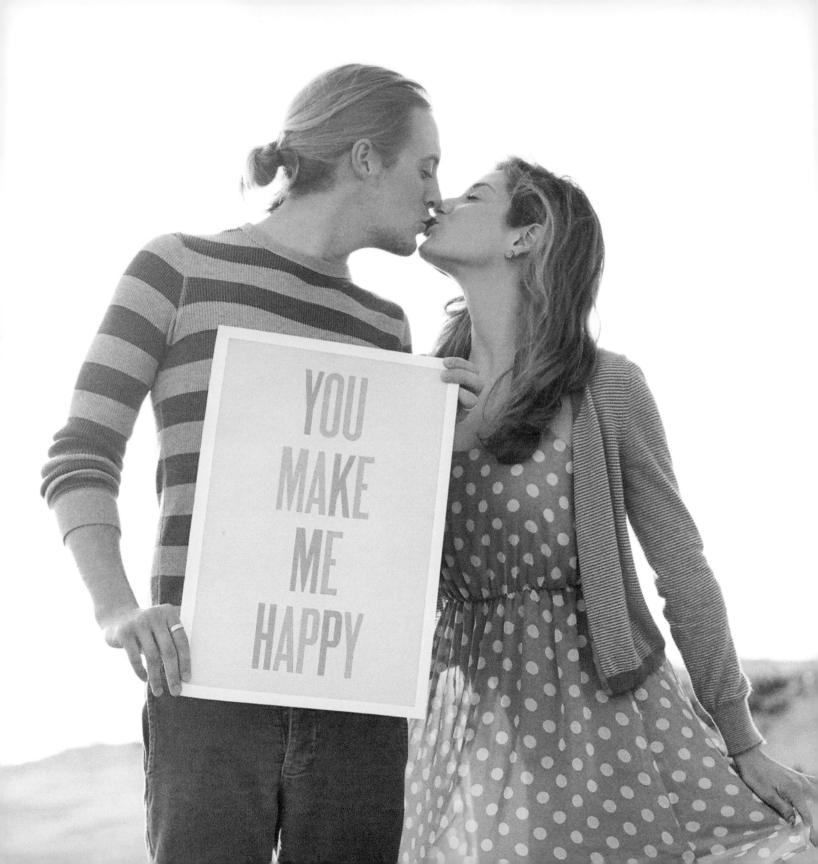

Wardrobe and Styling

Standing out as an engagement photographer requires creativity and innovation, but it also requires perseverance, patience, and a lot of hard work. The upside to all that hard work is that it can be a really fun and creative process. The examples of engagement photography featured on top blogs and in magazines all feature a stylized element, even in their simplest forms. The use of props may be slimming down but they are still integrated to accurately tell a story or to fit into a specific color palette.

The most published engagement sessions all feature a common thread running through them—they are well thought out, creatively conceptualized, and have attention to detail. They often involve props that complement the couple, a visually harmonious wardrobe and location, and a carefully considered color palette. You may have couples that want a simple shoot and perhaps aren't up for all the effort involved in using props, a stylist, or a make-up artist. These sessions are just as important as your more styled sessions, but they are less likely to be picked up for publication. When shooting with clients that prefer a natural style, you still have the most important aspect of any engagement shoot to work with—their love and connection. To enhance a laid-back couple's story, try and find locations that emphasize the simplicity of their wardrobe. A quiet hiking trail pairs well with light, breezy clothing, while simple cozy sweaters look good on couples cuddling on the sofa at home. Even when your clients aren't interested in a more stylized shoot, you can still find ways to create a visual flow in the session through color and location.

Jacqueline Weppner, owner and main stylist at Merci New York, notes that:

when I first began Merci New York, heavily propped engagement sessions were a big trend, as was anything "vintage." I quickly acquired an arsenal of mid-century suitcases, hat boxes and bunting signs for clients and made good use of them, but secretly, I wished we could nix the clutter and keep the focus back on the clients. Luckily, I now have clients who appreciate my roots as an editorial fashion stylist, and specifically ask for fewer props on set. The focus is on the clothing, the accessories, and using wardrobe to showcase my client's unique personalities and chemistry—which makes me one very happy (and at-home) stylist!

For the most part, a lot of your couples will be very excited to style their sessions and put more thought into their shoot. Creating mood boards and storyboarding your shoot can make the creative preparation process exciting and help your couple to feel involved in the shoot. Utilizing the technology and tools that other creative forces in the wedding industry have designed will help you discover a more sustainable method to help your clients actualize their visions. Props may seem like they are featured in shoots less often these days, but the reality is that props will always be a key force in photography—they are just being slimmed down to accent the couple instead of being a driving force in the

"A prop can be as simple as an oversized sunhat or rope swing hanging from an olive tree."

Left image: Canon EOS-1V, 50mm 1.2, f/2 at 1/60 sec. Fujicolor Pro 400H; right image: Contax 645, 80mm Zeiss lens, f/2 at 1/60 sec. Fujicolor Pro 400H

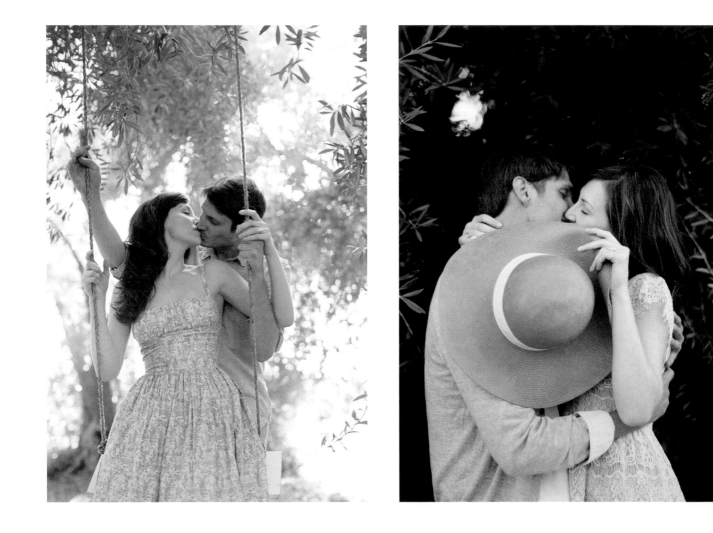

"Letter balloons are a fun twist! It was difficult keeping the letters still, the slightest breeze would twist the 'L' and 'E' backwards, but it was well worth the effort."

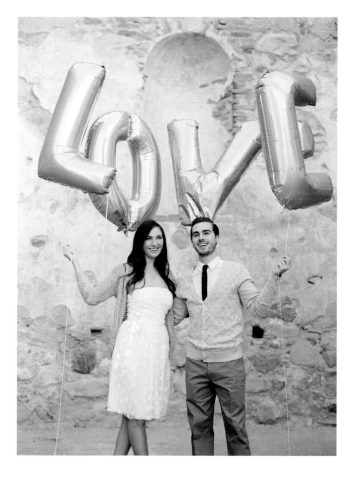

Contax 645, 80mm Zeiss lens, f/2.8 at 1/125 sec. Fujicolor Pro 400H

image. Teaching your clients and yourself how to pre-plan your shoot through the use of storyboarding, mood boards, stylists, and their inspiration will create a more cohesive story and well thought-out imagery.

Using Props

Adding props into your photos can be a charming way to provide some personal insight into your couple and their relationship. When used simply and in moderation, props can also add an engaging element to your shoot through additional storytelling elements and thematic cohesion.

Jen Campbell of Green Wedding Shoes noted that she

loves seeing how couples find new and interesting ways to incorporate props. Whether it's a balloon (which was really popular a few years back) or a rowboat (a current popular choice), using props is a great way to add an element of playfulness and, sometimes more importantly, to help couples relax in front of the camera and allow their personalities to shine through.

Your couple may benefit from having props to keep their hands busy or get into character to diminish their nerves. Real life couple Ashley and Tyman noted that using props

made the images more interesting. There are only so many pictures you need of yourself hugging, holding hands, and kissing, The props added a little diversity to the mix! And they put us more at ease during our shoot since we could be a little more goofy and less worried about looking perfect.

Innovative couples should always feel open to approaching you with their own ideas and personal props, but often your clients will look to you for help in finding the perfect, cute addition to their shoot.

Think of props as an element designed to bring the shoot together, by unifying your couple or complementing the story. You will come across many different opportunities

"Bicycles are always a fun element. They are graphically beautiful and give couples something to do. Riding a bike always elicits a smile. This couple couldn't stop laughing while trying to balance on this bike together."

Both images Canon
EOS-1V, 50mm lens,
Fujicolor Pro 400H

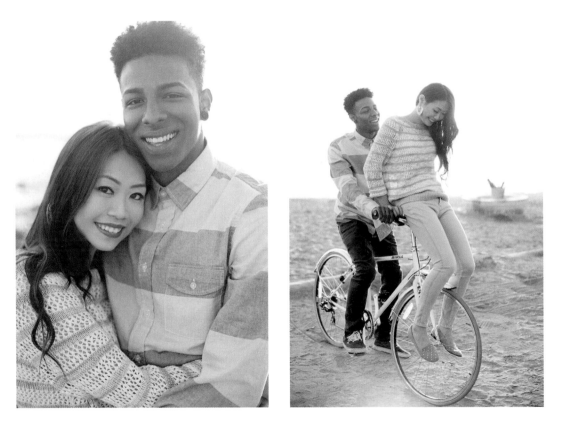

and types of props as you encounter different types of couples. Certain props will be more useful than others depending on the location and style that you're looking to achieve in your shoot. Some couples will want your advice on what kinds of props to use in their shoot.

Asking your clients questions about their pastimes, hobbies and other aspects of their lifestyles should help both you and them get a better feel for what sort of props would really reflect their relationship and personalities. Having a small pamphlet or PDF of photography tips that, along with your favorite sources for stylists, hair and make-up and wardrobe, features some sources for cute props can be very helpful. Sites like Etsy (www.etsy.com) or BHLDN (www.bhldn.com) are great resources for your clients. If you are trying to integrate certain looks into your portfolio, send your clients an email with a link to sites where they can view

"Ask couples about their hobbies and the activities they enjoy together. This couple loved photography and brought their prized Diana camera to their shoot. I shot these images of each of them taking a photo of the other with the intention of them being displayed side by side ."

Both images Canon EOS 5D Mark II, 50mm 1.2 lens, ISO 800, f/1.6 at 1/500 sec processed black and white with Alien Skin Exposure 4 Calotype filter

and purchase props that you like. If your couple aren't really interested in using props, don't push them into it. Instead, suggest other ways to tie the shoot together like a really unique location balanced with a nice wardrobe. Always remember to do your best to accommodate your couple and their desires. Your shoot really is about capturing the essence of the couple in front of you. Wardrobe, props, and styling are all just frosting on the cake. What matters the most is giving your couple a fun experience and capturing them looking their best.

Here are a few different genres of props that you might run into when preparing for engagement sessions and how to best utilize them.

--

"Simple banners, especially when they are handmade by the couple themselves, are a sweet symbol of celebration and make for a whimsical addition."

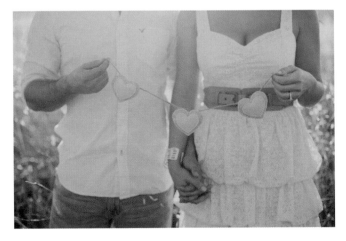

Both images shot with the Canon EOS 5D Mark II and 50mm 1.2 lens

Personal

Your couple may want to include one or two meaningful items in their shoot. These sorts of props generally have special significance (like a quilt knitted by a grandma) or reflect their lives together. For example, Ashley and Tyman chose to bring their vintage beach cruisers, since they love to go on bike rides together. They noted that, "It wasn't important for us to have a 'styled shoot,' but we did enjoy incorporating little things here and there that represented who we are as a couple."

Perhaps your clients love to travel—maps, a camping tent, Volkswagen bus, or other relevant props can make a great addition to their story. Think of personal props as telling part of their love story. Personal props can be used in conjunction with an activity that they are doing during an editorial style shoot. Help your couple get creative with personal props—they can be as simple as mittens and scarves while your couple is hunting for a Christmas tree or as bulky and colorful as surfboards, a cute beach towel, and a big umbrella for ocean lovers. Finding ways to utilize these props in the story's context will give them greater value while providing a colorful way to exhibit small glimpses into the couple's personal lives.

Creative/Cute

These types of props are used with the intention of adding a bit of whimsy and flair to the shoot. A little pop of color like flowers, a bright tandem bicycle, hats, balloons, umbrellas, silly glasses (or other fun photobooth-like props) can create a lighthearted tone in the image. Using prop letters (cake candles that spell love, cookies that spell their initials, balloons shaped as letters, Scrabble letters, etc.) can be a light and charming way to personalize these props. Using one of these props as a way to display the date of the wedding can add value to the session by making them usable for save-the-date cards and anniversary tokens. Another real life couple, Andrea and Eric, brought a custom banner, giant balloons, and large initial letters from Anthropologie for their engagement session. They assert, "What is more fun than getting all glammed up, looking fabulous and holding a giant balloon in the desert with your best friend?!"

"You can't forget the furry members of the family!"

Canon EOS 5D Mark II, 50mm 1.2 lens, ISO 640, f/3.2 at 1/160 sec

Location-Based

These are props that are based on, come with, or even are your locations. A fancy sailboat, a vintage car, a hip hotel room, or a cabin rented for the weekend, location-based props can also double as a fun weekend away for your couple. If they book a cozy vacation rental for the weekend, they can shoot on one afternoon and enjoy their mini vacation for the rest of the trip. This is a great way to create authentic photos out of what will become a treasured memory.

When using props, always begin the session without them—focusing directly on your couple. It is important to still use that initial time in the shoot to get a feel for your couple and to help them feel comfortable. If your couple want their pet or an animal featured in their session, remember that they are not just pets but members of the family, and they deserve their own special headshot.

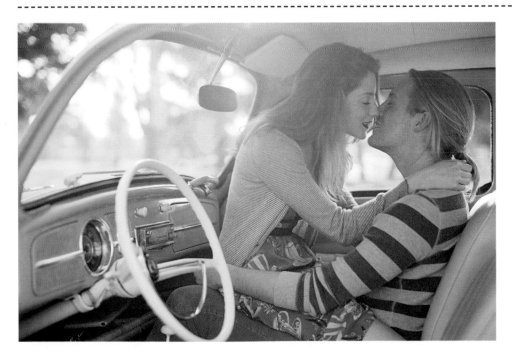

"This couple's vintage VW bug was the cutest prop and reflected the couple's love for retro style."

Canon EOS-1V, 50mm 1.2 lens, f/2.8 at 1/125 sec. Fujifilm Pro 400H

"This shot was all about logistics and had to be pre-planned. The person sailing the boat actually ducked out of sight, and I stood on the edge of a dock to get this shot."

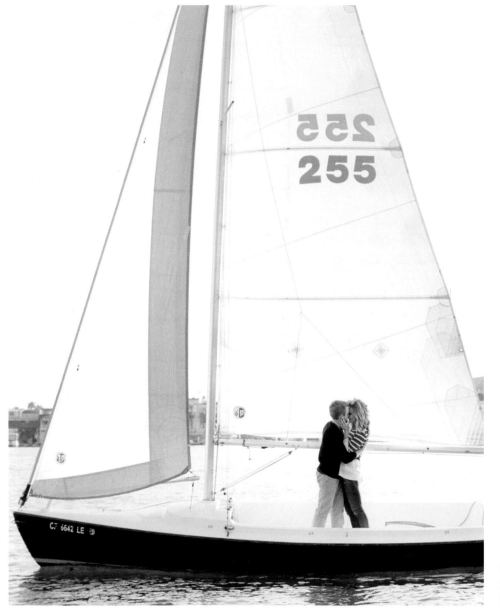

Canon EOS-1V, 50mm 1.2 lens, f/3.5 at 1/500 sec. Fujifilm Pro 400H

"This nautical themed engagement shoot had several main elements storyboarded, including all the props from Found Vintage Rentals (www.foundrentals.com) to make sure everything was incorporated into the shoot."

Canon EOS-1V, 50mm 1.2 lens, f/2 at 1/125 sec. Kodak Portra 800 film

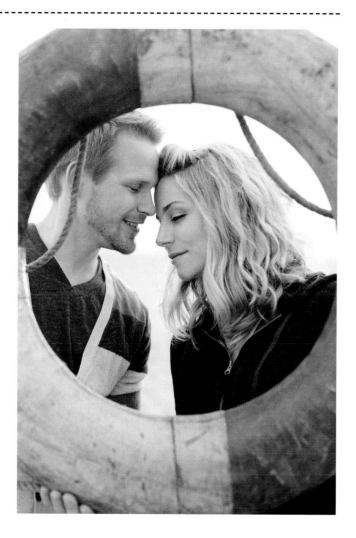

When props fail to make your session shine, the scene has probably become too busy. Like with many aspects of art, less is more. Your couple need to be the focus of the shot. You may come across clients that want to get all of their favorite props into their session. The couple risks the possibility of losing out on the whole experience because you are too busy trying to get all of their mismatched props in. As their photographer, try to keep the whole session in mind and direct them toward simplifying the scene if it shows signs of getting too busy.

Storyboarding Your Session

Storyboarding is a tool used often in filmmaking. It works really well when planning out an editorial session that has a certain intended flow to the story. While most storyboards are graphic methods of organizing a collection of images, you don't have to be an artist to plan out your shots. A storyboard is a layout of the various shots you want to get throughout shooting, from beginning to end. It will often go hand-in-hand with a storyline. Creating a storyboard does more than just help you plan your session, it stimulates your inventive mind, nurturing new ideas, compositions, colors, and direction. If you are planning a shoot that features a road trip as your storyline, identify the specific shots that you want ahead of time. Storyboarding key images in your story (photos of the couple holding their luggage, with a fun car, with a map, in front of a diner, etc.) will keep you from missing essential photos during your session and help you have a focused, professional shoot that maximizes light, time, and energy.

Bring your storyboard with you to the shoot. You don't have to follow it exactly, but you can always refer to it for inspiration. It will help organize your thoughts visually and can also help your couple understand your vision. Instead of having to direct them with entirely verbal instruction, you can show them the image you are trying to create from a magazine editorial or other source as well.

Storyboarding your session will make more work for you, but it is something to experiment with at least once or twice to see how it affects your shoot. The extra time you put into creating a storyboard has the potential to help you take your photography to the next level by adding an extra element of pre-thought, professionalism, and creativity. If creating an entire editorial storyboard is more work than you are looking to invest in your session, try creating a pose board instead. A pose board is a collection of images that reflect different poses and actions that you are inspired by. Your couple will appreciate the visual reference and you might find that it's easier to convey the look you want to achieve.

If you want your work to be cohesive and exceed the status quo, you must plan ahead. Standing out in today's market requires effort, but that doesn't mean you have to do it all for free. If you feel storyboarding your sessions will help you with your business, do a few storyboarded shoots to build your portfolio and then incorporate it as a service you offer to your clients for a fee or raise your prices accordingly to reflect the service added.

Mood Boards

If you are shooting a lifestyle-based engagement session, you may want to try creating a mood board as a way to set your visual intention for the session. Mood boards are generally a collage created out of related colors, images, and textures as a design palette. They give you and your clients a better idea of your vision so that the chosen location, wardrobe, and props can fit together harmoniously. Many bridal blogs will make and feature mood boards on their websites to inspire their readers. These featured inspiration boards are a great source for materials when making your own. If you are trying to make a mood board to inspire your clients or propose a certain theme for the shoot, try starting with an image that is central to your clients' relationship or part of their chosen

facing page: "This is a sample mood board for a nautical themed engagement session. It shows a strong color palette and sample wardrobe with nautical stripes, and a few of the props we will use. The couple and I will use this mood board as a guide to shop for wardrobe, scout out locations, and source props."

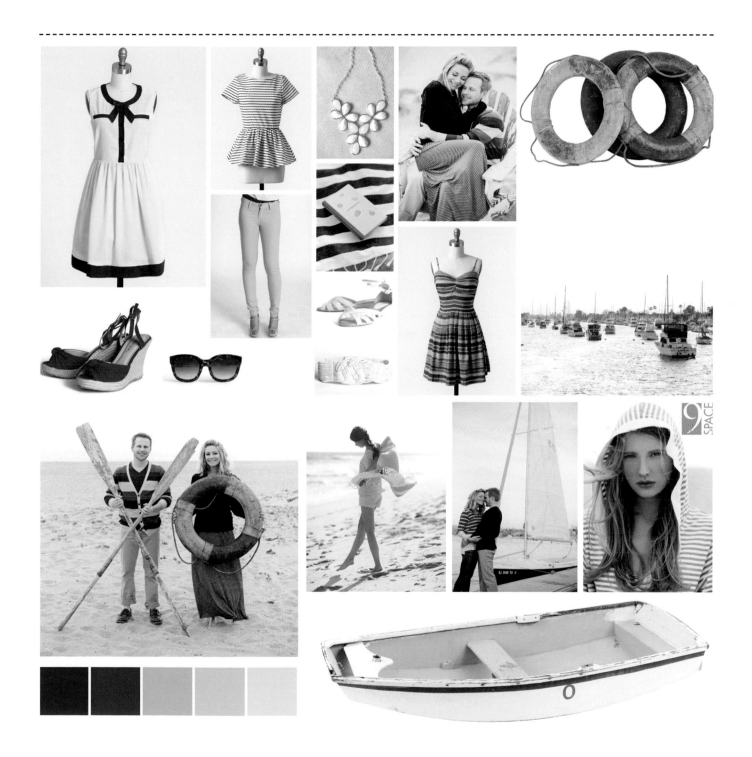

theme. If they have something cute and quirky in their life, it can be a great inspiration for the session's color palette and styling.

When you are seeking inspiration for your shoot, look for variety. Besides searching through inspirational online catalogs Loverly (www.lover.ly) and Image Spark (www.imgspark.com), look at the work of lifestyle and editorial fashion photographers. Romantic editorials, like the kinds shot for women's beauty and lifestyle magazines, pair well with bridal and engagement inspiration, creating a well-rounded style board. Wedding blogs spend a lot of time sourcing images for their inspiration boards based on color and theme. Use them as resources to think more creatively about your session.

--

Sources and Inspiration

The fashion industry is full of inspiration and bridal bloggers have done a lot of work sourcing the images they feature on their blogs and websites. For fashion and editorial inspiration, look to the stories featured on sites like www.fashiongonerogue.com or www.ftape.com. These sites allow you to find top ad campaigns and fashion shoots quickly without having to search through magazines at the bookstore. *Korean Vogue* and *Elle Girl* both feature lots of cute editorial stories that can help you create a storyline. Taking your engagement photography to the next level by styling them in the vein of fashion editorials is one way to make your work stand out from other photographers.

Another huge source of inspiration, for both you and your clients, can be Pinterest (Pinterest.com). As a website that allows users to share ideas by pinning collections of various images from the web or their own, it can be a great tool and huge inspiration when creating mood and style boards or when you are just looking for new ideas. You can direct your couple to this resource for inspiration by suggesting they look up romantic inspiration boards and style boards or curated collages dedicated just to wardrobe inspiration. You can even create secret Pinterest boards that only your clients may have access to. This ensures a unique and creative value added service for your clients.

SnippetandInk.com, Oncewed.com, greenweddingshoes.com and stylemepretty.com all have lovely curated inspiration boards that feature strong color palettes and themes. If you find an inspiration board designed for weddings that you love, try pulling a color palette or "feel" from it and use it to inspire your couple or come up with your own new style board. There are online tools to help you create mood boards, like Stixy (www.stixy.com), that allow you to make online collages and easily share them with others. With minimal Photoshop skill, however, you can quickly create a blank page in the application and resize and place your images in collage form.

As a photographer inundated with resources all the time, it's easy to forget that your clients may have never been exposed to the wedding industry before. Be sure to share as much information with your couple as you can by directing them to great bridal blogs and sharing your knowledge with them. By giving your couple the tools to find inspiration for their shoot, you will be adding more value to your services and your clients will really appreciate it. Be sure to keep hunting for new inspiration by asking other wedding vendors about their favorite resources—the wedding industry is booming and there are new websites, blogs, magazines, and tools being published constantly. Keeping up with the industry is vital in order to stand out as a photographer.

Canon EOS Mark II, 50mm 1.2 lens, ISO 100, f/2 at 1/3200 sec

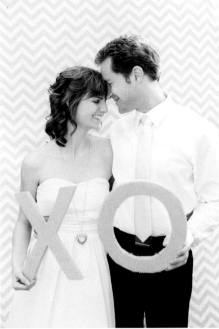

"Hugs and Kisses!
I bought this Chevron
print fabric backdrop
for under $20 and the
couple crafted their
own X's and O's."

Canon EOS-1V, 50mm 1.2 lens,
f/2.8 at 1/125 sec. Fujifilm
Pro 400H

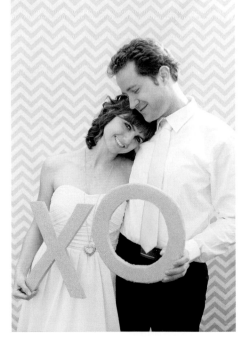

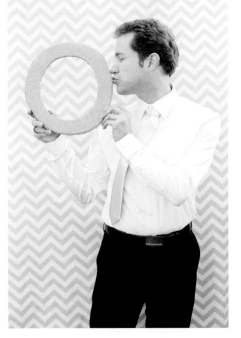

Wardrobe and Styling

One of the first questions couples often ask their photographers is "What should we wear?" The challenge with this question for many photographers is that not every photographer is a fashion stylist. Referring your clients to online resources or a stylist are great ways to help your clients look and feel their best with some professional help and also to help you network and build more relationships with stylists in the industry. **Jacqueline Weppner, at Merci New York**, works with couples from all different backgrounds and budgets:

> No job is too big or too small, and we revel in making their vision come to life! Engagement sessions can happen on a variety of budgets, and a styled session can too. Clients are always amazed how a little styling goes a long way in the process. Our clients come to us because they understand and appreciate the art of styling and how it brings another level of visual intricacy to their shoot. Because they are often very busy couples, they also take solace in having an expert handle the shopping, styling, location scouting and shoot production on their behalf.

There has been a recent increase in editorial and fashion stylists marketing their services to the wedding industry. Many bridal blogs have even added a "stylist" section to their vendor guides to make room for this growing category. Stylists are a wonderful resource that you can collaborate with and direct your couples to. If these kinds of services are a little too high-end for your couple, try recommending free resources like J. Crew and Nordstrom's, which both offer free personal shoppers to help people pick out clothing. If your couple are completely clueless about wardrobe, consultants at these stores can help them pick out clothing that flatters their shape and that compliments each other.

If your couple does not have the budget to buy new clothes or to get a stylist, there are always a few basic tips you can suggest to them. Recommend that your couple bring two outfits. You want your clients to be really happy with

"Shoe shots can convey a couple's sense of style."

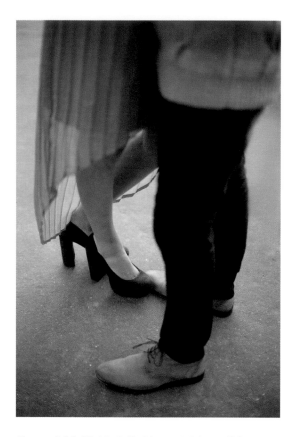

Canon EOS 5D Mark III, 50mm 1.2 lens, ISO 640, f/1.4 at 1/500 sec

their wardrobe. Having a few wardrobe choices allows them to have options when buying and framing prints afterward. Encourage your female clients to show their necks and to avoid wearing super high collars or turtlenecks. You can suggest fashion model "tricks" to looking fresh, like using eye drops to take the red out of the eyes about an hour before being photographed. Your clients don't need to match head to toe, but staying within a certain color palette will create more fluid images. In general, muted tones look better on

"The thin stripes on his shirt look ok shot with film, but if I had been shooting with digital, this kind of pattern would have created a moiré effect."

Building relationships with stylists, hair and make-up artists, and other vendors will help you have a network of trusted resources to send your couples to. Have a recommended vendor list of people that you work with often. Strong relationships with others in the industry might mean that you can negotiate a special rate for the couples as a trade for some photos. Ideally, the hair and make-up artist your clients use for the shoot will be the same one they use for their wedding.

Canon EOS-1V, 85mm 1.2 lens, f/2 at 1/250 sec.
Fujifilm Pro 400H

"I tend to send my clients recommendations or a list of resources in a tactful, suggestive way. I don't want them to ever feel pressured. Instead, I'd like them to feel like these are suggestions I make to all my clients and that I would send to a general audience. I want to be able to guide and direct my couples, however, I don't want them to feel forced into wearing something that does not reflect who they are. Same thing goes with props and location. The following is a tips sheet I send to my clients with suggestions from a wardrobe stylist."

camera. Some busy prints or large logos distract the eye too much and detract from the subject.

Remind your clients to avoid wearing tiny prints like small polka dots or small plaid prints with thin lines, since they usually don't photograph as well and can create weird artifacts in digital photography. This phenomenon of strange waves, rippling rainbow color, or rings of color over small patterns is called a moiré effect and is most often seen in digital photography.

SUGGESTIONS *from* A WARDROBE STYLIST

Mai Olivo, chief creative officer and co-founder of Ruche Clothing (WWW.SHOPRUCHE.COM), put together a great list to help couples with their wardrobe and style. Mai has been orchestrating great style by combining looks she loves from designers around the world since 2005 and has successfully created a great website for people to find unique clothing at reasonable prices.

Dress the Occasion: First and foremost, your outfits need to match your engagement photo shoot location and theme. Will you be walking under the city lights, or will you be riding bikes on the pier? This will determine how fancy or casual to dress. If your photographer allows it, bring at least two changes of clothes. Outfit options are always great to have, just in case!

Colors: Color is a key element for the perfect outfits. When choosing your outfits, select colors that complement your hair and skin tone, of course, but also stand out in your photos. Keep in mind the location of your engagement photos, and avoid colors that will blend into your surroundings. For example, green may not be the best choice for taking photos at a park. If you plan on using props in your photos, which are common for themed engagement shoots, keep your prop colors in mind too. You don't want them to blend (or clash) with your outfits.

As a couple, your outfit colors need to complement each other, but not match exactly. If you both wear the same color palette, the photos may end up looking unnatural and flat. Bold colors are recommended, but with the right styling, neutral colors can also work just as well. If you prefer wearing neutrals, find statement pieces that are rich in detail and add color with accessories. A "color pop" pair of shoes, piece of jewelry, or lipstick can sometimes be all you need. Also, if one person is wearing a neutral palette, the other person can wear a bolder color palette for contrast.

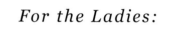

OUTFIT PAIRINGS

For the Ladies:

DETAILED TOP + SIMPLE BOTTOM
(skirts, pants)

SOLID TOP + PRINTED BOTTOM
(skirts, pants)

DRESS
(detailed, printed, solid)

DRESS + A TOP OVER DRESS + BELT

DRESS + A COLLARED TOP
UNDERNEATH

OPTIONAL OUTERWEAR:
CARDIGAN, COAT, BLAZER, SHAWL

DETAILS: JEWELRY, BELT, SCARF,
HAIR PIECE, TIGHTS

For the Gentlemen:

DRESS SHIRT
(l/s or s/s solid or printed)
+
BOTTOM
(pants or shorts)

A HENLEY, POLO, NICE T-SHIRT
+ BOTTOM
(pants or shorts)

SWEATER + PANTS

SUIT SET

OPTIONAL OUTERWEAR:
BLAZERS, CARDIGANS, JACKETS,
COATS, VESTS

DETAILS: TIE, BOWTIE,
SUSPENDERS, HAT

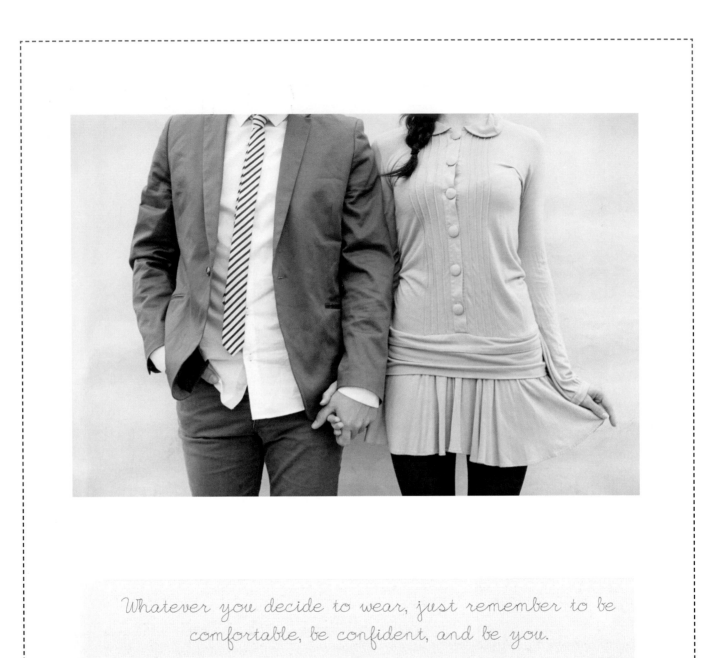

Whatever you decide to wear, just remember to be comfortable, be confident, and be you.

Details: After you select your colors look for the details. Textures, prints and patterns, or simply a detailed collar are essential! Feminine details, such as ruffles, rosettes, and bows, create interest and depth to your photos. More subtle details, such as lace, embroidery, and eyelets, create texture and interest as well. For men, rich textures such as tweed, wool, and detailed knits, photograph nicely, and you can't go wrong with stripes, gingham, plaid, or checkered prints, too.

Keep in mind that if you choose to wear prints, you must create the right balance between your outfits or else the photographs will look too busy. If one person is wearing a print, the other person should wear a solid color or a subtle pattern. An easy way to coordinate your outfits is to select a color from the print and have the other person wear that color. When it comes to styling, remember that you will be photographed together, and in a way, you end up being each other's accessories.

Accessories: Don't forget about the finishing touches! In addition to colors and details, accessories will complete your outfits and also make each other's outfits cohesive. For women, jewelry can often tie an entire outfit together, but the focus should be on the engagement ring. Avoid wearing additional rings, and if you choose to wear bracelets, wear them on the opposite hand. For men, a tie or bowtie is a great way to accessorize and tie in the colors that you choose. Play with additional accessory options, such as detailed belts, printed scarves, tights, and hats, but make sure you don't overdo them. Too many accessories, like too many prints, will disrupt the balance of your photos. For example, if you opt for a hair clip, wear dainty earrings and skip the necklace or vice versa.

Styling: With location, colors, details, and accessories in mind, it's now time to put all the pieces together. The most important words to remember are "layers" and "balance". Layers give your outfits' dimension, and they're an easy way to add color, texture, and different outfit options too.

When putting your outfits together, women have tons of creative options. You can add outerwear such as a knitted cardigan, a bold colored coat, or a shawl, to completely transform an outfit. You can also try different layering techniques, such as a top over or under a dress. For example, a sheer lace or crochet top over a dress and a belt at the waist will create the perfect balanced outfit. A peter pan collared blouse or a button-up collared blouse layered under a dress is a cute option too. Both outfits will create the perfect balance of texture and interest.

For men, layer a smart blazer, a textured cardigan, a tailored jacket, or a vest over a simple tee for a complete look. You can also layer a button-up collared shirt underneath a crew or v-neck sweater for effortlessly polished style. Another favorite combination is a collared shirt underneath a blazer for a casual, yet put-together look. With menswear, it will be easy to mix-and-match all the pieces for different options.

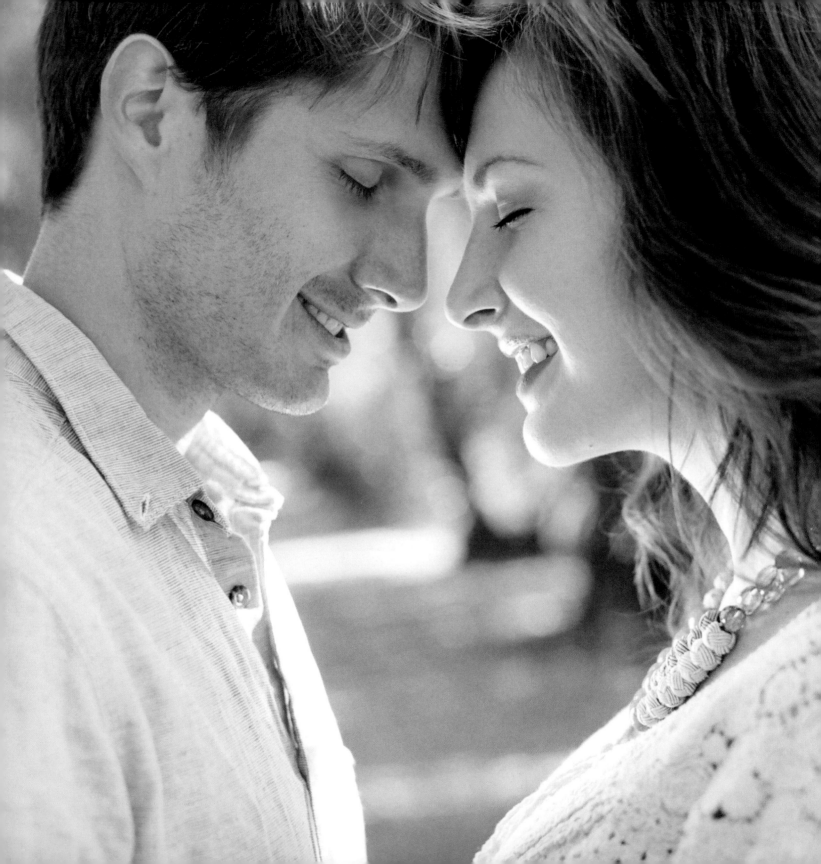

Workflow and Post-Processing

Post-production can be a dizzying subject for both the seasoned professional and the intermediate photographer. Software options abound and most photographers use one of the tried and true programs like Photoshop, Lightroom, and Aperture. With so many images, it is essential to design a workflow that helps you quickly deliver files to your clients and easily archive your images. Finding reliable methods to back up your work, store your images and process them quickly, and with consistency, is a necessary step toward being a responsible and professional photographer.

Post-processing doesn't have to drain you of all your time and energy. Establishing a workflow that fits your schedule and personality is attainable and important to establish early in your career. Developing a processing style that suits your in-camera images, whether it is minimal or heavily edited, is an exciting and formative part of your creative journey. Discovering your own philosophy on editing will help you remain true to the vision that makes your work unique.

Finding a healthy balance between work and life is also a part of developing your artistry, and an efficient workflow will help you maintain that balance. Post-processing can be a very time-consuming aspect of running a photography business. Be sure to schedule days off and keep track of your time so that you can maintain realistic, energized work hours. If you are struggling with overworking yourself it may be time for a workflow overhaul. Consider changing your business model by shooting all film, outsourcing your post-processing or hiring an employee or part-time assistant. Your time and

"It is important to see programs, actions, filters, etc. as a way to enhance a close to technically perfect image instead of constantly 'fixing' imperfect captures in Photoshop. If you are adamant about getting image exposure and compositions right in camera, then all an image will need afterward is just a bit of tweaking. I usually only add some brightness and run a slight action or apply an Alien Skin film filter to my digital images or add some contrast to my film scans. A lot of this back end work can be automated as a batch action in Photoshop to minimize your computer time."

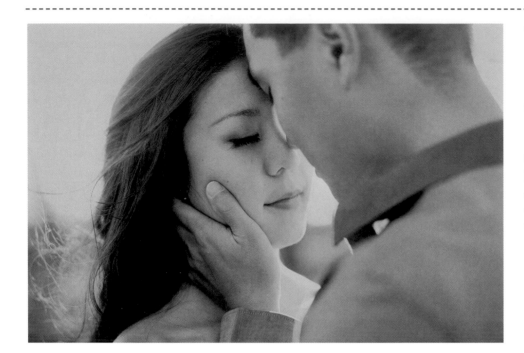

"I often find that black and white images convey emotion better."

Canon 5D Mark II, 50mm 1.2 lens, ISO 250, f/2.2 at 1/1000 sec converted to black and white with Alien Skin Exposure 3 Daguerreotype

life are valuable and are an important part of what makes you a great photographer.

Back it Up

Take your lifestyle into consideration as you develop your workflow. Every photographer is different and discovering how you work best will help you keep your photography fresh and exciting because you won't be burnt out by an inefficient post-processing workflow. Engagement sessions, unlike weddings, don't need to be an extremely laborious process but they do need to be well organized, backed up (in at least two locations) and consistent in your editing and shooting style.

For a one- to two-hour engagement session, you should be able to download, back up, cull, and batch edit the session in about two to four hours. A competent equipment set-up is crucial. An efficient and timely workflow translates to less

computer time over the course of a year. Critical to both your sanity and your post-production workflow are a fast compact flashcard reader and a computer system that is able to smoothly run programs like Adobe Photoshop and Lightroom. Laptops have limited storage capabilities and are generally not recommended for editing because the light and color change too easily depending on the angle of your laptop screen. Your computer system will need plenty of storage capabilities and RAM (Random-Access Memory) to run these heavy duty programs.

Whether you shoot RAW or JPEG, your hard drives will fill up pretty quickly. Setting up organized computer systems to back up, store and easily archive all of your files is a professional standard. If you don't shoot a lot of images or need to store a lot of data, you can safely manage your images through hard drives, time capsule, or using a cloud-based storage system. If you are storing your work on hard drives, keep a second copy backed up somewhere safe—perhaps on DVD, a second drive, or on cloud storage. If you are shooting

"This un-retouched film scan from Richard Photo Lab has the most lovely skin tones. I basically will only add a touch of brightness or contrast to finish the film scan for the client's proof."

Canon EOS-1V, 85mm 1.2 lens, f/2 at 1/125 sec. Fujicolor Pro 400H

engagement sessions and plan on moving into weddings or are already shooting weddings and other sessions, it is worth your time and energy to look into setting up a simple mirrored drive system, called a RAID1 system, so that you program it to automatically back up all of your images.

RAID1 systems are a bit of an initial investment, but the peace of mind and time savings of an automated redundant system are well worth it in the long run. Not only will it back up all shoots and work but it can also be set up to back up your main hard drive and all your programs and software. If any drive becomes corrupt or fails, it is simply a matter of swapping drives and buying a new backup drive. Compare this scenario to having to restore your whole computer and reinstall all programs and settings.

Talk to a computer specialist about the best methods to automatically back up and store your images. Let them know how much data you plan on processing each year and that it needs to be accessible to you and backed up twice. It is important to create a system that takes into account your future storage needs and has lots of room to grow and expand with your increased business. Asking professionals in the computer technology field will help you have the most up to date and appropriate options for your business.

Organizing your client folders and keeping a clean desktop are also important. Having additional images and folders on your desktop takes away from the RAM and scratch disk space to run RAM-heavy programs like Photoshop and Lightroom. Keeping your client folders organized by year, date, and name allows you to find a client's folder quickly and efficiently. For a multiple hard drive RAID1 system, you can keep a main hard drive to run your software programs and then have working and storage drives, keeping your fresh shoots in the working drive and older shoots in a drive dedicated to archiving. This ensures that you do not run out of storage space on your main or working drive. Older RAW folders can be deleted after a certain period of time and the final edited JPEG folder remains.

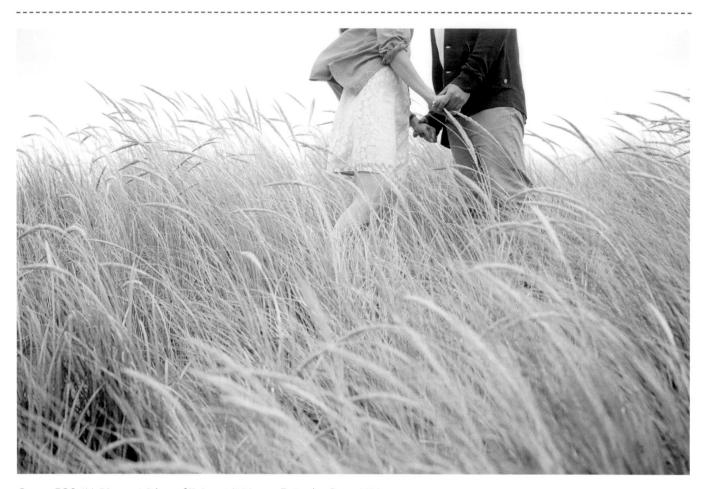

Canon EOS-1V, 50mm 1.2 lens, f/2.8 at 1/500 sec. Fujicolor Pro 400H

Post-Processing

Like the rest of your photography business, the way that you process images should reflect your style and brand. Shooting your images correctly in camera will make the editing process significantly easier and streamlined, enabling you to achieve a "less is more" approach in regards to post-processing and retouching.

Lucia Dinh Pador from *Utterly Engaged* magazine noticed that a few years ago there was a "lot of Photoshop processing, thus making the images, including the couple themselves, look very unnatural. [Now] beautiful, timeless, soft, and intimate is back. This is great for a lot of couples because that will never get too trendy or dated."

If you go into a shoot with a good knowledge of your camera, settings, light, and a clear vision of what you want to shoot with your clients, you'll find that you can achieve the look that you want with minimal processing and time

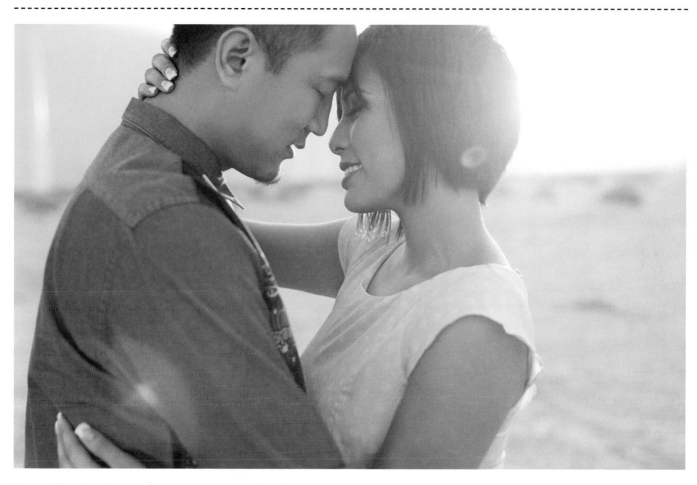

"I added a bit of contrast and cleaned up a few blemishes, but this film image was nearly perfect coming back from the lab."

Canon EOS-1V, 50mm 1.2 lens, f/2 at 1/250 sec. Fujicolor Pro 400H

spent in front of a computer. With photos that are well thought out, shot in good light, and exposed correctly, it's easy to find yourself simply adjusting some color and brightness and perhaps running an action to achieve the look that you're going for.

Be sure that your photos shot in similar lighting conditions all have the same exposures by shooting in manual mode. That way you can edit your images in batches—this is

a huge time saver! If you follow your engagement sessions with an established workflow, you'll find that your processing time will go by much faster. If you can't dedicate the time needed to process your images, especially if you're shooting digitally, there are a lot of post-production houses that produce great work and will edit your images for you at very competitive prices.

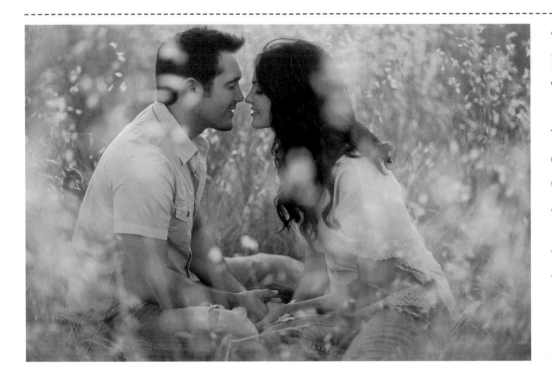

"These sunset images exuded warmth! I processed the images to emphasize the golden glow and warm tones using the tarnished gold tint action in Red Leaf Studio's Film Solution action set."

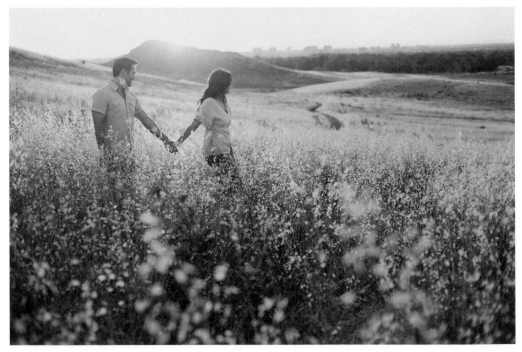

Both images shot with Canon EOS Mark II, 70-200mm 2.8 lens at f/2.8

Stephanie's Process for Digital Capture

Step 1: Set up client folder using an easy to organize naming system. I organize my sessions by clients' wedding date or the shoot date for à la carte clients and then their names. For example, 140322_Susan_Michael will be created for clients Susan and Michael with a wedding date of March 22, 2014.

Step 2: In the main folder, I will create several folders. RAW, RAW_KEEPERS, JPEG, JPEG_FINALS, PROOFS, and SLIDESHOW

Step 3: Download CF cards into the RAW folder. For a two-hour engagement session this will be around 300–400 digital images. I use a mirrored drive system that automatically backs up the session that I've downloaded and any other folders that I create on my hard drives.

Step 4: Create a catalog for culling (selecting the images you will keep). I use IView Media Pro, however, a Lightroom catalog or another organizational program like Photo Mechanic works just as well.

Step 5: Sort through the session with the catalog and tag or star the images you will keep and create into client proofs (I simultaneously double star the images I will blog or edit for teasers). I usually end up keeping one image out of every four or five to deliver a total of around 100 digital and 75–100 film images.

Step 6: Move the tagged/starred keepers to the KEEPERS folder. The images that are not selected are kept for about four weeks and then deleted from the drive.

Step 7: Go through the RAW Keepers in a bulk editing software like Lightroom or Adobe Camera RAW (ACR). Since I shoot in manual mode, this is a really quick process that includes making minor color balance changes and occasionally brightening the images that need it. I can select similar shot images in bulk and make changes to all images simultaneously.

Step 8: Use the software to batch the RAW Keeper images into high resolution JPEG and save in the JPEGS folder.

Step 9: Create a batch action that includes a film filter and action to help mimic the look and grain of film. I play around and tweak my formula often, but to give an example, I would use Alien Skin Exposure 3 filter Fuji Astia 100F with a medium grain combined with Red Leaf Boutique Soft Muted action at around 50 percent with the grain turned off. I like the look of Alien Skin's film grain over Photoshop's noise filter. Using Photoshop's File>Automate>Batch tool, this action is run onto all the JPEGs and they are automatically saved in the JPEG FINALS folder.

Step 10: I then quickly create a catalog to rename the JPEG finals and choose a few images to change into black and white.

Step 11: Run a batch to create small web size images and save in the PROOFS folder. I use the 'save for web' feature.

Step 12: Upload the web-sized proofs to an online proofing cart.

Step 13: Select highlights from the proofs folder and upload into an online slideshow program.

Step 14: Email slideshow and proofing links to clients.

Step 15: Burn and archive high res two copies of the JPEG FINALS images onto DVD, one for the client and one copy for archive.

The RAW and RAW Keeper images are kept for a few months before eventually being deleted off the hard drive. I archive the JPEG FINALS folder indefinitely on a hard drive and on DVD.

Stephanie's Process for Film Capture

Step 1: mail out the rolls of film to my lab. Personally, I like to use Richard Photo Lab. I print out their mail-in form and select the size of film scan and whether or not I want to receive proof prints.

Step 2: in about seven business days, download the film scans.

Step 3: tweak any images that need a little extra work but, for the most part, the film scans come back with nearly perfect color, exposure, and contrast.

Step 4: create a main client folder which includes FILM SCANS ORIGINAL, JPEG FINAL, PROOFS AND SLIDESHOW folders

Step 5: follow steps 10–15 of the digital workflow to catalog, rename, and upload to web.

Canon EOS Mark II, 45mm 2.8 tilt shift lens, ISO 320, f/3.5 at 1/125 sec processed with Red Leaf Studio's Soft Muted action from the Film Shift set

"I always include a slideshow of highlights because I want
my couples to be able to see their images set to music—especially
the first time they see the photos. Also, people love sending the
slideshow links to friends and family or sharing them through social media.
The slideshow then takes them to the proofing site where my
couples and their families and friends can order prints and make their
selections for their album. A valuable service I build into my pricing is to
fully retouch any print over size 5x7 and any image included in an
album or guest book. This includes perfecting skin, dodging and
burning, or running any additional actions to create a desired look.
I want their favorite images and the final tangible product
to be perfect!"

Film

Engagement photography, like much of the wedding industry, lends itself well to the gentle, dreamy look that comes with the look of slightly overexposed film. Soft skin tones, muted colors, and organic grain embody the romance of engagement photography well. You can create very different types of images using film, depending on the type and speed of film, type of light and processing decisions. If you focus on shooting correctly in camera, film will be extremely forgiving of skin tones and can help you to spend less time editing at your computer. After you send your film to be processed, you'll generally receive your scans back within a week or two. Some of the more well-known labs, like Richard Photo Lab (www.richardphotolab.com), offer such a superior service that photographers will mail in their film from all over the world.

Labs will generally make digital scans of your film available to download right away using a file transfer protocol (FTP) system or will mail you a CD along with your negatives.

You can also choose to receive printed proofs for your client as well, so they can view a tangible image.

When your scans come back from the lab, there is very little processing that needs to be done to the images—one of the perks of having a professional lab work on your images. Some drawbacks that photographers face when shooting film is that there are limitations on the kind of blemish and body editing that can be done to a film-based image. Because your film scans will already have a certain amount of grain to them, your ability to retouch your couple's images by clone stamping and manipulating their bodies or clothes with the liquify tool in Photoshop will be impacted. The grain pattern will easily become distorted and will need to be "patched" by adding more grain to that edited spot. The beauty of film is that nothing can truly replicate the way it captures light and the tones that it produces, but many digital techniques can come close.

"Even using Alien Skin Exposure 4 black and white filters won't produce the same results as shooting true black and white film."

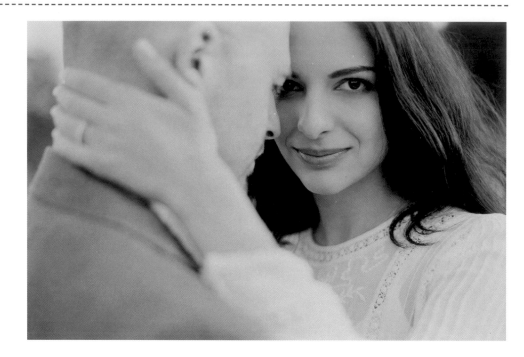

Canon EOS-1V, 50mm 1.2 lens, f/2 at 1/60 sec. Ilford 400 XP2 film

Digital

A digital workflow allows photographers to take advantage of all the photographic technology that exists while still emulating the look of film. Don't be afraid to play with your style, experiment with editing, and take classes to help you understand the tools at your disposal a little better. Digital images can be very sharp and hyperreal to begin with, so shooting with a wide open aperture paired with softening and adding grain to your images in post processing will help to create the sought-after film look. Using actions and filters on top of your digital images can help you mimic the look of film on your digital images.

Retouching

For the most part, the amount of retouching that you do to an image is a personal preference, but maintaining a standard that includes only color, exposure, and contrast for your proofs will mean that you spend less time in front of a computer. If you've shot correctly in camera, you should be able to edit most of the images from your shoot through a batch edit process, so they all get processed at once and with the same edits. Save the retouching and major manipulations for images that you love and want to use on your website and blog, and for the photos that your clients select for their album and prints.

Any images that you post on your blog and website, publish, print, or put into an album should always be fully retouched. Putting your best foot forward will take you far

"To get rid of the graffiti, I used the clone stamp tool and stamped the blue section over the graffiti. Since this is a film image, I had to add grain using Alien Skin's grain only filter and match the grain to the grain pattern that was erased. This process is a little tedious and takes some Photoshop skill to master, but most of the time you cannot tell if something has been edited after grain and texture are reintroduced."

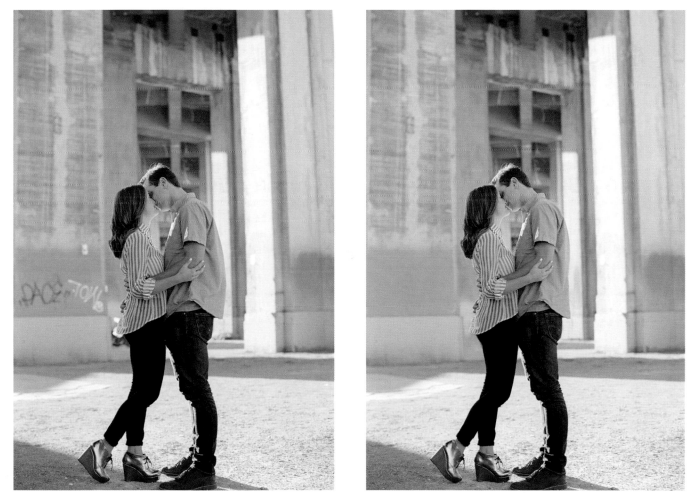

Canon EOS-1V, 50mm 1.2 lens, f/2.8 at 1/250 sec. Fujicolor Pro 400H

"Once I go through the steps of processing full galleries of images for my clients, I will take extra time to fully edit my own or my clients' favorite images. Any image that I put on my blog, website, or in a client's album will be a fully edited presentation of my work. The first steps I take in Photoshop are to remove any small blemishes with the band-aid tool and then use the clone stamp tool to further perfect skin and even out skin tone. I select a soft brush at 20 percent opacity and select the lighter areas to then stamp the darker spots, like dark circles under eyes, uneven skin tone, frown lines, etc. This takes practice and is more of an art than a science. Using a soft brush and low opacity ensures that you don't take away too much natural skin texture: you don't want your clients to look like flawless dolls! I also may use the liquify tool, which comes in handy when adding body to hair or perfecting clothing. I don't use it to change a person's natural appearance, but it can offer some great enhancement options.

After the image is edited for perfect skin, I then add filters, actions, and grain. Adding the right amount of grain that mimics film is critical to achieving a softer film look with digital images. It also adds texture to retouched skin to mask the appearance that any editing was ever done. My current favorite filter set is Alien Skin Exposure 4. The film filters and well mimicked film grain pair well with a finishing action from Red Leaf Boutiques Film Shift series. I create an action to achieve my current favorite recipes so they can easily be combined and applied to each image. This ensures that a blog post or album has a consistent look. My recipes have changed over time and are always evolving. I love to experiment with different action sets, however I almost never use them at full strength. It's a little finishing touch that helps polish a well shot image."

"This young couple had nearly flawless skin, and since they were low to the ground, there was additional light bouncing up at them from the light colored sand. Retouching this image simply needed a little bit of clone stamping under their eyes and a few razor burn marks were removed with the band-aid tool. I then applied an Alien Skin Fuji Astia 100 filter to the image and ran Red Leaf Studio's Soft Muted action at 50 percent power to put on the finishing touches."

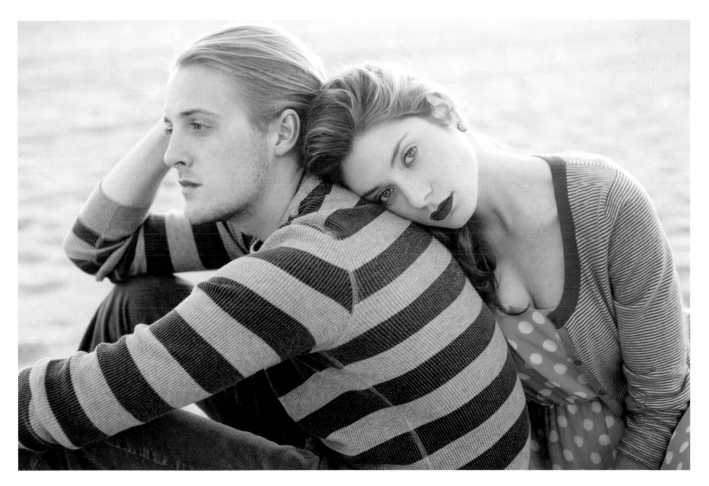

Canon EOS Mark III, 50mm 1.2 lens, ISO 400, f/2.8 at 1/125 sec

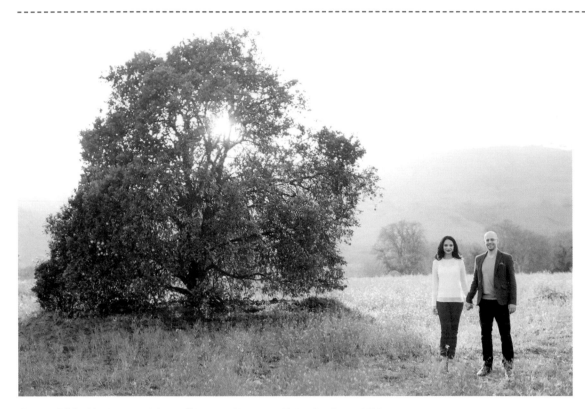

Canon EOS-1V, 50mm 1.2 lens, f/2.8 at 1/250 sec. Fujicolor Pro 400H

in the industry and show what you are truly capable of. Learning how to retouch images in a discreet and subtle manner is a professional skill that differentiates many photographers from their amateur counterparts. Retouching shortcuts in Photoshop will significantly speed up your editing time.

For instance, learn keyboard shortcuts for commonly used tools like 'Command' + 'm' to bring up the Curves tool or left or right brackets ([]) to quickly decrease or increase brush size respectively. There is a wealth of online tutorials and books dedicated to Photoshop. There is always something entirely new to learn about this powerful and complicated editing program. For the visual learner, Creative Live (www. creativelive.com) offers some excellent online in-depth courses on Photoshop, Lightroom, and other editing programs. For photographers that don't want to spend too much

time working on retouching images, there is always the option of outsourcing the work to a specialist company.

Outsourcing

For many photographers, outsourcing post-production has become a cost-effective way to manage the time-consuming tasks associated with editing. As a business owner, you need to be able to devote your energy to shooting engagement and wedding sessions, bringing in more business, networking, and getting your work seen by your target clients. For photographers with limited time, sending photos to post-production houses can free up time to photograph more test shoots and better your portfolio.

Film photographers usually send their film to get processed by professional labs, and digital photographers have

the same option with their files. If you find that you need more time to shoot or are getting burnt out on editing, consider outsourcing the work in order to free yourself up to focus on building your business. Many photographers end up burnt out by the business end of photography because they don't know how to delegate the work to others. It's also a great way to make sure that you find time for yourself and can have the energy and enthusiasm needed to push your career forward.

Proofing

Setting up an efficient, simple and accessible proofing site for your images is an industry standard for engagement photographers. In general, there are two main types of proofing sites, one where you do most of the work yourself and one where the proofing site handles most of the work. There are sites where you pay a significant initial fee for the online program, hosting the proofing site yourself and keeping all profits generated from the print orders. In this scenario, you must take care of fulfilling the image orders and the payment processing yourself. Most other proofing sites charge you a monthly fee or take a percentage of your print profits but they take care of the payment processing and cut you a check at the end of the month. Either they will also take care of the print orders if they are associated with a lab or you will continue to do so. There are of course many variations on these two types of site, so you must figure out what will work best for your business.

"These images were processed using Red Leaf Studio's Soft Muted Action at 80 percent. The action pinches and colors the highlights to create a creamy look that softens digital capture."

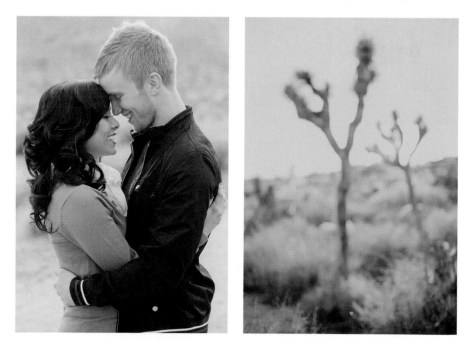

Both images shot with Canon 5D EOS Mark II, 50mm 1.2 lens at f/2.8

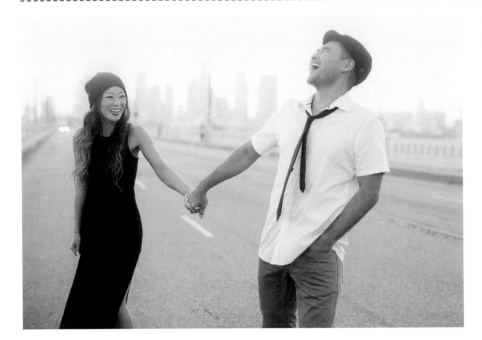

Canon EOS Mark III, 50mm 1.2 lens, f/2.8 at 1/640 sec. 800 ISO. Image processed with Totally Rad Replichrome Lightroom preset Kodak Portra 800: Frontier

Online Vendors, Outsourcing, and Film Lab Resources

Action sets, filters, and lightroom presets
Red Leaf Actions www.redleafboutique.com
VSCO www.vsco.co
Alien Skin Exposure www.alienskin.com/exposure
Totally Rad Actions www.gettotallyrad.com

Film
Richard Photo Lab www.richardphotolab.com
Indie Film Lab www.indiefilmlab.com
Pro Photo Irvine www.prophotoirvine.com

Digital outsourcing
The Album Design www.thealbumdesign.com
Lavalu www.mylavalu.com
Photographers Edit www.photographersedit.com
The Next Edit www.thenextedit.com

Print products
proDPI www.prodpi.com
White House Custom Color www.whcc.com

Album products
Leather Craftsmen www.leathercraftsmen.net
Renaissance Albums www.renaissancealbums.com
Artifact Uprising www.artifactuprising.com
Vision Art Albums www.visionart.com
Couture Book www.couturebook.com

Online proofing
Into the Darkroom www.intothedarkroom.com
Insta Proofs www.instaproofs.com
Next Proof www.nextproof.com

Royalty free music
Triple Scoop Music www.triplescoopmusic.com
Song Freedom www.songfreedom.com
The Music Bed www.themusicbed.com

"Pairing film and digital capture can get a bit tricky, but for the most part both mediums can coincide if digital is processed to be softer and film-like grain is applied. In this pairing, the left image is film while the right is digital capture."

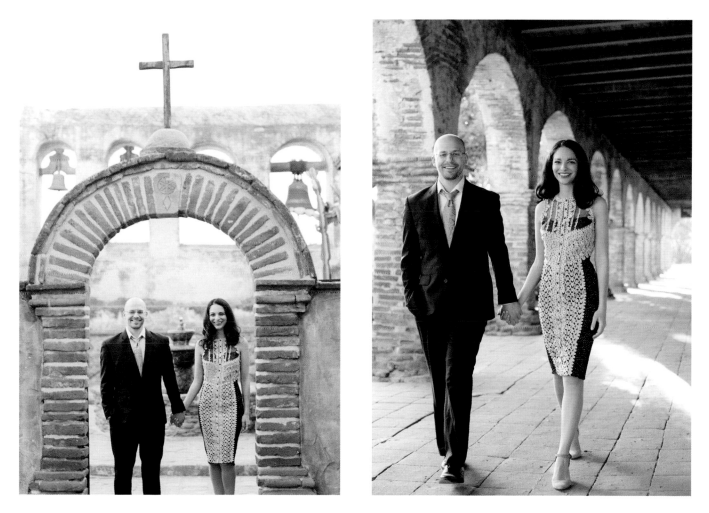

Left image: Canon EOS-1V, 50mm 1.2 lens, f/2.8 at 1/125. Fujicolor Pro 400H; right image: Canon EOS 5D Mark III, 50mm 1.2 lens, ISO 400, f/2.8 at 1/320 sec processed with Alien Skin Exposure 3 Fuji Astia 100 filter

Try to choose a proofing program that is as user-friendly as possible and can be customized to fit your look and branding. Remember, it should be easy enough that clients who aren't computer savvy can easily figure out the viewing and ordering system or be quickly and simply walked through the process. Some proofing programs will come with slideshow programs or have them as an added feature that links back to the proofing site. Adding a slideshow to your clients' proofing site will help create a great experience for your couple and also help you promote your business to their friends and family.

Into the Darkroom has a great slideshow software called Flaunt for purchase that works seamlessly with other media. Try putting together a "best of" slideshow set to music that showcases your favorite images from the session. Remember that when putting music to your slideshow, you still have to follow licensing regulations. Using royalty free music from sites like www.triplescoopmusic.com can help you find the perfect song for your slideshow and allow you to purchase the licensing for it. Spend some time finding a few songs that you love and you can use them with different slideshows for different clients. Your clients will always remember and be moved by both the photos and the memorable experience that you created for them. While slideshows do involve extra time on your end, consider them as an investment into your advertising and a part of your branding. Slideshows encourage couples to share their photos with their friends and family, which helps you book more sessions and sell more prints.

If your photography is easy to manage once you step away from the camera, you'll find that you have more time to spend shooting photos and building your business. It is extremely important to create a solid foundation for your post-processing workflow. It's easy to get overwhelmed by editing, especially if you are shooting multiple sessions a week, but by setting up a streamlined, efficient workflow and reliable computer systems, you can free up time to focus on more important things, like making beautiful photos, branding, online presence, and getting your work published.

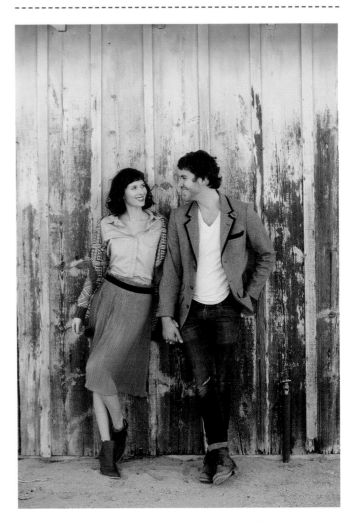

Canon 5D EOS Mark III, 50mm 1.2 lens, ISO 400, f/3.2 at 1/2000

"You can use either film or digital capture to create stunning images. Your eye and use of light along with your ability to direct your couples will supersede whether you use film, digital, or both mediums."

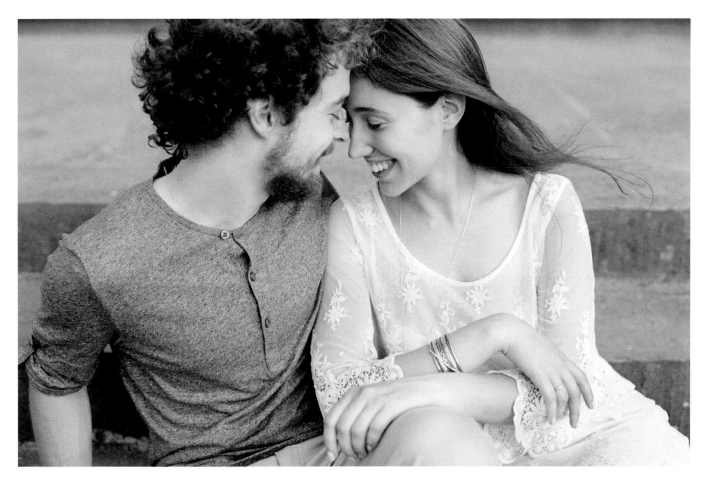

Canon EOS-1V, 50mm 1.2 lens, f/2.8 at 1/250 sec. Kodak Porta 800

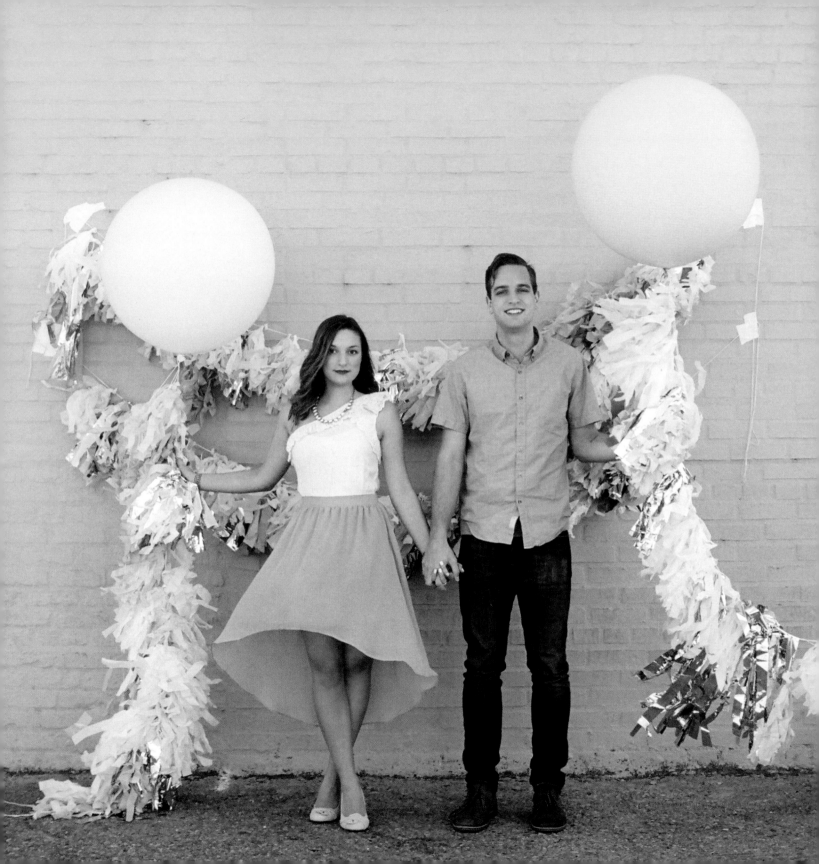

Branding and Online Presence

Attracting clients and moving upwards in the wedding industry stems mostly from exposure and relationship building. Good exposure begins with a clean portfolio featuring stunning photos that align with a well-defined brand. Getting your engagement sessions published is a successful way to get clients to view your photography and get a better feel for your style and voice. Online publication, especially on bridal blogs, will result in more traffic to your website and a wider network, translating to more potential clients viewing what, at this point, should be an already grounded and branded portfolio. Publication of your images is your avenue to connect with potential clients. Finding your voice and establishing your brand will create the opportunity to continue shooting engagement sessions that you love and help you begin shooting more weddings or enhance your current wedding photography business.

Branding

In order to attract a specific clientele, you have to know yourself and your own style. Establishing a cohesive brand means taking the time to tune in to who you are and what makes you tick. Discovering the unique image that you wish to build your brand upon is not an easy task, and for many photographers it is an ever-evolving process. Developing your brand means delving deeply into yourself, clearly identifying what your vision is and how you plan to move forward with your photography business. Branding is much more than matching the color of your logo to your website; it goes deep into the heart of your story and your style. It is the gossamer string that binds your tone, style, and image together into one clean package. A strong brand makes it easy for the public to recognize your look, style, work, and what you are known for.

Branding is the whole of how you choose to present yourself to the world. Take a day or even a week to sit down and think about what you want your brand to convey. Reflection upon what makes your business unique will help you discover not only what brought you to where you are now as a photographer, but will help you see where you want to go with your business. Sit down for an afternoon and take time to reflect on some of the following questions:

- What inspired your business name (if it is different from your personal name)?
- Who is your target market?
- Who is your perfect couple? Describe them: where do they shop? What is their personal style? What is their income level? Your perfect couple will most likely be interested in the same things you are interested in and share a similar aesthetic.
- What do you love and what are you aesthetically drawn to?
- What magazines do you love to read and what style of images do they contain?

Both images Contax 645, 80mm Zeiss lens, f/2. Kodak Portra 400 film

- Which photographers do you admire (not including wedding photographers) and why are you drawn to their work?
- Write down several adjectives to describe your photography and style.
- What makes your work and your vision unique?

Once you've taken the time to ask yourself some of these questions, you will begin to see a theme. Now look at your current portfolio, website, business name, and social media

image. Does it match the descriptions that you've written about? Creating a coherent theme, from the images that you put on your website to your website style, logo typography, social media voice, and color scheme will help make your brand identifiable by the public.

Another exercise to do when trying to revitalize and identify your brand is to spend time scouring the Internet for all sorts of imagery that you love, and save it to an inspiration folder or Pinterest board. Look at your collection to find themes, typography styles, and color palettes. Sending these

"These images have a very strong color palette of peach, cream, blue, and turquoise and would attract a young, fun client who wants to add a whimsical or DIY element to their shoot."

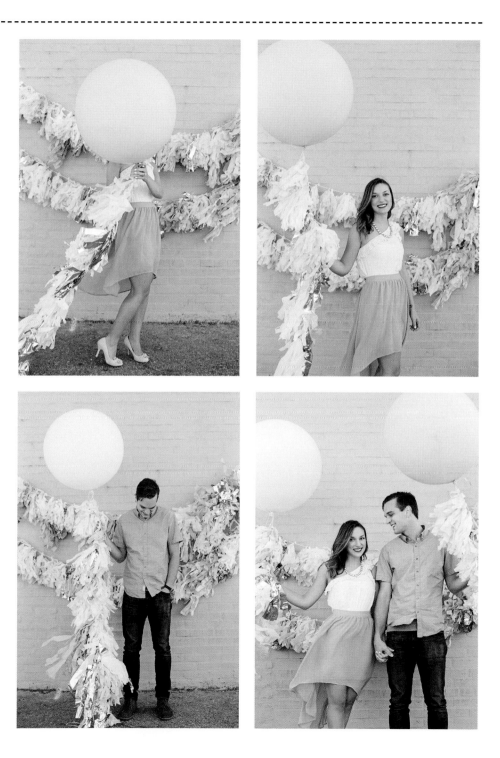

Canon EOS-1V, 50mm 1.2 lens. Fujicolor Pro 400H

"It was a long journey to finally settle down with my current studio name. I initially decided upon the name in response to the song 'Modern Romance' by the Yeah Yeah Yeahs. Although I loved the song, I disagreed with the lyric "there is no modern romance." I knew from my own personal experience and love story that modern romance was alive and beautiful. I held onto the name for almost a year, until finally deciding to change from 'Stephanie Williams Photography' to 'This Modern Romance.' Most studios at the time only had the main photographer's name as their business name, so I was worried that it would be received as too 'cute' or 'cheesy.' I chose to separate my name 'Stephanie Williams Photography' as my fashion and commercial brand, and 'This Modern Romance' as my wedding studio brand. Since I was shooting as a husband-and-wife team at the time and knew I wanted to eventually have associate photographers in the future, it made sense to brand under a different name or phrase."

inspiration images to a graphic designer can be a really great way to show them what you're looking for, in addition to a verbal description. Your potential clients may be on your site to view your photos, but they'll also be taking in the website's colors, your logo, and typography that you are attracted to. If you choose to work with a graphic designer, they should ask you a lot of questions to help draw out what you're looking for, ask more about your business and where you are headed, and who your target market is.

Photographers often have many skill sets, but if you don't know much about graphic design or typography, it may be better to hire someone who knows how to help with logo and web design to ensure that it looks extremely professional,

well designed, and up to date. Being able to delegate work out according to your strengths and weaknesses will let you focus on what you are good at instead of being unrealistic about your capabilities.

It is rare for an artist to be a professional at everything; acknowledging your weaknesses and delegating them to someone who is an expert in that field not only helps ensure that everything about your business conveys professionalism, but also helps to build your network. Finding a talented and unique graphic designer, illustrator, painter, or other collaborative artist can be a daunting task. Look for referrals from other industry professionals or by contacting artists whose work you see featured in magazines. Pay attention to

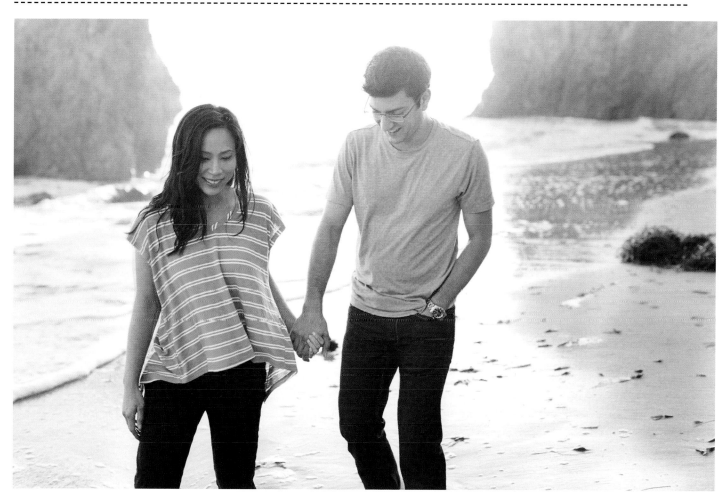

Canon EOS-1V, 50mm 1.2 lens, f/2.8 at 1/250 sec. Fujicolor Pro 400H

Canon EOS-1V, 50mm 1.2
lens, f/2.8 at 1/125 sec.
Fujicolor Pro 400H

the artists' names under the posters and artwork that you are drawn to. If one artist isn't interested in taking on a certain project or is beyond your budget, ask them for referrals to their colleagues.

Online Presence

Most couples search for their photographers online. **Blair deLaubenfels, founder of the blog Junebug Weddings**, notes that:

> Technology has made the biggest impact on the wedding industry as couples have moved online to book professionals and find inspiration for their wedding. Ten years ago, many top professionals relied on referrals and an occasional magazine ad for their bookings. These days savvy business owners have to market themselves effectively online while they build and maintain name recognition through social media platforms like Facebook, Twitter, Pinterest, and so on. Similar to the transformation that film photographers underwent to learn digital technology, today's wedding professional needs to learn how to successfully market themselves online. Potential clients expect to see a well developed website and/or blog and a social media profile from the professional they choose to book and interact with.

Creating a clean, easily accessible website, in addition to utilizing social media, will help you appeal to more couples and build relationships with other players in the wedding industry. Consider using a template from photography-based web developers like Bludomain (www.bludomain.com) to Big Folio (www.bigfolio.com) if you can't afford to hire a web designer. Your website is the first thing that your clients will see—you want it to be user-friendly, clean and well designed and search engine friendly.

It is essential that your website is easy to navigate. Potential clients should be able to access important information like image galleries, contact information, and a section about yourself within two clicks. Make sure that the images

"Don't let budget stand in your way—there are the big names in the wedding industry who specialize just in photography branding, however, you can find amazing graphic designers and artists, at many different price points, in places you wouldn't expect, like Etsy (www.Etsy.com).
Before I could afford to work with a graphic designer, I did some of the branding package myself, but hired an illustrator to do my logo and a few other elements. I fell in love with the illustrator's work while viewing some posters published in *Frankie* magazine (www.frankie.com.au) and already knew she would understand my aesthetic."

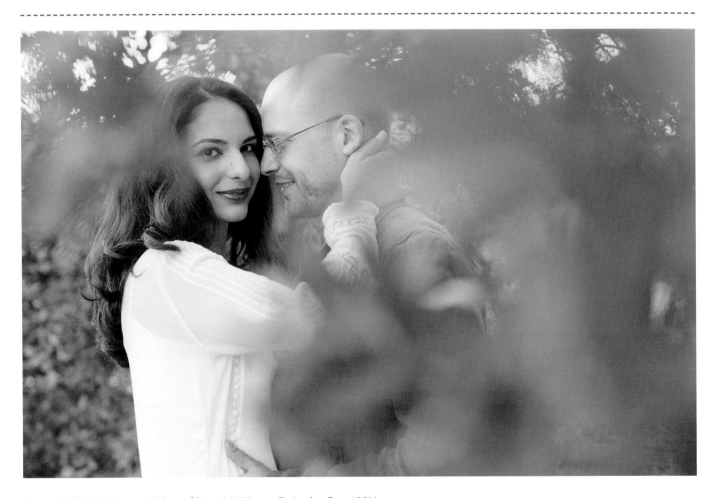

Canon EOS-1V, 50mm 1.2 lens, f/2 at 1/125 sec. Fujicolor Pro 400H

in your portfolio represent your best work. Careful selection of images will ensure that you create a clear idea of what your clients can expect from you. Approaching your portfolio with a "less is more" mentality can be especially helpful in targeting a specific audience. Regardless of how many images you choose to feature, select only your best and display them in a clean, easy to view format. Every one of your photographs should convey your brand and style so that potential clients aren't confused about what they can expect when they book

you. Many top photographers cull their portfolios the way a fine art gallery might curate a display and choose images that appeal very precisely to their target clients. They might choose to only show the images that will effectively attract a very specific couple.

Staying up to date on current technology includes participating in social media. Your website should contain, or at least link to, a blog. Your blog is one of your most powerful advertising tools. Blogging your images is a great

Use Twitter, Instagram, a Facebook page, Pinterest, etc. all with a unifying name or brand, so people can find and follow your work.

A variety of Fuji Instax Wide images

Canon EOS-1V, 50mm 1.2 lens, f/2 at 1/160 sec. Kodak Portra 400

way to show off recent shoots, utilize tags and keywords, and display additional images without making your website too busy. Your blog is also your chance to show off your personality while maintaining a professional space for clients to learn about you. Avoid saying anything on your blog or social media platform that you don't want potential clients to see; including politics, religion, and negative reviews about other vendors.

Your blog is also your opportunity to show off other creative projects besides engagement sessions and weddings. Use your blog to create an inspirational dialog with your audience by regularly updating it with business news, inspiration, vendors you like, and bits about your life and interests. Try to update your blog on a regular basis to generate a loyal following. Everything that you shoot can have a place online if you utilize your own blog and connect with bridal blogs around the country. Collaborating with other vendors on shoots will open up your network and get your photos seen by more people. Creating a symbiotic relationship with stylists, make-up artists, and other wedding vendors will create an opportunity for others to talk about you. By working with others in the industry regularly, you can create an inner circle, supporting each other through referrals.

Contax 645, 80mm Zeiss lens, f/2 at 1/250 sec.
Fujifilm Pro 400H

"For this engagement shoot, adding a lot of keywords will help couples find this session online. Since the session was at a resort, I would list the resort's name, the major colors or themes in the session, as well as other things the images bring to mind. This resort had a Moroccan and Mediterranean theme, so I'll even add the keywords 'Moroccan' 'Mediterranean' 'Greece' 'engagement'."

Canon EOS 5D, Mark II,
50mm 1.2 lens, ISO 400,
f/1.2 at 1/1000 sec

When creating blog posts, get creative with your key-words and tags. Naming the venue, location, color palette, props, future wedding venue, and other descriptive words that relate to the shoot will help your blog post show up in online search engines. In addition to keywords, if you want your session to be searchable based on the location that it was shot at, name your images according to the location or venue so that it will be more likely to show up in a Google image search. If you use a Flash-based website, make sure that it also has an HTML-based text section so that it can be found by search engines. Your work will be easier to find online if you have a better grasp of technology. The industry has become very Internet based, and having an understanding of Search Engine Optimization (SEO), keywords, and other elements of Internet-based marketing will help you build a structurally sound client base.

Networking

Building relationships with other vendors is a great way to get referrals and to integrate your business into the wedding scene. Using a public relations service can help you with initial development by networking on your behalf and creating a buzz about your work. If you do decide to work with a public relations (PR) consultant or marketing and branding specialist, find one that is connected to your area. Look to top-notch wedding PR consultants like Leila Khalil of Be Inspired (www.Beinspiredpr.com) and Lara Casey (www.laracasey.com) to get your name out there and bring in more referrals. While hiring a PR consultant is a big investment, it can pay off if you feel stuck, want to move up in your pricing, or want to take your business to the next level.

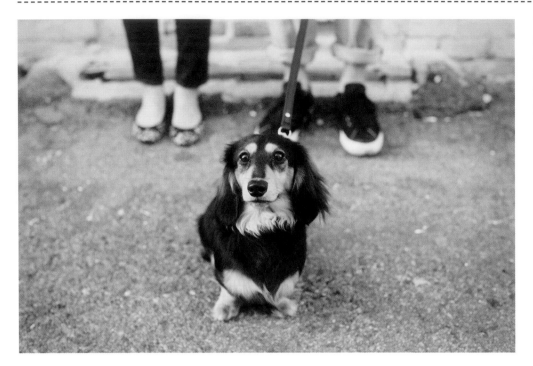

Top image: Canon EOS 5D Mark II, 50mm 1.2 lens, ISO 400, f/2.2 at 1/1000 sec; bottom image: Canon EOS 5D Mark II, 50mm 1.2 lens, ISO 800, f/3.5 at 1/400 sec

Find local vendors in your area that you would like to work with and reach out to them. Ask them to meet up for coffee and suggest setting up a collaborative photo shoot. Vendors in the wedding industry are always in need of fresh images, and as an added bonus, these images can usually be submitted to inspirational wedding blogs to be used as a feature or on inspiration boards. Be adaptable and never allow yourself to get too comfortable—the wedding industry is constantly changing. Social media is an ever-evolving platform for exposure. This may be rather obvious, but make sure to be kind to everyone that you meet in the wedding industry, especially smaller bloggers who may want to feature your work. If you view everyone as though they might be the next big thing in the industry, you will develop positive relationships and create opportunity where you least expect it. Pay attention to how the market is changing, so that you can stay relevant.

Social Media

Utilizing social media outlets like Twitter, Facebook, Pinterest, and Instagram is a great way to expand your readership. They are ideal tools to get your name out there while initiating dialog with others in the industry. Keep your social media accounts professionally oriented. Use them to announce new blog posts, mention the inspirational work of others in your network, share aspects of your personal life and personality, and show that your business is active. Use social media to follow relevant magazines, publications, bloggers, and other industry players to find out about events that you can attend and network at. Building your business is all about building relationships!

On Publications

Building your business means having a well-defined brand and a solid online presence. Your ideal client will be excited about their upcoming engagement session, browsing bridal blogs for inspiration. Shooting engagement sessions that are styled, with clients who are invested in making a creative, out of the ordinary photo shoot, whether it is through wardrobe, a unique location, a vibrant color palette, or fun props, will get you published more often than un-styled sessions.

Summer Watkins from Grey Likes Weddings states:

Usually only bloggers feature engagement sessions (as opposed to magazine editors) because they have much more room in their editorial calendar with up to 15 or even 20 posts per week in some cases. That being said, engagements are very tough to get accepted for publication. The reason is because engagements are competing with weddings and other creative features and, as you might guess, engagement sessions don't feature many unique details or still life photography to mix with happy-couple-smiling pictures. They can also tend to be boring, only because they are all so similar.

With easier access to publication, the quality of images shown on blogs has improved. Each blog has a different reach and target reader, some more local than others, while others cater to a certain style. For instance, the blog Green Wedding Shoes tends to showcase West Coast weddings and vendors, while Brooklyn Bride mostly features East Coast inspiration. Once Wed leans towards featuring photographers who shoot mostly film and have a fine art aesthetic, and their readers tend to have a higher income and wedding budget, while Broke Ass Bride features more do-it-yourself (DIY) weddings and brides on a budget. When looking to submit an engagement or wedding session, make sure you do your homework and check if what you are submitting aligns with that blog's aesthetic and readership.

Creating relationships with bloggers and others involved in wedding publications will provide more opportunities to have your work seen. By showing your work on websites with a lot of traffic, you will ultimately have more of your future clients trafficking your own website. Bridal blogs serve as a platform for photographers to showcase their work in a setting that inspires competition, and thus, artistic growth. With so many blog writers, editors, and publishers to appeal to, photographers are provided with nearly instant feedback

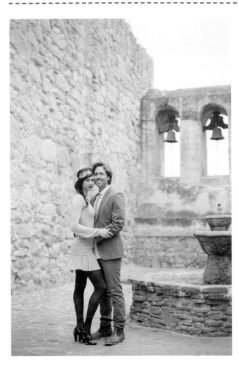

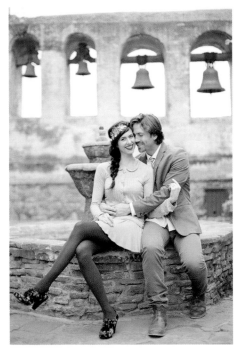

"Make sure to take a variety of angles and crops during your session to be able to tell a visually rich story for your couple. Don't forget to take detail shots of your surroundings to help set the scene and pair with images of the couple. Editors love detail shots and they make lovely pairings for albums or fine art prints for your couples to order."

Canon EOS-1V, 50mm 1.2 lens, Fujicolor Pro 400H

Canon EOS-1V, 50mm 1.2 lens, f/2.8 at 1/125 sec. Fujicolor Pro 400H

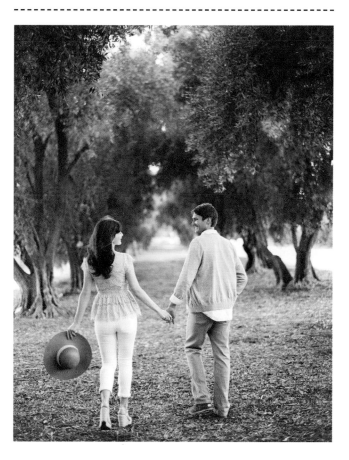

Contax 645, 80mm Zeiss lens, f/2.8 at 1/125. Fujifilm Pro 400H

Bridal Blogs

A sample of the best wedding blogs with the largest reach:

- **Green Wedding Shoes**
 www.greenweddingshoes.com
- **100 Layer Cake**
 www.100layercake.com/blog
- **Style Me Pretty**
 www.stylemepretty.com
- **Junebug Weddings**
 www.junebugweddings.com/blog
- **Once Wed**
 www.oncewed.com

- **Grey Likes Weddings**
 www.greylikesweddings.
 wordpress.com
- **Snippet & Ink**
 www.snippetandink.
 blogspot.com
- **Wedding Chicks**
 www.weddingchicks.com
- **Ruffled blog**
 www.ruffledblog.com

- **Southern Weddings**
 www.iloveswmag.com
- **Brooklyn Bride**
 www.bklynbrideonline.com
- **The Brides Café**
 www.thebridescafe.com
- **Rock n Roll Bride**
 www.rocknrollbride.com
- **Broke-Ass Bride**
 www.thebrokeassbride.com

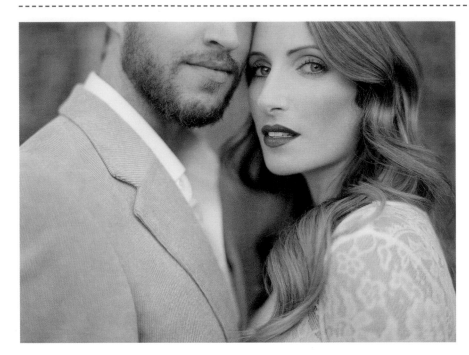

Contax 645, 80mm Zeiss lens, f/2 at 1/60 sec. Fujifilm 400H

on their work; these relationships help improve the quality of work by both rewarding great photography and showcasing inspiring images as a learning tool.

Look into advertising options with blogs that seem to cater to your client base. Sometimes developing a relationship with a blogger means becoming a featured vendor for a month when first starting out. If you are just starting out, listing your business on free directories like Project Wedding and Wedding Wire is also a great way to connect with those in the industry and begin to make your name searchable. Blogs and social networking have plunged the wedding industry deeply into a fast-paced field that improves communication between both vendors and consumers. Potential clients are more connected with vendors and the relationships formed in the digital realm will have a major impact on your business.

Getting Featured

Getting your engagement sessions featured on a bridal blog can play an integral role in promoting your brand and reaching out to a clientele that relates to you and your style. Researching popular blogs and websites will help you get a feel for which ones fit well with your style. Bridal blogs are as varied as the brides that they are appealing to, so finding sites that truly reflect your own style will serve you best in the long run. Every site will look for photography that meshes well with their own brand, but submitting a coherent body of work and meticulously curating your submissions to only the best images is a professional approach regardless of what blog it is. What Jen Campbell of www.greenwedding shoes.com looks for in a submission, she says,

is actually quite simple. When a session works, it's immediately obvious to me. The key elements I look for when considering an engagement session for a potential feature

--

"Creating a unique visual story that will stand out to editors is a big part of why you should take the extra time to plan creative shoots and photograph details and scene settings."

--

"Showing your best work online is important and being selective about the imagery that you put into the blogosphere will make a good impression on editors and your potential clients."

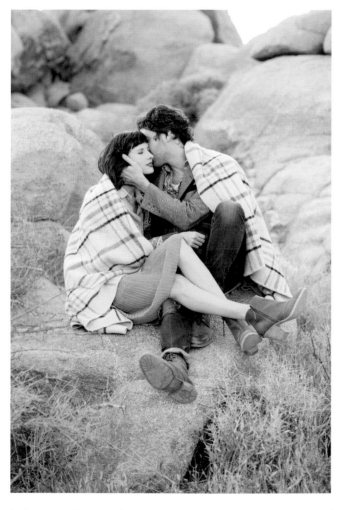

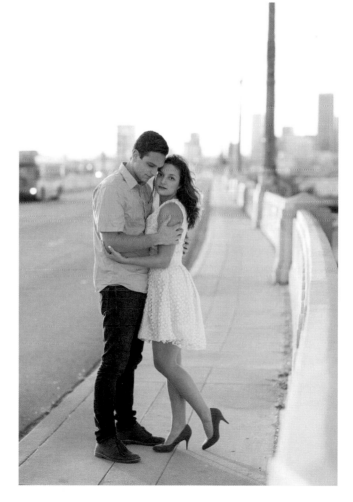

Left image: Canon EOS 5D Mark III, 85mm 1.2 lens, ISO 400, f/2.8 at 1/1250 sec; right image: Canon EOS 5D Mark III, 85mm 1.2 lens, ISO 400, f/2.5 at 1/1000 sec

are: great photography, a couple that shows the love between them, great styling, and something that makes the photos unique and very personal to the couple being featured.

Creating a unique visual story that will stand out to editors is a big part of why you should take the extra time to plan creative shoots and photograph details and scene settings. The most engaging stories have a strong theme, a fascinating plot, structure, unforgettable characters, a well-chosen setting, and an appealing style. Just as a great story captivates a reader, so should your visual stories.

Utterly Engaged editor Lucia Dinh Pador notes that:

as a magazine we are storytellers. So the most important part of any submission is that we want to see if the images tell a story. We live for stories—the couple's personality and their style. We want our readers to be able to connect and relate to the couples that we feature. Without the story, the personality of the couple and style, the images wouldn't stand out or be memorable.

Showing your best work online is important and being selective about the imagery that you put into the blogosphere will make a good impression on editors and your potential clients. In an ideal world, you will have clients that you connect with—and in doing so, you will be able to build a solid client base. Submitting engagement sessions that accurately and authentically reflect your couple's and your own style is essential when promoting yourself online.

Take a moment to step away from your engagement shoot and look at it from an outside, editorial perspective. Bridal blogs that feature engagement sessions are looking for vibrant stories that will keep their readers interested. Leila Khalil, of Inspired By This, loves to see variety in engagement sessions. "Whether it's the couple's outfits or what they are doing in the photos, it's nice to have different shots," she says. "Also, action shots are always fun! It doesn't matter if they are running through a field or playing with their dog they decide to incorporate into the session, I enjoy an engaging element. The most important part is that the couple look comfortable and like the photographer isn't even there!"

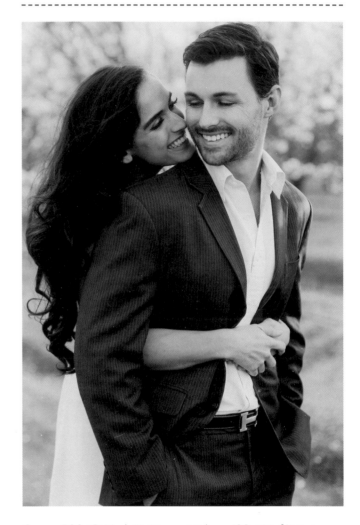

Canon EOS 5D Mark III, 85mm 1.2 lens, ISO 400, f/3.5 at 1/400 sec

A well-rounded collection of images will contain a variety of angles, crops, and frames of the couple—from very wide landscape-based images to tightly cropped intimate portraits. It will also include lots of details. Engagement sessions exist to describe a couple and their relationship without words. Remember to take photographic note of everything during the session. Editors like to see a series of images with intentional design and arrangement.

"One of my first engagement sessions published was featured on Green Wedding Shoes and was chosen because of the unique setting—a beautiful persimmon orchard that was ripe with fruit and very visually compelling. It also helped that the couple had great style and a personal story to go with it. The banner 'I'll see you at home' had a special meaning to the couple. It was what they would say to each other each night they lived long distance from one another. I also made sure to take detail shots to pair with the images of the couple— individual shots of the orchard, a detail of a cluster of persimmons, and the banner by itself hanging in the tree. All these elements made it a compelling and unique online feature."

"We seek a fresh editorial topic in our engagement shoots," says Rebecca Crumley, of the Knot.com. "This could be the way the photos are composed, the location, theme, or other unexpected coordination. Since nearly every couple is doing an engagement session, it's in the photographer's hands to make a striking impression."

Having detailed shots of elements from the environment that you are shooting in, close-ups of your couple's styling and props and wide shots of the scene without the couple will provide an interesting, detailed storyline that engages the viewer without repetition. Photograph your location and the details within it as if your couple are not there; a full visual perspective will appeal to editors that are looking to keep their audiences interested instead of boring them with stale, repetitive images.

Make sure that your engagement shoot is relevant. If you are shooting in multiple locations or with multiple outfits and props, try to make sure that they follow a consistent narrative. A cohesive shoot will have the same 'voice' throughout—you are shooting the same people after all, so it should feel like them the entire time. When editors choose an engagement shoot to feature, they look at it as a whole and not image by image.

"When you submit your work, try to submit images that are related, complementary in color and tone, and work well together. Edit down your selection for me so I can see the best concept you shot," says Summer Watkins from Grey Likes Weddings.

Looking through fashion features in magazines will help you gain an idea of how to create a collection of complementary images that document the entire shoot—from your couple to the ground below them, the sky above them and everything in between.

As emphasized in earlier chapters, bridal blogs are your pathway to connect with potential clients. These blogs will often focus their published photos on weddings, since that is their primary audience, but will sometimes feature engagement sessions that stand out as unique editorials featuring elements of style that will appeal to future brides. When querying bridal blogs and submitting images for publication, it is very important to follow their submission protocols and establish a respectful relationship with the publication.

"The banner 'I'll see you at home' had a special meaning to the couple. It was what they would say to each other each night they lived long distance from one another."

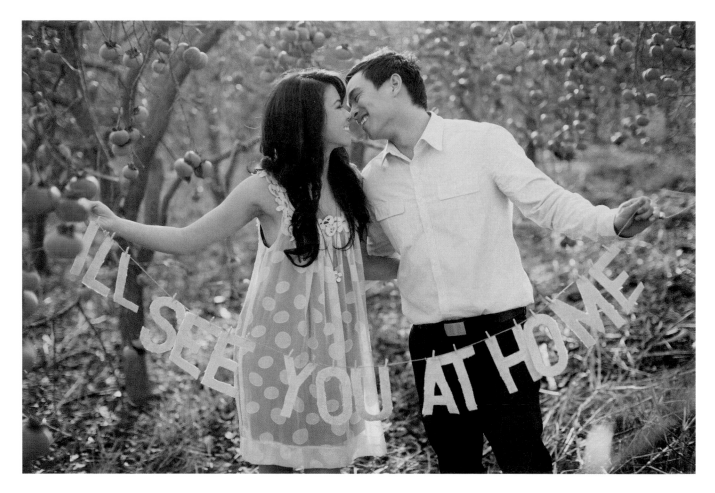

Canon EOS 5D Mark II, 50mm 1.2 lens, ISO 200, f/2 at 1/200 sec

Blog editors that publish your work are going to be attracted to stylized shoots as well as images that convey a true, intimate glimpse into a loving relationship.

When **Kathryn Storke Grady of Snippet & Ink** features engagement sessions she looks "for something that's simply lovely and feels authentic to the couple. If they are doing something together that they enjoy . . . in a place that has special meaning for them. I tend to avoid engagement sessions that feel overly styled." They want to see imagery that appears as a very real moment. As discussed earlier in the book, those moments come when you create them. So don't be afraid to get close to your couples; create intimate moments that pair with stunning locations, a great wardrobe, and some personality.

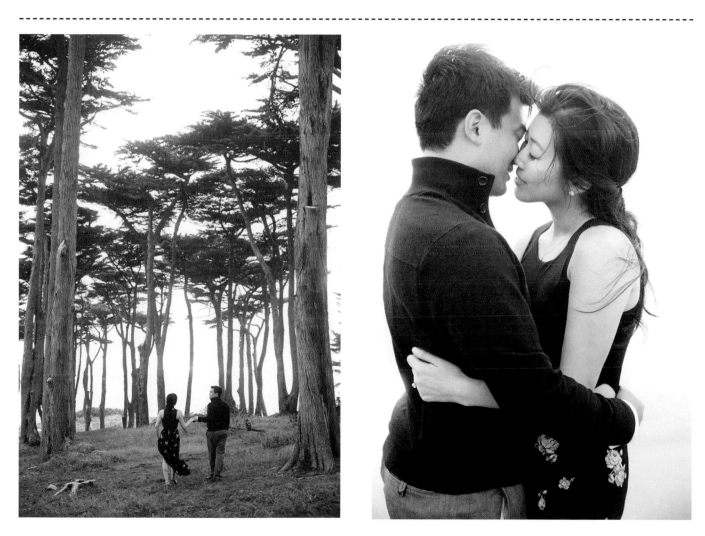

Both images shot with Canon EOS-1V, 50mm 1.2 lens at F/2.8 with Fujifilm Pro 400H

Brand Clarity in a Changing Industry

Building a brand is a lot of hard work, but the effort that you put into refining your image, by thoughtfully streamlining your website, logo, image selection, and the energy that you invest into creating solid, long-lasting relationships with both your clients and those that work in the wedding industry, will result in a business born of intention. By bringing a clear vision and a dedication to personal discovery into your photography business, you can not only fulfill your clients' expectations but exceed them. These relationships will create a ripple effect in your business, giving you the referrals that you need to expand your business and create longevity in your career.

Green Wedding Shoes' Jen Campbell predicts that:

photographers will continue to push the envelope of what we expect from engagement shoots. This means that they'll continue to experiment with photocomposition and technology, whether old or new. I'm seeing so many talented photographers going old school and delivering such amazing work on film, while others are finding new and creative ways to use new technology to capture and manipulate their work. I expect the couples getting married this year and in the future to draw inspiration from the great work featured last year, but take the emphasis on personalization and creativity even further. This means many couples will complement their creative ideas by hiring professional stylists to help them realize the full potential of their vision of their session.

Engagement photography ultimately boils down to love. Love between your couples, love for your art, and love for this growing and changing industry. As you experiment with different types of photography—discovering styles that inspire you and creating work that celebrates authentic, loving relationships—you will continue to grow and become a better photographer. Tapping into your unique perspective will challenge you with every shot. The wedding market changes rapidly, but as long as you strive to capture the love that is beaming out of the couple in front of you, your work will remain relevant, timeless, and will never go out of style.

"In recent years, there has been a growth in the skill and quality of wedding and engagement photographers as a whole. Many photographers that shoot weddings also have the capability of shooting commercial work as well and are viewed as true artists rather than 'bottom of the totem-pole' photographers. I believe that engagement sessions will continue to align with the fashion industry and be inspired and influenced by editorial fashion shoots. As the wedding industry continues to grow and improve and become more fashion forward, I see that clients will expect this kind of style and creative level."

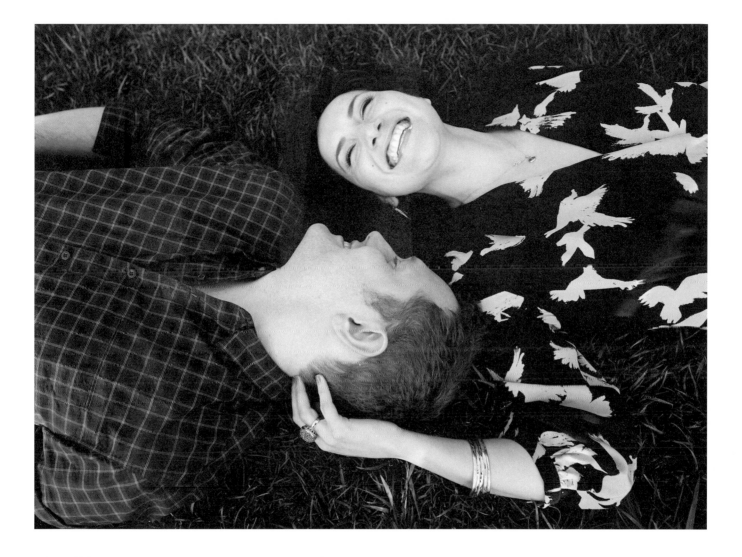

"As long as you strive to capture the love that is beaming
out of the couple in front of you, your work will remain relevant,
timeless and will never go out of style."

Canon EOS 5D Mark II, 24-70mm 2.8 lens, f/3.5 at 1/250 sec

Index

Page numbers in *italics* refer to illustrations.